Islands

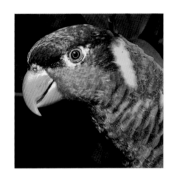

PHOTOGRAPHS BY ROD MORRIS
TEXT BY ALISON BALLANCE
FOREWORD BY FRANS LANTING

SOUTH SEA
Islands
A Natural History

FIREFLY BOOKS

A FIREFLY BOOK

Published by Firefly Books Ltd., 2003

First Printing
National Library of Canada Cataloguing in Publication Data

Morris, Rod, 1951-
 South Sea islands : a natural history / Rod Morris, Alison Ballance.

Includes index.
ISBN 1-55297-609-2
 1. Natural history—Oceania. I. Ballance, Alison II. Title.
QH198.A1M67 2003 508.95 C2003-900402-3

Publisher Cataloging-in-Publication Data (U.S.)
(Library of Congress Standards)

Ballance, Alison.
 South Sea Islands : a natural history / Alison Ballance ; photographs by Rod Morris ; foreword by Frans Lanting. – 1st ed.
[160] p. : col. ill. , photos. ; cm.
Includes bibliographical references and index.
Summary: The history and ecosystems of 14 South Sea Islands: Easter Island, New Zealand, Fiji, Hawaii, Madagascar, French Polynesia, Galapagos, Komodo, Sulawesi, New Guinea, Tasmania, Lord Howe, Phillip, and New Caledonia.
ISBN 1-55297-609-2
1. Natural history — Oceania. 2. Natural resources — Oceania. 3. Marine ecology — Oceania. 4. Natural history — Madagascar. 5. Oceania. 6. Madagascar. I. Morris, Rod. II. Lanting, Frans. III. Title.
577.5/ 2/ 099 21 QH198.A1.B17 2003

Published in Canada in 2003 by
Firefly Books Ltd
3680 Victoria Park Avenue
Toronto, Ontario M2H 3K1

Published in the United States in 2003 by
Firefly Books (U.S.) Inc.
P.O.Box 1338, Ellicott Station
Buffalo, New York 14205

Design by Shelley Watson/Sublime Design
Maps by Russell Kirkpatrick/Standout Maps & Graphics
Printed in China through Colorcraft Ltd

Page 3: (from left) Golden mantella (*Mantella aurantiaca*); Small islands, or motus, surrounding Blue Lagoon, French Polynesia; ornate lorikeet (*Trichoglossus ornatus*).
Opposite: (main photograph) Low-lying coral atoll, Fiji; (inset) *Zygogynum baillonii*.
Page 7: A young coconut palm (*Cocos nucifera*) germinating on a coral shore, Fiji.

SOUTH SEA
Islands
A Natural History

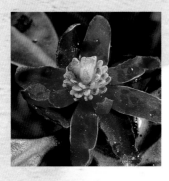

Acknowledgements

Many thanks to Michael Stedman, Managing Director of NHNZ, who has quietly sponsored our interest in islands for over two decades now.

Special thanks also to our colleagues at NHNZ, for their support and companionship, sometimes over many years, in the making of various island documentaries, especially Merv Aitchison, Lexie Arnott, Robert Brown, Paul Donovan, Stephen Downes, Neil Harraway, Peter and Jeannie Hayden, Jeremy Hogarth, Adrian Kubala, Marilyn McArthur, Ian McGee, Glenda Norris, Andrew Penniket, Errol Samuelson, Ray Sharp, Peter Simkins, Richard Thomas, and Wayne Tourell.

In the field, particular thanks must go to James Haile, whose interest in Sulawesi made him the perfect researcher and assistant producer on the documentary *Island Magic*, and also to Roger James, now Conservation International's Threatened Species Specialist for Melanesia, who was the researcher for our early *Islands* series. On that series cameraman Mike Lemmon good-naturedly shared many hardships and countless unexpected adventures, including sharing a bat cave with Komodo dragons and being marooned on Yaduataba. Cameraman Mitchell Kelly has shared more recent adventures with Tasmanian devils, quolls, kiwis and bats.

The works of Darwin and Wallace have inspired us and many others, but our interest in islands really began in the late 1960s when we first discovered the book *Island Life* by Sherwin Carlquist. Two decades later, Sherwin acted as scientific advisor on our *Islands* documentary series, joining us on the Antipodes and Bounties—islands he had never visited before—and searching with us for tarweeds off the Californian Coast. While filming in the Hawaiian Islands, we encountered his "disciples" everywhere—evolutionary biology students who were inspired by his writing and teaching, and wanted to learn more about such fragile worlds. Their enthusiasm must surely hearten him.

A great many people—often after a lifetime's work—have provided ideas which are passed over in no more than a sentence or two in the specific chapters of this book. To mention all would be impossible, but we would like to pay special tribute to the following:

In Fiji and New Zealand, Fergus Clunie generously provided both an historian's and a natural historian's point of view. In 1982, Fergus together with the late John Gibbons and Ivy Watkins from Orchid Island encouraged us on our first-ever overseas wildlife documentary—the Fijian iguana story. Hal Cogger kindly looked over the Fijian reptile information, and Fergus checked and rechecked our chapter until (in his words) it finally "passed muster."

Alison Jolly took valuable time off from writing her latest authoritative book on Madagascar to comment on our chapter. Peter Ballance cast an eye over the information on Gondwana. Our friend and traveling companion Rod Hay checked the French Polynesia chapter, while Caroline Blanvillain shared information on pihiti distribution.

Nearly twenty years ago Cam and Kay Kepler provided a sanctuary and base in Athens, Georgia for ten days while we discussed the natural history of Hawaii. They suggested the following people in Hawaii, all of them great field companions: Betsy Gagne (Maui), Steve Montgomery, Sheila Conant, Ken Kaneshiro and Duane Meier (Oahu), Jim Jacobi, Jack Jeffrey, Bill Mull (Big Island), and Dave Boynton (Kauai). We sailed with Ed Carus on *Aeolus* along the Hawaiian Leeward chain, stopping off at Laysan Island and French Frigate Shoals. Our memories of friends in Hawaii and adventures along the Leeward Chain, are especially treasured. Jack Jeffrey kindly read the chapter on Hawaii.

The Galapagos chapter, written after a ten-day tour of the islands, benefited from Tui de Roy's and Mark Jones' insight and helpful advice.

Condo Subagyo shared all of our Komodo adventures over many years, and became a great friend and traveling companion, ably assisted by Matius Ndapawunga and Dede Rubianto. Walter Auffenberg, whose name is synonymous with Komodo dragons, and his wife Katelin joined us for three memorable weeks on Komodo, when we talked dragons from dawn till dusk.

David Bishop first introduced us to the mysteries of Sulawesi, a country we have returned to several times. Alain Composte, cameraman and companion, missed both Christmas and the dawn of a new millennium to film the mysterious Sulawesi civet. Duncan Neville of TNC Palu, assisted us on several field endeavors, and Paul Brock, Jon Bridle, and Roger Butlin identified invertebrates. Tim O'Brien and Margaret Kinnaird of the Wildlife Conservation Society answered our questions about figs, and Margaret kindly read over our chapter.

Tim Flannery was happy to talk about marsupial "tigers and devils," and the apparent lack of large predatory mammals in New Guinea. He also looked over both the New Guinea, and Tasmania chapters for us. While in New Guinea, Gary Dodson took us in search of antlered and wide-eyed flies.

In Tasmania, Androo Kelly has proved a vital ally every time we go near the Dasyurids, while Menna Jones has provided scientific support and guidance on two documentaries, as well as commenting on the Tasmania chapter. Bob Mesibov and Penny Greenslade, helped with advice on Tasmania's invertebrates.

In New Caledonia, Yves and Henriette Letocarte provided hospitality and valuable field assistance during filming of both plants and kagu. Gordon McPherson provided botanical advice, as did Peter Lowry and John Dawson, who puts the finishing touches to his own book on island plants as we write. Peter and John both kindly read through the New Caledonia chapter.

And so to New Zealand, where conversations have run deep and long over this and other chapters as well. Without Don Merton many of us in New Zealand would know less about the value of islands and island species, especially kakapo. Don's tremendous energy, example and infective enthusiasm are also held in high regard overseas, particularly on the troubled islands of the Indian Ocean, where many regard him as one of the world's most special people. Trevor Worthy brought a palaentologists eye and field experience not only to the New Zealand chapter but also to Fiji and Madagascar. Richard Holdaway brought enthusiasm to countless discussions, as well as that unique perception that all palaentologists have of the havoc that modern predators have brought to islands. Ian Atkinson discussed subjects as varied as the impact of kiore on islands and of moa browse on plants. Tony Whitaker recounted his experiences across the Pacific searching far and wide (and high) for *Metrosideros* species, as well as for new reptile species in New Zealand and lost species in New Caledonia. George Gibbs, John Dugdale, Brian Patrick and Mike Meads have always encouraged our interest in invertebrates. Mike Daniel and Brian Lloyd shared with us the extraordinary world of the short-tailed bat, and John McLennan, Philip Smith, and Tony Billing each, in their own way, understand our very special kiwi.

The perspective of overseas visitors to New Zealand helped us take a second look at our own animals and plants. Sir David Attenborough, Mike Archer, Sue Hand and Jared Diamond's visits were particularly insightful.

Ian Hutton has been an enthusiastic companion on several trips to Lord Howe Island, and kindly read over the Lord Howe chapter, while Owen and Beryl Evans shared their extraordinary tent camp with us on the summit of Phillip Island during an expedition to band seabirds and search for endemic plants.

Several trips to Easter Island have been enriched by conversations with John Flenley back in New Zealand—his new book on Easter Island is eagerly awaited by many of us.

With the help of all these people and more we have tried to make this book as accurate as possible, but we take full responsibility for any errors that remain.

Finally, we would like to thank Frans Lanting and Christine Eckstrom for their insight and encouraging comments, and for agreeing to write the foreword for this book.

To Sherwin Carlquist, for casting the first spell.

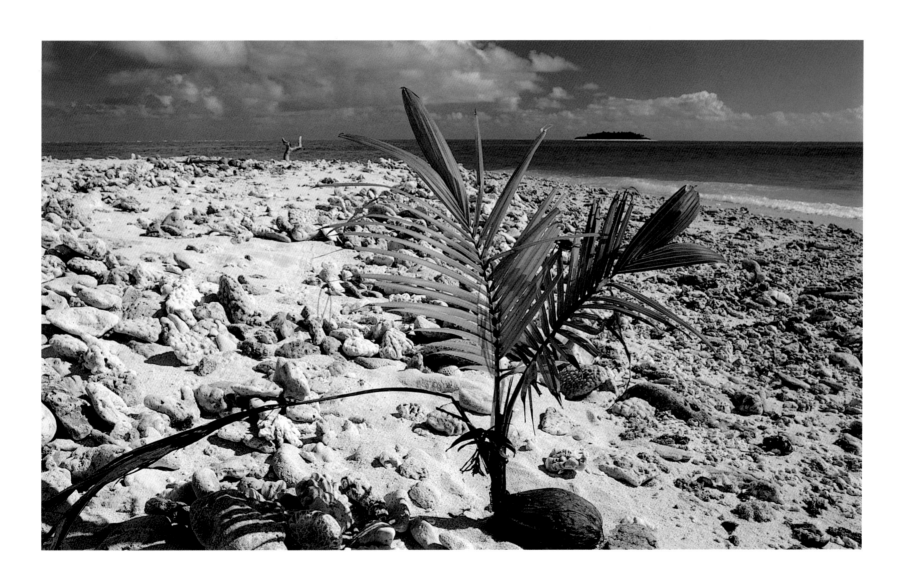

Foreword

Islands are magic. Whether you are a biologist on an expedition or a traveler on vacation, when you go to an island you hope to see something out of the ordinary. Islands appeal to our yearning for the exotic, and they often fulfill that desire. The distance from home may vary, but be it a speck of coral in mid-ocean or a bigger landmass just offshore, islands always provide a new perspective on where you come from.

In this age of globalization, when life is beginning to look and feel the same everywhere, islands are essential reservoirs of biological diversity. They are reminders that life can adopt very different forms when it is presented with new opportunities. In Madagascar the empty niche of a woodpecker is filled by a primate, the aye-aye, which uses a skeletal middle finger to tap old logs and dig out insects hidden inside. In New Zealand it took two birds of the same species—male and female of the now-extinct huia—combining forces to do the woodpecker's job, with each bird equipped with a different shaped beak.

I've been under the spell of islands myself for years. In Hawaii, I struggled through boggy forests along mountain slopes, hoping to hear the calls of endangered songbirds. I camped among giant tortoises in a volcanic crater in the Galápagos Islands and marveled at their improbable existence. I fell in love with the other-worldly landscapes and wildlife of Madagascar, where I had the privilege to explore places never photographed before. Each of those experiences added to my appreciation of the transforming power of islands.

Just as global economic forces increasingly affect local patterns of social and cultural diversity, the spread of non-native species to vulnerable, isolated environments is having disastrous effects on island ecologies around the world. From the devastating impact of brown tree snakes on the birds of Guam to the invasion of Tahiti's forests by introduced miconia trees, the replacement of unique island species by alien opportunists presents one of the great conservation challenges of our time, and I hope this book will contribute to an awareness of what is at stake.

It is fitting that two naturalists from New Zealand are tackling this subject. Few places in the world can claim such an unusual natural heritage as can the islands of New Zealand. From kakapo to kiwi, takahe to kea, the birds of New Zealand are as wondrous as any animals I have had the pleasure to work with. And in my opinion, few people are as well qualified to produce a book on this subject as Rod Morris and Alison Ballance. They both bring an island sensibility to the subject that is conveyed through exquisite images and insightful text. Their work will enable those people who wander through these pages to glimpse the magic that islands bring to anyone with a mind open to their wonders.

Frans Lanting

Map of the Islands

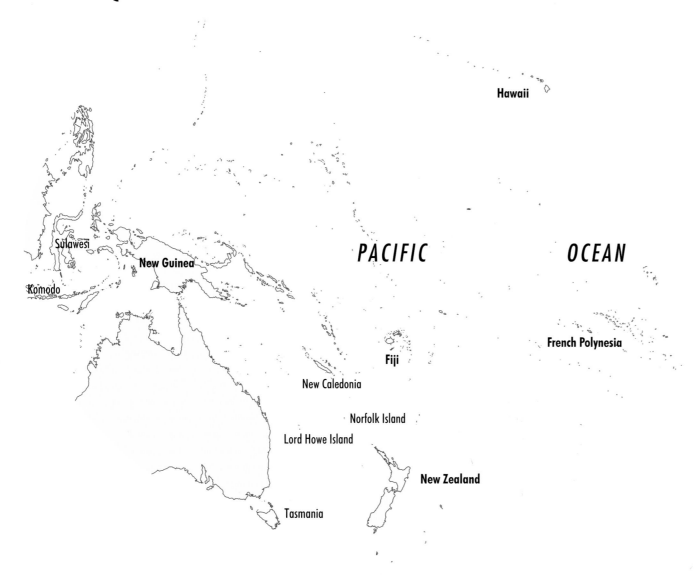

Hawaii

Sulawesi

Komodo

New Guinea

PACIFIC

OCEAN

Galapagos Islands

Fiji

French Polynesia

New Caledonia

Easter Island

Norfolk Island

Lord Howe Island

New Zealand

Tasmania

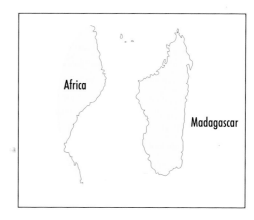

Africa

Madagascar

Introduction

"… from so simple a beginning, endless forms most beautiful… evolved"

CHARLES DARWIN

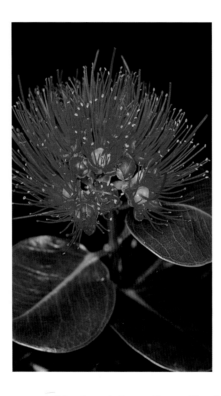

Puarata (Metrosideros collina collina), ABOVE RIGHT, *in flower on the rainforest slopes of Mount Marau, Tahiti, is a close relative of New Zealand's pohutukawa (M. excelsa). Pohutukawa's descendants are widely dispersed across the islands of the Pacific, with puarata in its many forms cropping up throughout the eastern Pacific. La Diademe,* OPPOSITE, *at 4335 feet (1321 meters), is an eroded basalt outcrop near the summit of Mount Marau. The humid forests on high islands frequently contain* Metrosideros *species.*

*R*oll up, roll up, to the Greatest Circus Sideshow on Earth. Discover magical worlds of dwarves and giants, where casts of astonishing creatures shrink and grow and morph into unexpected and bizarre shapes and forms. Marvel at topsy-turvy worlds, where harmless lizards are transformed into fearsome killers, where kangaroos live in trees and birds become earth-bound.

These may sound like fanciful words from a nineteenth century circus poster but such worlds aren't imaginary works of fantasy and fiction. They are very real and are the result of a very special kind of magic—the magic of islands. Islands have the power to change life itself, to mold species into something entirely new. Island species can lead an Alice-in-Wonderland existence: in New Zealand a tiny fern turns into a mighty forest giant, while in Sulawesi a massive buffalo shrinks to the size of a small goat, as has happened with the anoa. On the same island the giant civet, a predator, now prefers to eat fruit, while in Hawaii small leaf-eating caterpillars have become voracious killers.

Islands excel at the creation of dwarf species. The tiniest vertebrates in the world are two minuscule lizards, one of which is just slightly more than half an inch (16 millimeters) long and is a very newly discovered species that shares its West Indies island home with the world's smallest frog and smallest bird.

Island magic is equally capable of creating giants. On Komodo Island a lizard has become a mighty dragon, and on the Galapagos Islands tortoises are among the animals that have grown in size almost beyond belief. In New Zealand a cricket has become an enormous nocturnal "demon," the heaviest insect in the world, and the weightiest parrot of all smells like musty freesia flowers and lurks in the shadows of the night forest.

Although continents are also home to weird and wonderful species, islands have far more than their fair share.

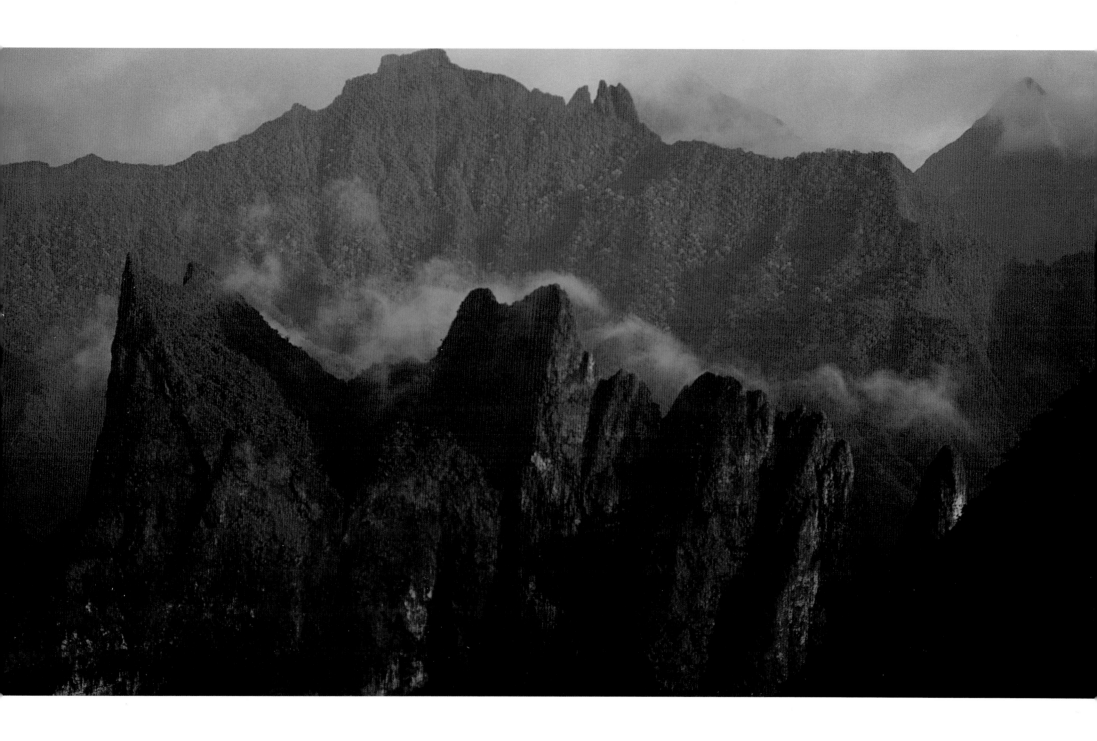

The wealth and diversity of life on islands can be unexpected if you look only at the prosaic dictionary definition of what an island is: "A piece of land surrounded by water." What truly defines island life is much more intangible than that—it is the processes that create themes and patterns, what we like to call "magic."

We were brought up near the northern tip of New Zealand's North Island. The sub-tropical worlds of our childhood were colored by the red flowers of the *Metrosideros*, pohutukawa, and the yellow *Sophora*, known as kowhai. Our familiar songbirds were honeyeaters such as the tui and bellbird, and much of the landscape was strewn with the distinctive shapes of volcanic cones. To some it may seem an extraordinarily exotic world, but to us it seemed very ordinary, because we had never known anything different. We dreamed of visiting exotic Pacific islands without realizing we were already living on one.

We are natural historians and filmmakers, working for the documentary company Natural History New Zealand. Like us, it was born in New Zealand, and like us it has been shaped by place and geography. It's a southerner, based in the temperate city of Dunedin, near the southern tip of the South Island. Dunedin's wildlife neighbors were the subject of the company's first films—penguins, sea lions, the giant rail takahe and the giant flightless kakapo.

It wasn't until we left home to work in other parts of the world that we really began to appreciate how biologically unique New Zealand is, and how it stands apart from the rest of the world yet is connected to it. To this day we are inspired

A fly with antlers on its head might seem the ultimate in fanciful island creation, but this is just one of a whole suite of fly species from the island of New Guinea, all of which have adornments that resemble different kinds of deer antlers. The males' ornamentation ranges from gazelle-like spikes, to fine multi-branched antlers like a red deer, through to the heavy moose-like palmate antlers of this fly, Phytalmia alcicornis, ABOVE, *whose name even means "elk-like."*

*A New Zealand harvestman spider (*Megalopsalis fabulosa*),* RIGHT, *also sports spectacular ornamentation. It has claws that a crab would be proud of, each larger than the animal's body. These weapons are useful in male to male rivalry.*

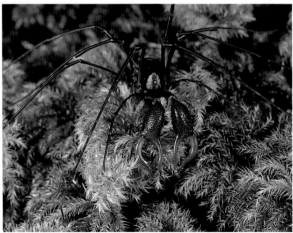

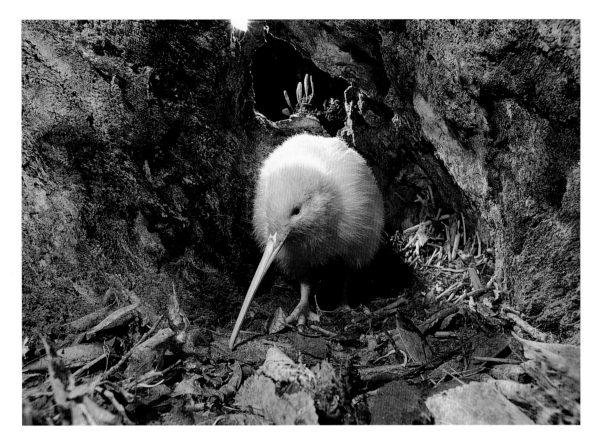

Is it a bird or is it a beast? New Zealand's kiwi (Apteryx mantelli), LEFT, is a flightless bird that behaves like an honorary mammal—its feathers are soft and hair-like, and it has whiskers for sensing in the dark. Unusually for a bird, it hunts its prey by smell and even scent-marks its territory.

On the other hand, New Guinea's long-beaked echidna (Zaglossus bruijnii), BELOW, is in fact an egg-laying mammal. It belongs to a group known as monotremes, and is one of the few surviving relatives of Australia's platypus. Monotremes are primitive mammals that lay a single egg, which hatches after just ten days. Like all mammals, the young are suckled on milk. The adults feed almost exclusively on earthworms, as does New Zealand's kiwi. Island living really can blur the boundaries between birds and mammals.

every time we set foot on a new island or revisit an old and treasured friend here in New Zealand. In this book we want to share the splendor and joy of life on islands. We hope it will tempt you to experience the real thing or look at a familiar place in a different light, and lead to a new appreciation of the magic and wonder of islands.

Alison Ballance

Rod Morris

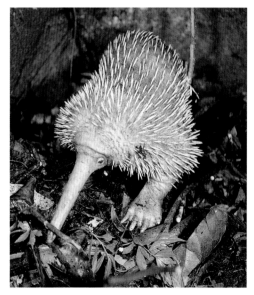

13

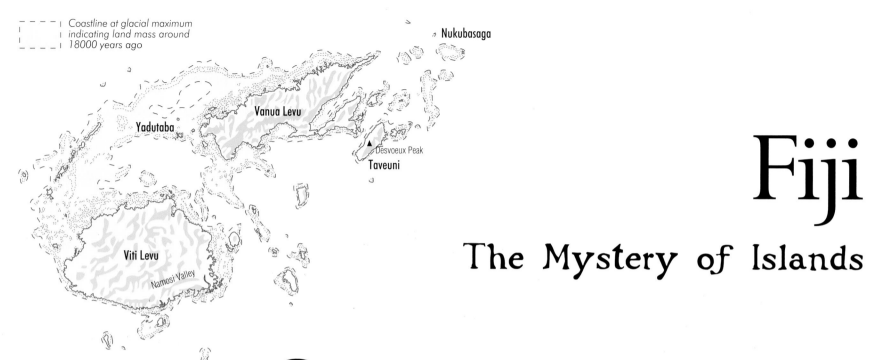

Coastline at glacial maximum indicating land mass around 18000 years ago

Nukubasaga

Vanua Levu

Yadutaba

Desvoeux Peak

Taveuni

Viti Levu

Namosi Valley

Fiji
The Mystery of Islands

Fiji's crested iguana (Brachylophus vitiensis), RIGHT, can transform from a seemingly harmless green and white lizard to an aggressive, hissing black and white monster in just a few minutes. The recently discovered crested iguana is the larger of Fiji's two iguana species, both of which are an unexpected and mysterious presence so far out in the middle of the Pacific.

Looking across Taveuni's rainforest canopy from Desvoeux peak, with the Somosomo Strait in the distance, OPPOSITE. Unlike most of Fiji's high islands, Taveuni retains an impressive 60 percent of its rainforest, and is still home to many of Fiji's endemic plants and animals.

O NE OF THE MOST striking features about Fiji for a first-time visitor, apart from the usual heat and humidity of the tropics, is the birdlife—parrots and pigeons that are among the most colorful in the world, so bright they're visible even high in the dense forest canopy. On our first visit to the islands to make a documentary about Fiji's iguanas these birds were a revelation. The kaleidoscopic reds, blues and greens of the lorikeets and shining parrots with their glossy plumage are a colorful contrast to New Zealand's darker hued olive and brown parrots. The *Emoia* skinks are as breathtakingly techni-colored as the birds: black, brown and turquoise, green and yellow, and black and gold with blue tails.

The Fiji rainforest can sound surprisingly like a dairy farm with cows mooing, dogs barking, ducks quacking and roosters crowing, until you discover that the improbable sources of all these farmyard sounds are the various tropical pigeons, doves and jungle fowl. The variety of sounds can be deceptive, though. When our sound recordist returned from a successful day on the island of Taveuni with recordings of a whole medley of beautiful birdsongs, he said he couldn't believe how much variety and beauty were to be found everywhere, and how easy it was to record the birds. Later we

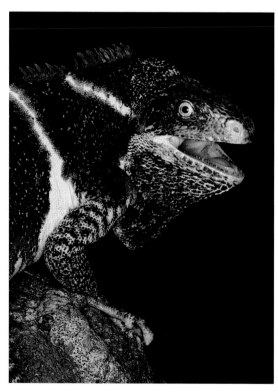

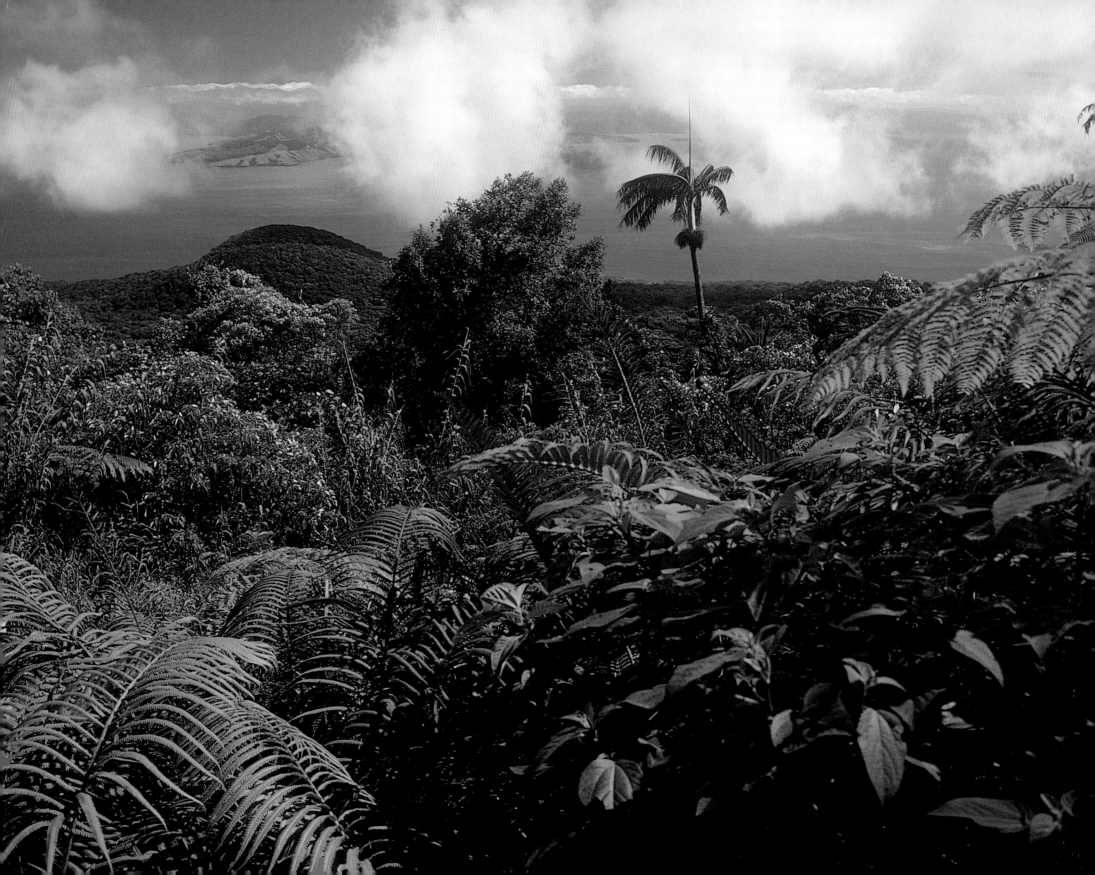

learnt that this impressive variety of song was the work of just one bird—the golden whistler.

But it was three species of *Ptilonopus* fruit dove that really caught our eye—and our imagination. The fruit doves look and sound very different from each other. Vanua Levu's flame dove has unusual hairy feathers and "tocks" like a dripping tap. The golden dove has long, rooster-like feathers in lemon-yellow, edged in green, and it yaps like a puppy. Kadavu's velvet dove has a golden head and dark, velvet green body plumage, and its call is a strange double whistle, an unusual sound for a dove to make. No one knows why the plumage and calls of each species are so varied. Some researchers have suggested that at least one of these doves might be a "lek" species—in which the males try to out-display and out-compete one another for the attention of a female—like New Guinea's famous birds of paradise. "Doves of paradise" certainly has a nice ring as a name, but we won't know whether this nomenclature is deserved until more work is done.

More research also needs to be done on Fiji's ants. Why, for instance, are so many of them strangely ornamented with spikes, flanges and even tiny antlers? Is it for defence? And if so, against what are they so heavily armed? There are many mysteries to be solved about Fiji's wildlife.

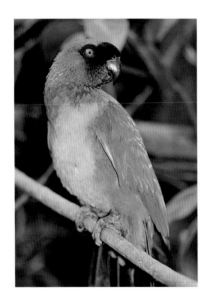

*The masked shining parrot (*Prosopeia personata*) of Viti Levu,* ABOVE, *and the red shining parrot (*Prosopeia tabuensis*),* RIGHT, *which is scattered through most of Fiji's larger islands, are Fiji's two largest parrot species. They are called shining parrots because of the sheen on their back and wings and are closely related to broad-tailed parrots found elsewhere in the Pacific, such as New Zealand's* Cyanoramphus *parakeets and New Caledonia's horned parrots.*

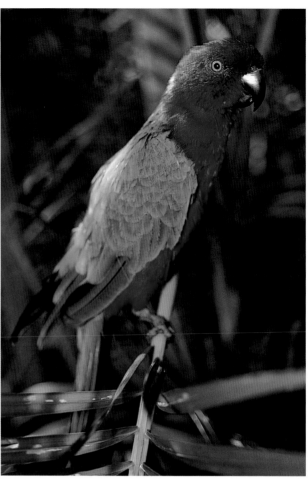

Ants aren't Fiji's only wonderful invertebrates; the islands are also home to dwarves and giants. The enormous 6 inch (15 centimeter) long Fijian longhorn beetle is the second largest beetle in the world, while a tiny cicada less than half an inch (one centimeter) long holds the world record as the smallest cicada. Fiji's plants and animals can be strikingly different and exotic, but there is also the surprise of the familiar, such as a rata tree in the forest related to New Zealand's *Metrosideros*, or pohutukawa. Fiji has, in fact, two *Metrosideros* species, one of which is descended from the pohutukawa, which has widely dispersed across the Pacific.

Metrosideros isn't the only link to other Pacific islands. Fiji's shining parrots are part of a tribe of broad-tailed parrots that includes New Caledonia's horned parrots and New Zealand's *Cyanoramphus* parakeets.

Fiji is actually a group of 322 islands, which collectively make up the largest landmass in the central Pacific. The biggest islands, including Viti Levu, Vanua Levu and Taveuni, are ancient volcanoes clothed in rainforest. The highest mountain rises more than 4200 feet (1300 meters), tall enough for these islands to be known as "high islands." Taveuni, also called the Garden Island, retains an impressive 60 percent of its original rainforest cover.

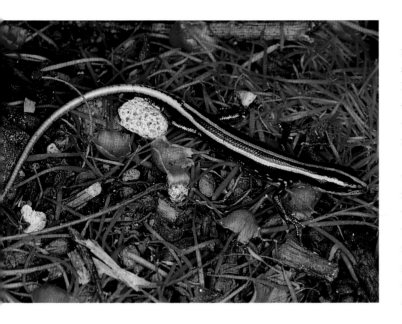

The largest Fiji island, Viti Levu, has the oldest rock—it may be about forty million years old—making Fiji much older than any other island group in the Pacific, apart from New Caledonia and New Zealand. Some scientists also think that they may be the remnants of a sunken continent or of volcanoes that erupted through ancient continental crust. It is all a bit of a mystery, as indeed is so much of Fiji's natural history, past and present.

The Fijian iguanas present another mystery. The presence of these reptiles so far out in the middle of the Pacific on a group of small islands is intriguing. Where did they come from? And how did they get to Fiji? To truly grasp the magnitude of this puzzle, pause and reflect on the sheer size of the Pacific Ocean. Two-thirds of the surface of the Earth is covered in ocean, and by far the greatest ocean is the Pacific. Spin a globe until the side with the Pacific faces you and all you see is blue ocean, with just tiny sprinkles of land across it. The continents of North and South America and Asia are ribbons of land at the far edges.

For a long time the Fijian iguanas, which also occur on Tonga, were considered to be most closely related to the iguanas of Central America. However, most iguana species are common on the eastern, Caribbean side of the continent—and that's a very long way from Fiji, 7500 miles (12,000 kilometers) to be precise. Later research suggested that perhaps the Fijian iguanas' closest relative is the Galapagos iguana, which makes more intuitive sense given that both island groups are in the same ocean. However, the recent discovery of fossil remains of a primitive iguana in Asia's Gobi

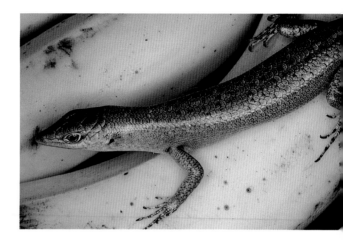

*Fiji's commonest skink, the small and brightly colored striped skink (*Emoia impar*), ABOVE LEFT, can be found everywhere—on tree trunks, at the back of sandy beaches and even around hotel swimming pools. Active even on the hottest days they seem less at risk from cats and mongooses than other Emoia skinks such as the green tree skink (*Emoia concolor*), ABOVE. Several new species, particularly tree-climbing forest dwellers, have been described in recent years, including the barred tree skink (*Emoia trossula*), LEFT, which was discovered on the small island of Yaduataba living with crested iguanas.*

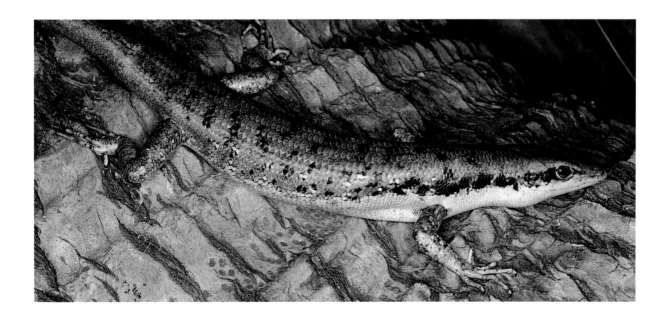

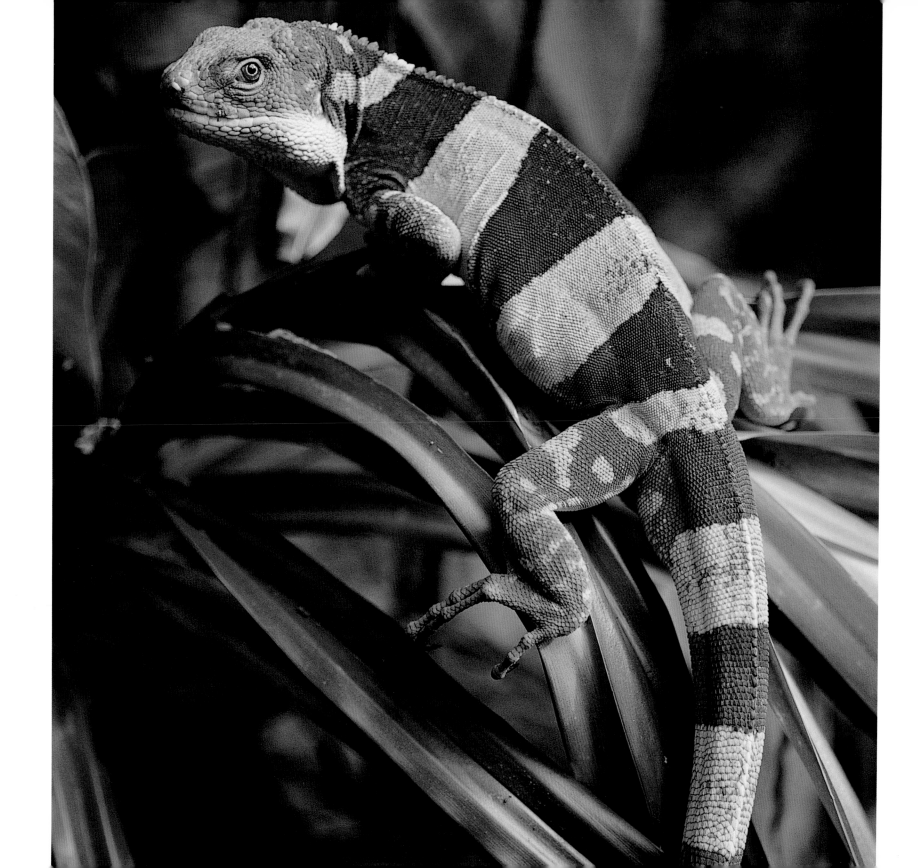

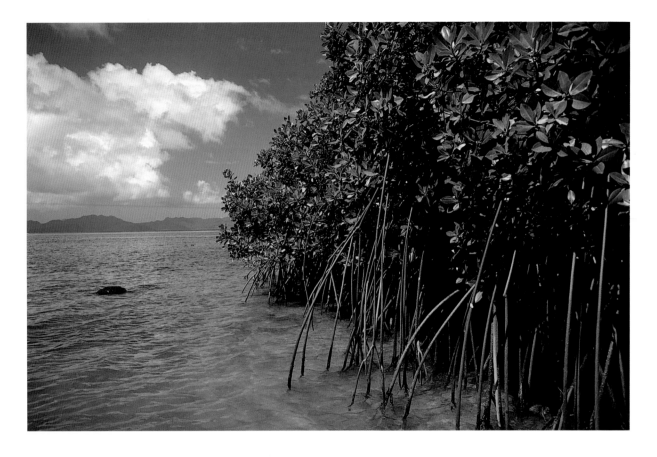

*The most spectacular of all Fiji's reptiles are its two species of iguana. Fiji's banded iguana (*Brachylophus fasciatus*), OPPOSITE, has long been known as an inhabitant of the humid, rainforest-covered islands and coastal forests on the larger islands. However, how they first reached Fiji is a mystery. One theory suggests they rafted there, an idea supported by the presence of the red mangrove (*Rhizophora sp.*), LEFT, which like the iguanas is thought to have dispersed from Central America.*

Desert has raised the intriguing possibility that perhaps Fiji's iguanas dispersed from the west, and not the east. This idea is supported by recent research on evolutionary relationships between iguanas which suggests that Fiji's iguanas are a very primitive ancestral type, older than either the Galapagos or Central American iguanas.

A further confounding clue in this mystery is the red mangrove, another Central American inhabitant that has made its way through the Pacific to Fiji. The only thing that is clear about the puzzle of where Fiji's iguanas originally came from is that the jury is still out.

Why the iguanas do not occur further west than Fiji is also something of a mystery. Perhaps, indeed, they once did. However, many of the western islands are home to two other, more aggressive groups of reptiles—monitor lizards and Asian agamids. These reptiles have spread into the Pacific out of Asia, and may well out-compete or even prey upon the iguanas.

Fiji's iguanas could equally have dispersed from either the east or west, as the Pacific Ocean is a complex of currents and counter-currents that flow variously east and west, and of winds that prevail in one direction for most of the year but change directions at other times. Objects can—and do—defy the odds to get swept long distances around the Pacific. The late John Gibbons, a herpetologist who discovered a second species of Fijian iguana in 1978, once had a friend toss a bottle into the sea off the Galapagos Islands. Incredibly, it turned up in Fiji twelve months later.

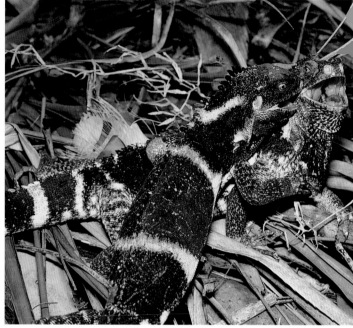

These delicately colored Blechnum *fern fronds,* ABOVE, *grow at the edge of cloud forest near the summit of Desvoeux peak.*

*A female crested iguana (*Brachylophus vitiensis*),* RIGHT, *produces up to twenty leathery, or parchment-skinned, eggs at a time and lays them on the forest floor. Crested iguanas are large, more than 3 feet (up to 1 meter) in length, and heavily built. A visual threat display is usually enough to settle any dispute but occasionally, when iguana numbers are high, two males will end up in a full-blown territorial dispute,* ABOVE RIGHT. *Crested iguanas are found only on Fiji's drier islands, such as the tiny island of Yaduataba, off the coast of Vanua Levu,* OPPOSITE, *where they are abundant.*

Twelve months is a very long time to be adrift at sea. But iguanas have several features that would have helped them on a long ocean journey. Reptiles aren't nearly as energy demanding as mammals—they need only about one-tenth of the food. Iguanas can survive for months in a state of near torpor. And the Fijian iguanas, like many other iguana species, secrete salt from glands in their nostrils. Classic photographs of the Galapagos marine iguana sometimes show the animal in the midst of what appears to be a blast of salt spray from a wave, but it's more likely that the iguana has just sneezed, expelling clouds of salty moisture from its nose. This ability to process and excrete excess salt is probably the key to iguanas surviving long periods adrift at sea.

Because the eggs of the Fijian iguana can take up to eight months to develop, longer than any other iguana species, it is also possible, although unlikely, that eggs could have been swept by a river's floodwaters out to sea on a massive raft of vegetation and debris, eventually washing up in Fiji or even on another island that acted as a stepping stone in the journey. Although it is difficult to imagine such a string of events could happen successfully, over millions of years a chance event like this need succeed only once or twice.

While the iguana has a number of survival skills in its favor, it is more difficult to imagine how such a random colonizing event happened with some other species. Among such unlikely colonists are Fiji's two species of frog, which are most closely related to frogs from New Guinea and the Solomon Islands, far to the west. Like the westerly traveling iguanas, these easterly moving frogs are the most far-flung of their kind. But, unlike reptiles, thin-skinned amphibians are not well adapted to survive at sea. How they successfully populated this remote island group is another of Fiji's

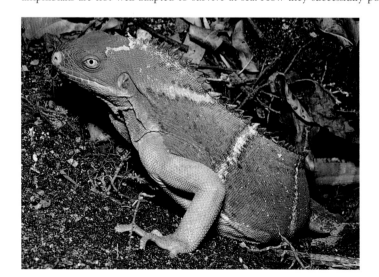

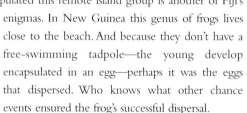

enigmas. In New Guinea this genus of frogs lives close to the beach. And because they don't have a free-swimming tadpole—the young develop encapsulated in an egg—perhaps it was the eggs that dispersed. Who knows what other chance events ensured the frog's successful dispersal.

About 18,000 years ago, during the last ice age, the sea level in the Pacific dropped more than 300 feet (about 100 meters). Volcanoes and mountains that were earlier submerged appeared above water (see map). Suddenly a myriad temporary stepping stones linked the islands that now poke out of the sea. Perhaps the frogs island-hopped, from New Guinea—via the Bismarck Archipelago, the Solomons, Vanuatu and New

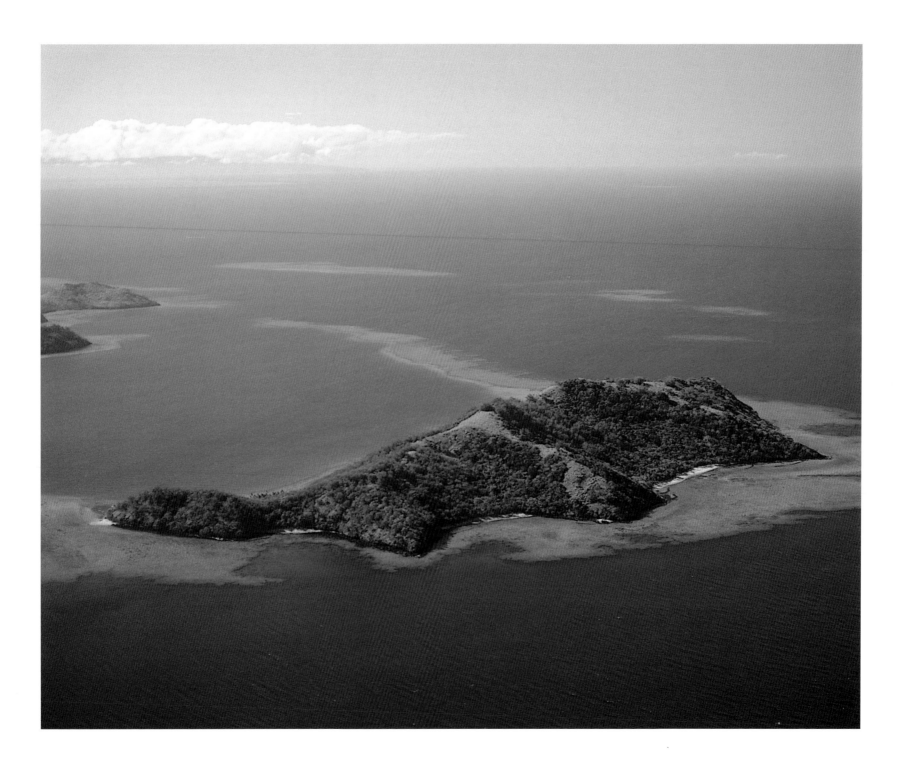

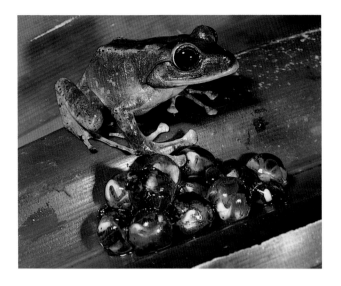

The presence of Fiji's endemic frogs on this island group so far out in the Pacific is something of a mystery. Typically frogs are not good oceanic island dispersers. However, the genus Platymantis *exhibits two characteristics that may have aided dispersal. First is a slight tolerance of salt water—the giant ground frog* (Platymantis vitianus) *on Viwa island, for instance, can live quite close to the seashore. And unlike most other frogs, tadpoles such as these of the Fijian tree frog* (Platymantis vitiensis), RIGHT, *develop encapsulated within the egg, so they aren't dependent on free-standing fresh water.*

The presence of Fiji's tiny endemic burrowing snake (Ogmodon vitianus), BELOW, *is more mysterious, and is of great interest from a biogeographic point of view. Little larger than a pencil, these extremely rare subterranean earthworm hunters are seldom seen and little is known about them. These two extraordinary individuals were photographed in the species' only known habitat in Namosi Valley, inland from the southern coast of the main island of Viti Levu, which is currently threatened by copper mining.*

Reptiles such as snakes are generally better at crossing oceans than amphibians such as frogs. The Pacific boa (Candoia bibroni), OPPOSITE, *has a wide range across the islands of the western Pacific. It is relatively common, and can reach up to 6½ feet (2 meters) in length.*

Caledonia—to Fiji, making a number of short trips instead of a single arduous one.

That is probably how the Pacific boa, which has a wide range across the islands of the western Pacific, reached Fiji. The other land snake, a tiny chocolate-brown relative of the cobras, is much more of a mystery. This endemic poisonous snake, the size of a pencil, lives buried in the soil and eats earthworms. Although its nearest relatives occur in the Solomons, we haven't got a clue how it reached Fiji. It may be a relict from a mysterious ancient continent—perhaps that is how the large terrestrial and very salt-intolerant *Placostylus* snails also came to be here.

There are still far more questions than answers, and each new piece of information added to the puzzle has only proved that it is much more complex than has ever been imagined. To make matters even more complicated, scientists are only just realizing that half of the puzzle is missing. Missing, because sadly the animals that might provide the answers are extinct.

In the late 1990s paleontologists excavated several caves on the island of Viti Levu, and as a result, for the first time, Fiji has a fossil record, showing that Fiji's original fauna had several remarkable, and completely unknown, members. Like Australia and New Caledonia, it had a small, terrestrial crocodile, about 10 feet (3 meters) long, and a kind of tortoise. And, like the Galapagos Islands and Tonga, it had a giant iguana, up to 5 feet (1.5 meters) in length. Interestingly, the extinct primitive iguana is not closely related to Fiji's modern iguanas, and is to be classified in an entirely new genus.

An early suite of frogs included a giant, bigger than any other Pacific species, and there were two species of megapodes—

birds that build large nest mounds in which to lay their eggs—including a gargantuan species that was surpassed in size only by an extinct species from New Caledonia. The giant megapode had very small wings, and a huge beak that was deep and narrow like that of a dodo, which raises the intriguing possibility that this bird specialized in eating fruit. Among the extinct pigeons was a giant ground pigeon, which appears to have as its closest relative the crowned pigeon from New Guinea.

All told, the excavations revealed seven newly recorded extinct Fijian bird species as well as frogs and reptiles. How did they get here? Why were they giants? What

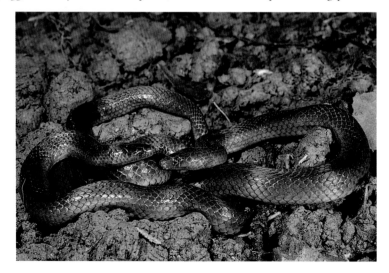

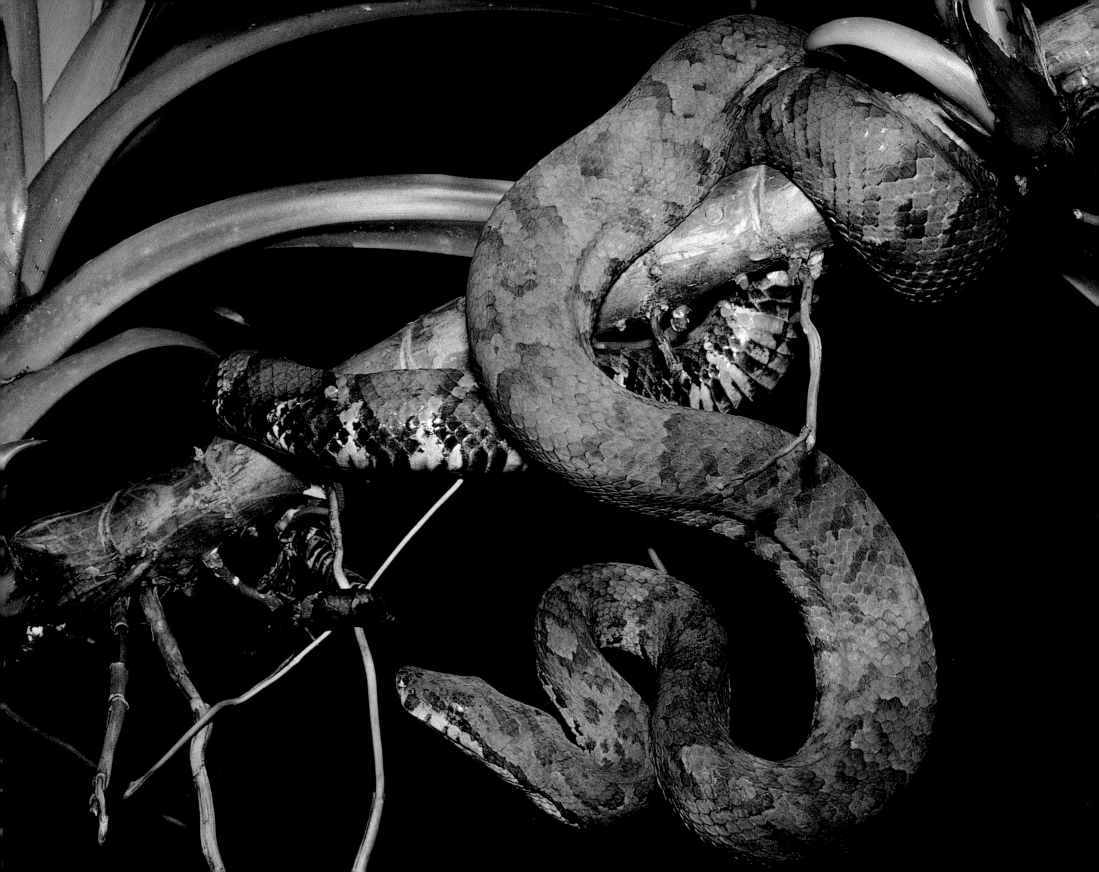

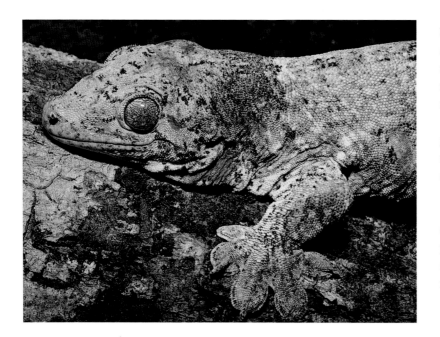

became of them? Islands truly are places of mystery and intrigue. Were all these extinct creatures still around when humans first arrived in Fiji about 3000 years ago, and were they early casualties of human contact? The animals of Fiji are a lesson about taking things at face value—what we see today is almost certainly not what would have been there a thousand years ago, let alone a hundred thousand years ago.

Nobody has heard of Fiji's strange, lost giant ground pigeon, but most people know of the dodo, the large, extinct flightless ground pigeon from the island of Mauritius in the Indian Ocean. This is a bird that was so bizarre that Lewis Carroll dropped it into the middle of his fantastical otherworldly literary creation *Alice in Wonderland*—and it fitted perfectly.

Both birds were the result of island magic. They demonstrate that even though every island has its own unique cast of characters, they share many of the natural processes and patterns that have shaped them. And the dodo proves that island magic doesn't just happen on the tropical islands of the Pacific—it happens on other islands, in other oceans.

Fiji's rainforests conceal a variety of Gehyra geckos, the largest of which is the voracious gecko (Gehyra vorax), ABOVE, seen here beautifully camouflaged on a tree trunk. This species can grow to 1 foot (30 centimeters), and local Fijians treat larger individuals with respect because of their strong claws, powerful bite and aggressive nature.

The coastal broadleaf forest on Nukubasaga Atoll, to the north of the main island group, is a popular nesting island for sea birds such as noddies, boobies and frigate birds, and is also home to land birds such as banded rails and fruit doves. The distinctive bird's nest fern (Asplenium australasicum), RIGHT, is common in these atoll forests.

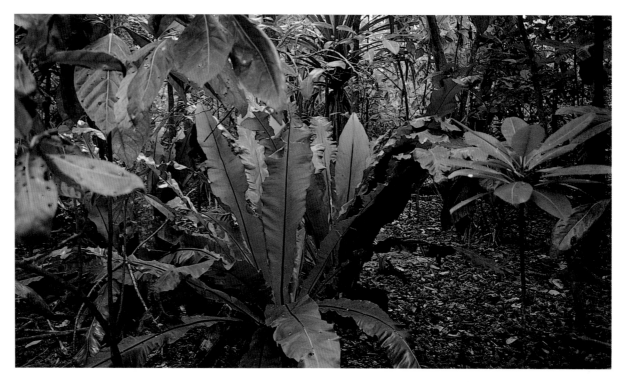

As night falls on the cloud-forested summit of Taveuni, LEFT, *fruit bats emerge to feed in the trees, eating fruit and widely dispersing seeds. The Samoan fruit bat (*Pteropus samoensis*),* BELOW, *is one of two large common fruit bats in Fiji. It is seen here eating pandanus fruit.*

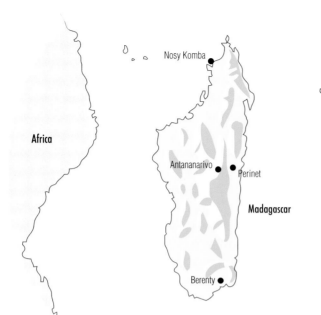

Africa

Nosy Komba

Antananarivo
Perinet

Madagascar

Berenty

Madagascar
Lost in Time

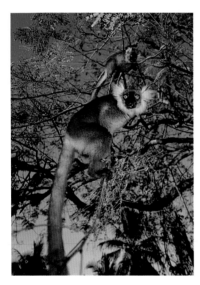

*Lemur and Madagascar are two words that are inextricably linked. Two female black lemurs (*Eulemur macaco macaco*), ABOVE, keep a sharp lookout for tourists in the village of Nosy Komba, where these striking creatures have become very tame. A curious lemur investigating the camera, OPPOSITE, appears to be a different species, but is in fact a male black lemur.*

LEGENDS AND MYTHS from around the world are full of stories about fabulous creatures, some of them real, some of them not. In the *Arabian Nights*, Sinbad the sailor tells of an enormous bird called the roc, a bird so big it blocked the sun and could carry Sinbad on its back as it flew. In fact the roc never existed—but such tales contain tiny grains of truth, and, in this case, it is a truth that is almost more magical than the mythology.

In the thirteenth century Venetian explorer Marco Polo wrote about a bird he called a "rukh" that lived on the island of Madagascar and was so strong it could carry an elephant in its talons. Elephants have never lived on Madagascar, but something more fantastic did exist there—an enormous bird that was truly deserving of the name elephant bird, or *Aepyornis*. More than 10 feet (3 meters) tall, and weighing over 1100 pounds (half a tonne), *Aepyornis* was one of the heaviest birds to ever walk the Earth. And it did walk, because it was a giant, too heavy to fly. It laid eggs that were more than 20 inches (half a meter) in length—larger than even the largest dinosaur eggs. Like the dinosaurs, however, this spectacular bird, made famous in H.G. Wells' 1894 short story *Aepyornis Island*, is now extinct. But unlike the dinosaurs, it did not die out millions of years ago—it was still in existence only 300 years ago. People not only saw it, they lived with it.

The elephant bird was the largest of twelve species of giant flightless birds on Madagascar, all of which are now extinct. Yet these fabulous creatures have modern relatives still wandering the rest of the world—Africa's ostriches, Australia's emus and cassowaries, and New Zealand's kiwi as well as its large extinct moas. Collectively these birds are known as ratites, flightless running birds. The ancestor of all these ratite birds evolved on the southern supercontinent of Gondwana. Until 140 million years ago Madagascar was at the very heart of Gondwana, nestled between India and Africa. Then, because of activity deep in the mantle, the Earth's crust started to deform and crack and Gondwana slowly began breaking up (see map on page 28). Madagascar and India started to drift east together, until finally, 88 million years ago, Madagascar parted company with India and was left on its own: it had become an island.

Today Madagascar is the fourth largest island in the world—1000 miles (1600 kilometers) long and 350 miles (560 kilometers) wide. A very deep ocean separates it from its nearest neighbor—Africa, 250 miles (400 kilometers) to the west.

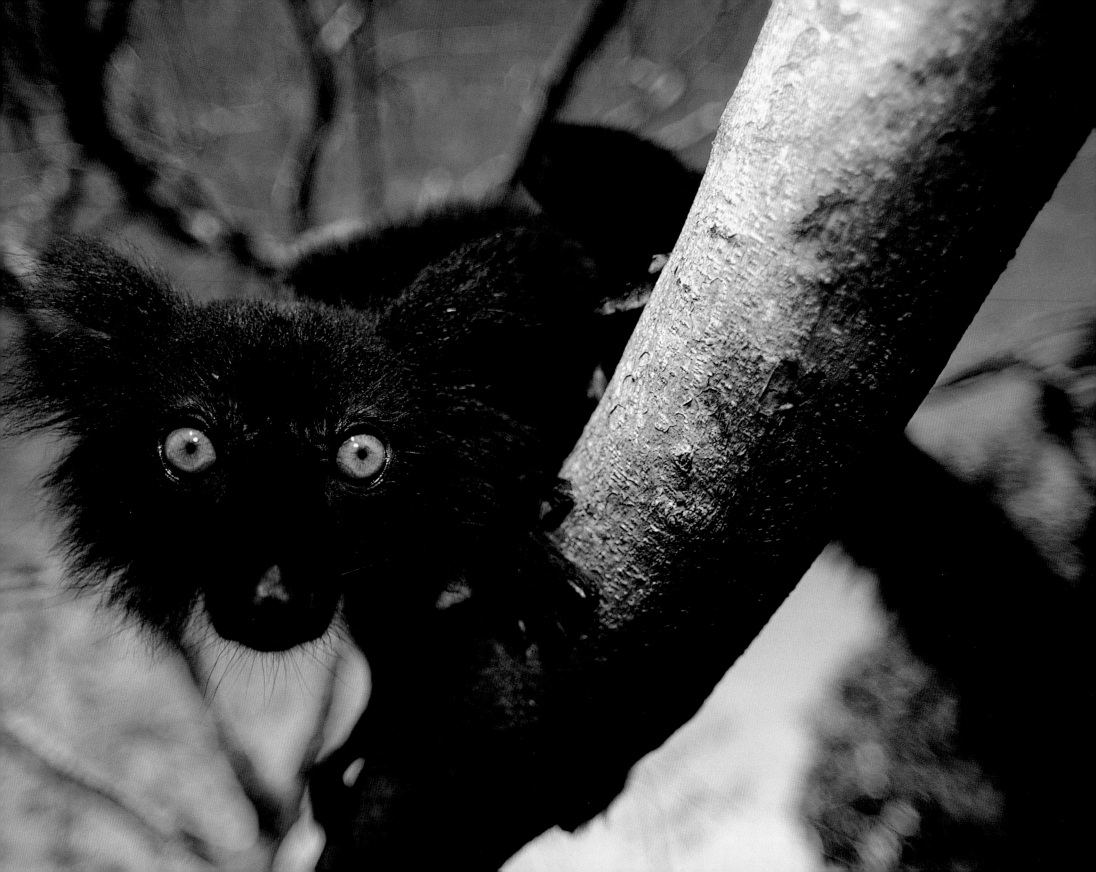

GONDWANA

The continents and land masses of the southern hemisphere are all pieces of a giant geological jigsaw puzzle. Rewind 200 million years and the pieces all fitted together as Gondwana, the great southern supercontinent. At its heart was Antarctica, and spread around it in a clockwise fan were South America, Africa, Madagascar, India, Australia and New Guinea, and finally New Zealand and New Caledonia.

In geological time—measured in hundreds of millions of years—the face of the Earth has been, and still is, constantly changing. Its surface is made up of enormous moving plates, which carry the continents like passengers. The plates constantly ride into each other, are sucked under or over, or slide past one another, a process known as plate tectonics. Over the last 180 million years, this process has moved Gondwana around the southern hemisphere, slowly rearranging it and pulling it apart.

The first chips off the block were Africa, India and Madagascar. Africa headed north towards Europe, while India was on a collision course with Asia. The results of those collisions are the European Alps and the Himalayas—the Himalayan Mountains began to form 50 million years ago as India started pushing into Asia. Madagascar became an island on its own roughly 88 million years ago, about the same time that New Zealand began to separate from Australia and Antarctica. The last land masses to sever their connection with Antarctica were Australia, about 45 million years ago, and South America, about 25 million years ago.

These old parts of the supercontinent carried with them ancient plants and animals that are a unique living as well as fossil Gondwana heritage. In the same way that rocks and geography prove a joint past, so too do plants and animals—they are animate pieces of the great Gondwana jigsaw puzzle.

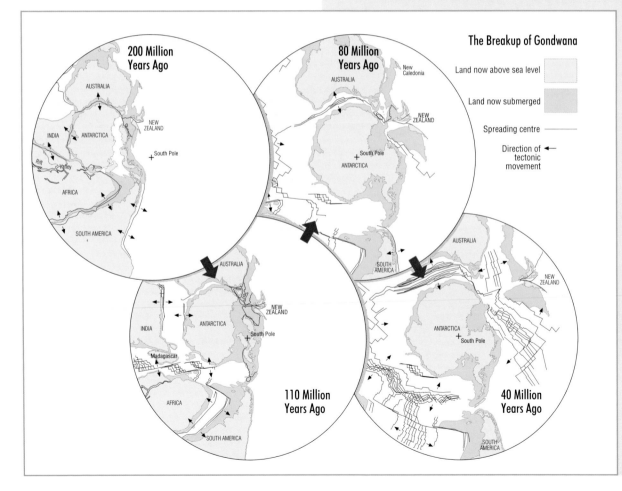

The Breakup of Gondwana

Land now above sea level

Land now submerged

Spreading centre

Direction of tectonic movement

200 Million Years Ago

80 Million Years Ago

110 Million Years Ago

40 Million Years Ago

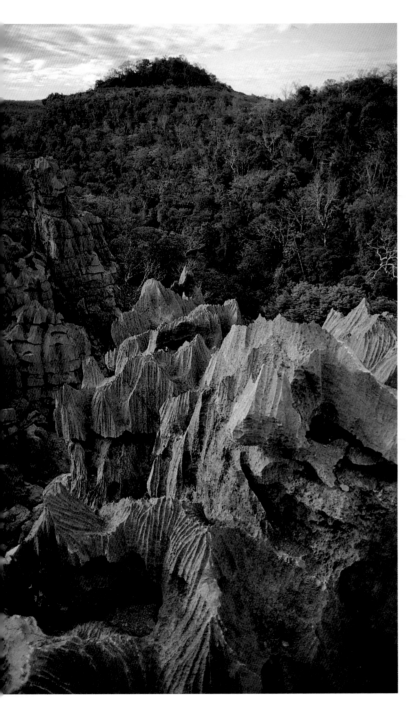

The island has effectively been isolated from the rest of the world since it split from Gondwana, and that long isolation in both time and space has allowed Madagascar to develop a unique and unusual biota.

Even though it became isolated tens of millions of years before mammals evolved, Madagascar is home to four groups of primitive mammals. The only way these mammals could have reached the island would have been by swimming or rafting across on piles of floating vegetation. As rare and improbable as this seems, Madagascar has ended up with a whole suite of primitive insectivores, early mongoose-like relatives, some rodents and the lemurs, an ancestral group of primates. Lemurs belong to a group known as prosimians, which means pre-monkey and it is not clear where they originated from.

Modern Madagascar lies relatively close to the coast of Africa, but in its distant past it lay close to both Africa and India. Both places are still home to a handful of other early primates, small nocturnal solitary prosimians, although all their other early primates were replaced when modern monkeys evolved about 35 million years ago.

Lemurs are usually considered to be less intelligent than their more advanced monkey cousins, which is why they died out in most places. But chance plays a large role in island colonization, and on Madagascar the lemurs were lucky enough to end up somewhere that monkeys never reached. This quirk of fate has had a profound effect on Madagascar's fauna. Unchallenged by other primates, and in splendid isolation for maybe forty to sixty million years, the species factory got to work on the lemurs. The term "species factory" refers to an island's ability to turn one species into many—on Madagascar, for instance, lemurs evolved into more than sixty-five different forms, ranging from diminutive mouse-size to a Herculean gorilla-size giant.

The biggest lemurs are known as sloth-lemurs. *Archaeoindris* was the heavyweight, resembling a giant ground sloth, and tipping the scales at 350 to 440 pounds (160–200 kilograms). Next in size was *Megaladapis*, as big as a female gorilla but acting more like an oversized koala. Like the koala it probably shimmied slowly up trees and sat propped between branches

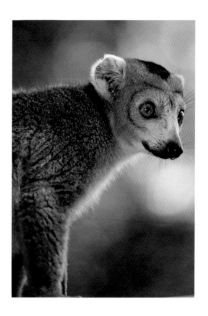

Many of Madagascar's day-active lemurs are beautifully, even strikingly marked. Some have bold rings on their tails, brightly colored ruffs around their necks or crowns on their heads, such as the golden one on this crowned lemur (Eulemur coronatus), ABOVE. *Unusually amongst mammals, lemurs are capable of seeing color, and their colorful patterns help distinguish each species. Crowned lemurs are at home amongst the tsingy's sharp, jagged limestone pinnacles,* LEFT. *Despite their soft, human-like hands and feet, lemurs wander with impunity across the razor-sharp terrain.*

Madagascar Lost in Time

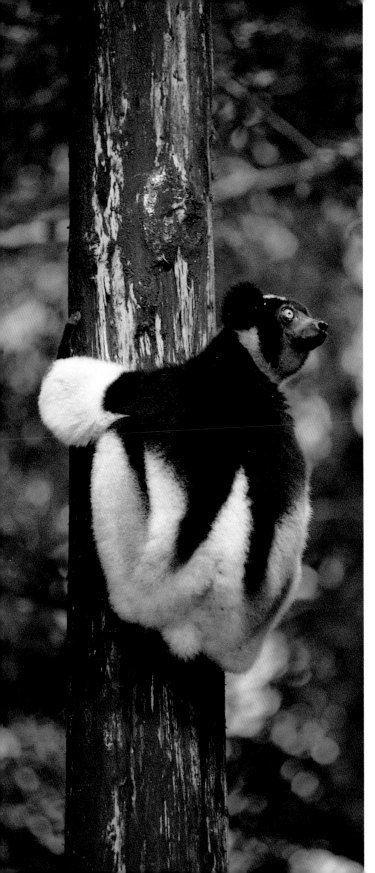

and the trunk. The slightly smaller *Paleopropithecus* hung upside-down from branches like a tree sloth.

Weighing in at around 30 to 55 pounds (15–25 kilograms) were two terrestrial species—*Archeolemur* and *Hadropithecus*—that probably behaved much like modern-day baboons. Their feet resembled paws, better adapted to life on the ground than in the trees, and with their strong grinding teeth they were probably grazers.

The word "probably" features often in descriptions of these lemurs' lifestyles, because as with those other lost giants the elephant birds, everything we know about giant lemurs comes from fossil evidence. Giant lemurs were extinct by about 500 years ago, less than a thousand years after the arrival of Madagascar's only modern primate, Malayo-Polynesian people from South-east Asia. Great ocean voyagers, they traveled right around the northern edge of the Indian Ocean and down the coast of Africa before reaching Madagascar, one of the last lands on Earth to be settled by people.

Following the arrival of humans, fifteen species of large lemurs became extinct, as did other fantastic island beasts: three species of pygmy hippo, giant tortoises, and a civet the size of puma, the largest that ever walked. What was the real cause of all these extinctions? A Malagasy legend tells of an enormous fire that burnt 70 percent of

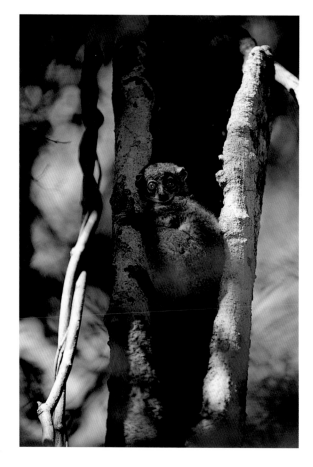

the island's heartland, but this may be nothing more than folklore. Whatever happened, the sad fact is that today only 10 percent of the original vegetation is left. The rest of the island is regarded as the most eroded place on earth. Red soil, the island's lifeblood, washes off in such copious quantities that astronauts can see the reddened ocean surrounding Madagascar from space.

The first people brought with them herds of zebu cattle as well as other modern mammals, and the eventual demise of many of the original animals was probably caused by a lethal blend of habitat destruction, hunting and competition from hoofed animals. Unfortunately that lethal cocktail is still at work today: ten more lemur species are critically endangered, and another seven are endangered. Extinction is still an active process on the island of Madagascar.

The surviving lemur species, however, remain the most striking and distinctive element of the Madagascan fauna. Lemurs are the reason people from other countries visit the island, and the memory people take when they leave.

The largest remaining lemur is the indri, the black-and-white panda of the lemur world. At 15 pounds (7 kilograms), it is small compared with the extinct giants. Small family groups live high up in the forest canopy, making huge leaps from tree to tree. They keep in touch with one another by calling, a call that is one of the loudest of any

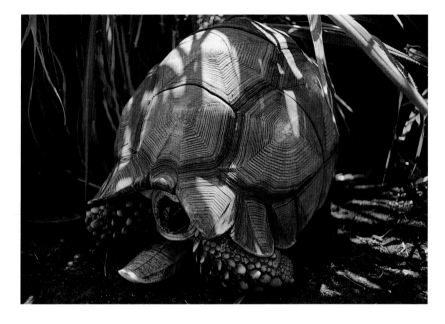

animal on earth. It is a soulful, mournful wail that can carry for up to 2 miles (3 kilometers) through the rainforest. At close quarters it is painfully loud to human ears.

Unlike modern monkeys, that have a social system in which the males take precedence over females, indris and other lemurs have gentle societies in which the females are dominant. A female gets to eat the choicest young leaves, while her mate feeds below on larger branches—it makes evolutionary sense for the female to get the best food, as she is carrier and milk provider for their offspring. The male's role is to defend his mate and their joint territory. There are a number of large day-active lemurs that all have soft fur, boldly patterned into stripes and rings. The backs of their grasping hands are covered in soft hair, so they appear to be wearing gloves. Their faces are slightly fox-like, a function of their highly developed sense of smell. Highly curious, they will hang out of the trees and peer at people with intense amber eyes—it is a perceptive gaze that seems to look into your very soul.

They lead an easy, almost indolent, life—sleeping in late on cool mornings, keeping warm by wrapping their tails around their necks like scarves. As soon as the sun hits their tree, though, they rush up to sun worship, lying with their arms and legs thrown apart to soak up the heat. After spending the day eating, they retire to bed early.

Night-time is when the mouse lemurs come out. These tiny lemurs are omnivores that eat fruit, insects, flowers, young leaves and even gum. Some species are solitary, while others are very gregarious. Lively and abundant—they are so common they may well outnumber the Malagasy people—they are among the few native animals that seem to be doing well here.

The distinctive lemurs make their home in some equally distinctive and unusual habitats.

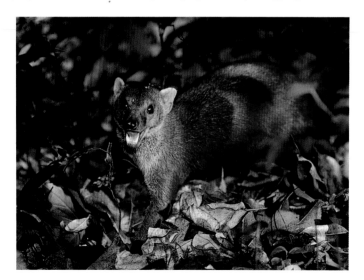

*The indri (*Indri indri*), OPPOSITE LEFT, is Madagascar's largest surviving lemur, renowned for its mournful wailing cries, and easily recognised by the absence of a tail. As has been happening for all Madagascar's lemurs, the indri's habitat is dwindling as a result of forest clearance. This individual is clinging to a power pole beside a road that bisects its forest territory. The northern sportive lemur (*Lepilemur mustelinus septentrionalis*), OPPOSITE, belongs to a group of nocturnal sportive, or weasel lemurs that are the closest living relatives of a range of spectacular, but now extinct, slow-moving giant leaf-eating lemurs. These foliage feeders are active only after dark, when males make their loud chattering cries from prominent perches. During the day they are most often seen gazing sleepily from a hollow tree or daytime roost.*

*The ploughshare tortoise (*Geochelone yniphora*), ABOVE LEFT, often known by its Malagasy name angonoka, is the rarest tortoise in the world, with only 100–400 individuals surviving in the wild. Male angonokas have a huge forward-pointing spike on their plastron, the belly part of their shell, that is thought to be a useful aid in toppling rival males during courtship battles.*

*The northern ringtailed mongoose (*Galidia elegans dambrensis*), LEFT, belongs to a group known as Viverids that was widespread before the appearance of large modern carnivores such as cats and dogs. Madagascar's representatives show great diversity, and include the mongoose, which is an unspecialized generalist, the fossa, which has specialized to hunt large prey such as lemurs, and the extraordinary fanalouc, which has adapted to hunt earthworms.*

There is one other group of primitive mammals in Madagascar besides lemurs and viverids. Tenrecs are primitive insectivores, a few of which bear spines that give them a remarkable resemblance to a related group of insectivores, the hedgehogs. The lowland streaked tenrec (Hemicentetes semispinosus), RIGHT, combines black and white warning coloration with detachable spines, making a very effective defence mechanism.

Warning coloration also explains why Madagascar's Mantella frogs are brightly colored. Active by day, they show remarkable convergence with South America's poison arrow frogs, although the two groups are not related. Mantella frogs such as this golden mantella (Mantella aurantiaca), BELOW, are tiny, about an inch (2–3 centimeters) long, and feed mainly on ants and termites. Their toxin is thought to be derived from the formic acid of their insect prey.

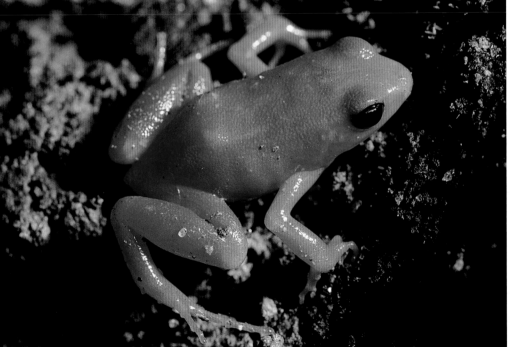

Probably the strangest is the dry spiny desert, where members of two families of plants have metamorphosed into enormous spiny cactus look-alikes, up to 50 feet (15 meters) tall. Despite the gigantic spines, ringtail lemurs and white long-tailed sifaka lemurs with distinctive chocolate-brown caps on their heads, leap nonchalantly from spiny tree to spiny tree. The locals, however, believe that the spines are a very effective deterrent for the predatory fossa, the lemur's arch enemy. Even though the fossa, a close relative of the civet, is also a strong, agile climber, its soft paws can't manage the spiky trees, so lemurs are quite safe there.

It's not only the animals of Madagascar that are fantastically bizarre. As well as the desert, there are four more types of original habitat on the island: high plains of dry forest, rolling highland savannah, coastal rainforest extending from high mountains down to sea level, and areas known as tsingy. Tsingy is an incredible unexplored limestone landscape, a high plateau covered in sharp impassable spires, and home to nine species of *Pachypodium* plants. These weird-looking plants, also known as elephant's feet, have a bottle-shaped trunk, and long spindly sinuous branches with large flowers perched at the end.

Among Madagascar's other remarkable mammals is a small, diverse group of extremely primitive insectivores, resembling the original mammals that inherited the world from the dinosaurs. These are the tenrecs, and there are at least twenty-seven species of them. Like the lemurs, tenrecs are astonishingly diverse. Five species resemble hedgehogs, and some look very incongruous indeed, running around in the branches of trees. Many look like shrews, while one swims and dives like a miniature otter. The most bizarre species, the streaked tenrec, looks like a tiny punk porcupine—it is covered in barbed detachable spines that provide very effective defence. When it is excited or defensive, the streaked tenrec furiously rattles thick spines down the middle of its back. It can also rub its spines together to make a supersonic noise that its babies can hear (but humans cannot)—it seems to be an important means of communication between mother tenrecs and their young.

Madagascar's chameleons, on the other hand, communicate not by sound, but by looks. They are well known for their ability to alter color at whim, but contrary to popular opinion most seldom change for camouflage reasons. Rather, the color changes are dramatic signals of a chameleon's mood swings—from lusty to aggressive to territorial. They are highly visible animals, advertising their presence with a kaleidoscopic array of colors—red, blue, gold, black, green or even apricot.

Madagascar is home to nearly half of the world's chameleons, including the largest species, a 23-inch (60-centimeter) giant, and the smallest, a 1-inch (2.5-centimeter) dwarf. Chameleons are arboreal, and have opposable thumbs and fingers so they can strongly

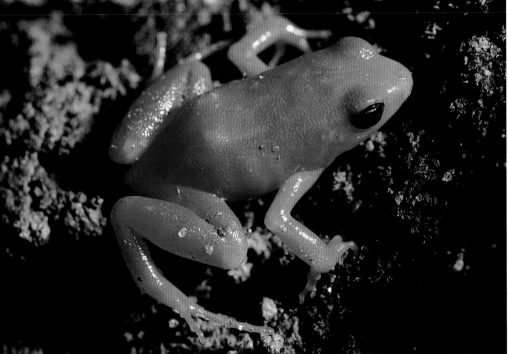

Madagascar Lost in Time

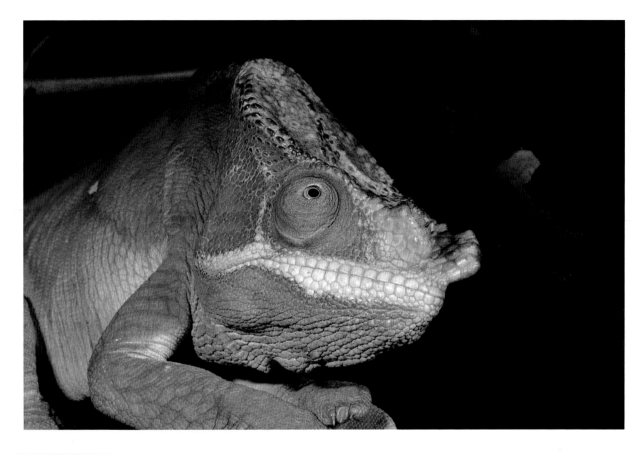

grasp onto branches, and prehensile tails they can curl tightly. Their bodies are laterally compressed so they can squeeze in between tight branches, but when threatened they can inflate themselves to look larger and rounder. The smallest chameleons are terrestrial and hide in the leaf litter.

Chameleons are stalkers—as they watch and wait for passing insects their incredible eyes, which are just large pupils surrounded by enormous eyelids, swivel independently. Then their most astonishing feature comes into play. Once they see an insect, their tongue—which is as long as their body and has a muscular sticky pad on the end—comes shooting out like a missile launcher and grabs the hapless insect. Chameleons can be as whimsical as they are bizarre. Many males have spikes, horns or false noses—leafy protuberances that stick out in front of their true nose. Curiously, two of Madagascar's eighty-five species of snake have false noses as well, while some of the island's geckos also verge on the fantastic.

Just as eclectic and varied as the lemurs and chameleons, are Madagascar's birds. There is one group in particular that Charles Darwin would have enjoyed as much as the Galapagos "finches" he's usually associated with. The vangas are related to Africa's helmet shrikes, but in Madagascar they've evolved into a motley collection with resemblances to woodpeckers, wood hoopoes, shrikes, tits, nuthatches and treecreepers, among others. The most fantastic of all, the helmet vanga, eats chameleons, and has a huge heavy blue beak that bears more than a passing resemblance to the hornbills of Africa and Asia.

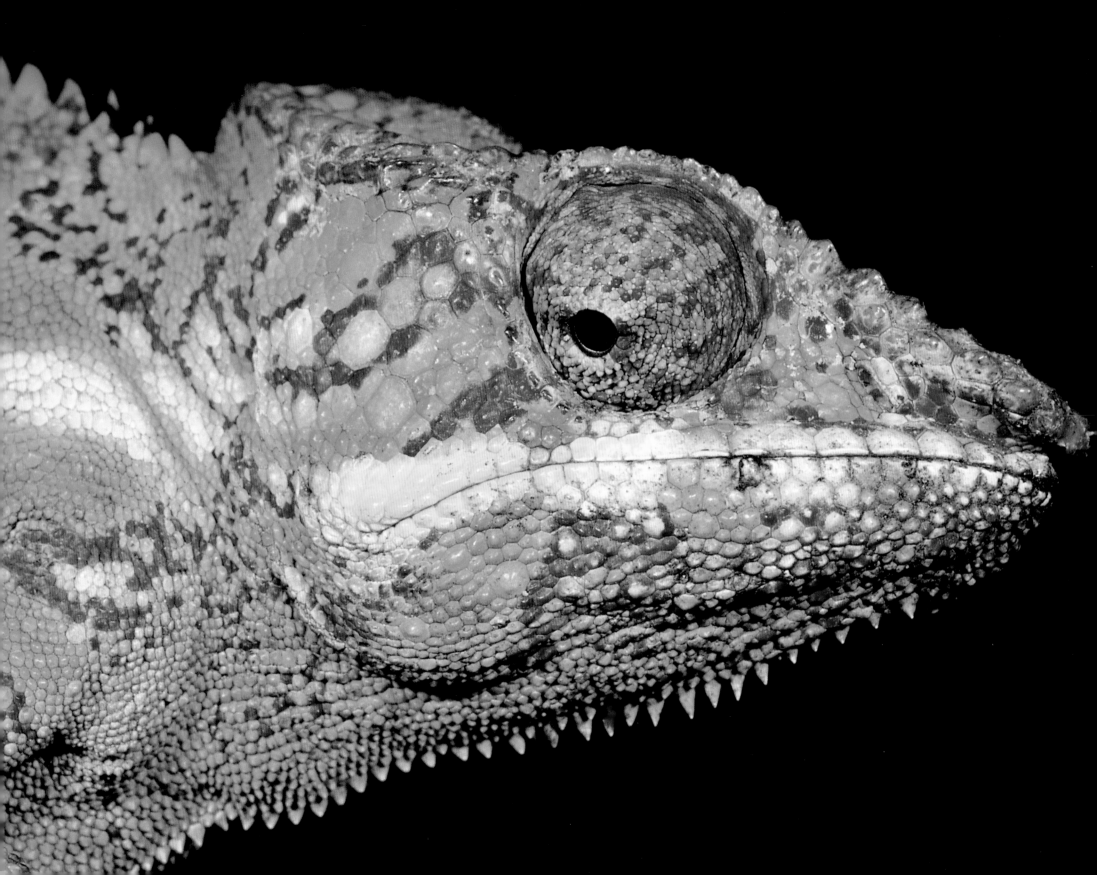

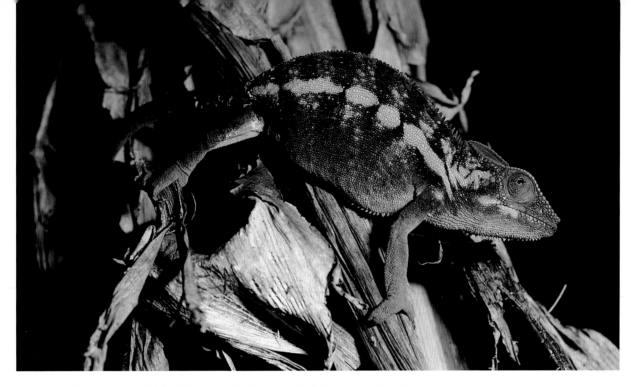

But the similarity is superficial—like most island species the helmet vanga is unique.

An enormous proportion of the magical cast of creatures on Madagascar are in fact unique, endemic species that are found here and nowhere else. The proportion of endemic species here is an astounding 83 percent. And endemism is important at more than just the species level—as well as five endemic families each of primates and birds, there are eleven endemic families of plants. Even more astounding, the numbers continue to grow as new species, including lemurs, are still being discovered.

Possessing a large proportion of endemic species is a distinctive feature of islands, and Madagascar shares this characteristic with other islands such as New Caledonia and New Zealand. These are all places that are species-rich beyond their size, containing many more species than a comparably sized piece of mainland in North America or Europe. They are treasure troves of biodiversity, so much so that of twenty-five areas in the world recognized as being biodiversity hotspots, nine are islands or groups of islands.

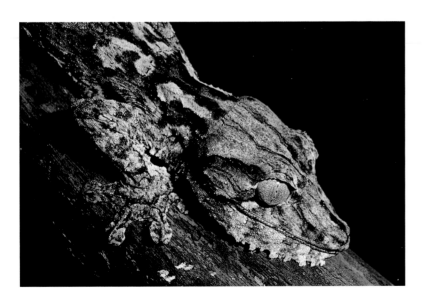

We've looked at how life has been shaped on the big and ancient continental island of Madagascar—the miracle of island magic is that it works equally well on smaller, younger islands.

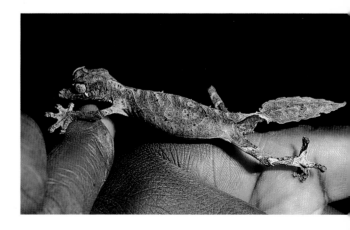

Nuku Hiva ○ ○ Ua Huka
Ua Pou' ⌀̇
Marquesas Islands ⌀

Rangiroa Atoll
Tuamotu Islands

▲ Mt Marau
Society Islands Tahiti

French Polynesia

From Simple Beginnings

MADAGASCAR is a chip off the old block, a continental remnant cast adrift from the mother ship Gondwana with an eclectic mix of ancient species on board. But not all islands are big and complex—some have surprisingly simple beginnings. An archetypal oceanic island often starts life as a volcano, forming in places where the sea floor is thinner, or along rift lines in the earth's crust. Some volcanoes grow into huge mountains, eventually rising above the surface of the water and giving birth to a new island. This is an island raw and bare, lacking any forms of life, a land of opportunity waiting for any species that can arrive and survive the bleak conditions.

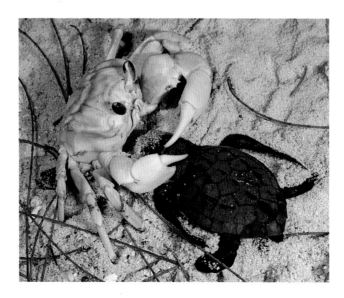

This speck of land, OPPOSITE, *surrounded by nothing but hundreds of miles of ocean, may become in time a breeding platform for ocean-going species, or a new home for an island colonizer. All over the world islands both large and small have become crucibles for the evolution of new species, as well as stages where every-day dramas are acted out, such as a hatchling hawksbill turtle* (Eretmochelys imbricata), RIGHT, *being captured and eaten by a ghost crab.*

In the warm, clear waters of the tropics, marine species such as corals are often the first to arrive. Over time these build a skirt of fringing coral reef around the island. Over aeons the original volcano may begin to subside, and the reefs become barrier reefs, separated from the original volcano by a lagoon. Eventually the volcano disappears altogether, leaving low-lying coral atolls. The great naturalist Charles Darwin was the first person to document this process, which we now know is how many of the Pacific's widely scattered islands were formed.

For a classic example of oceanic islands you can't go past French Polynesia, a political agglomeration of 118 small islands and atolls scattered across a 1200 by

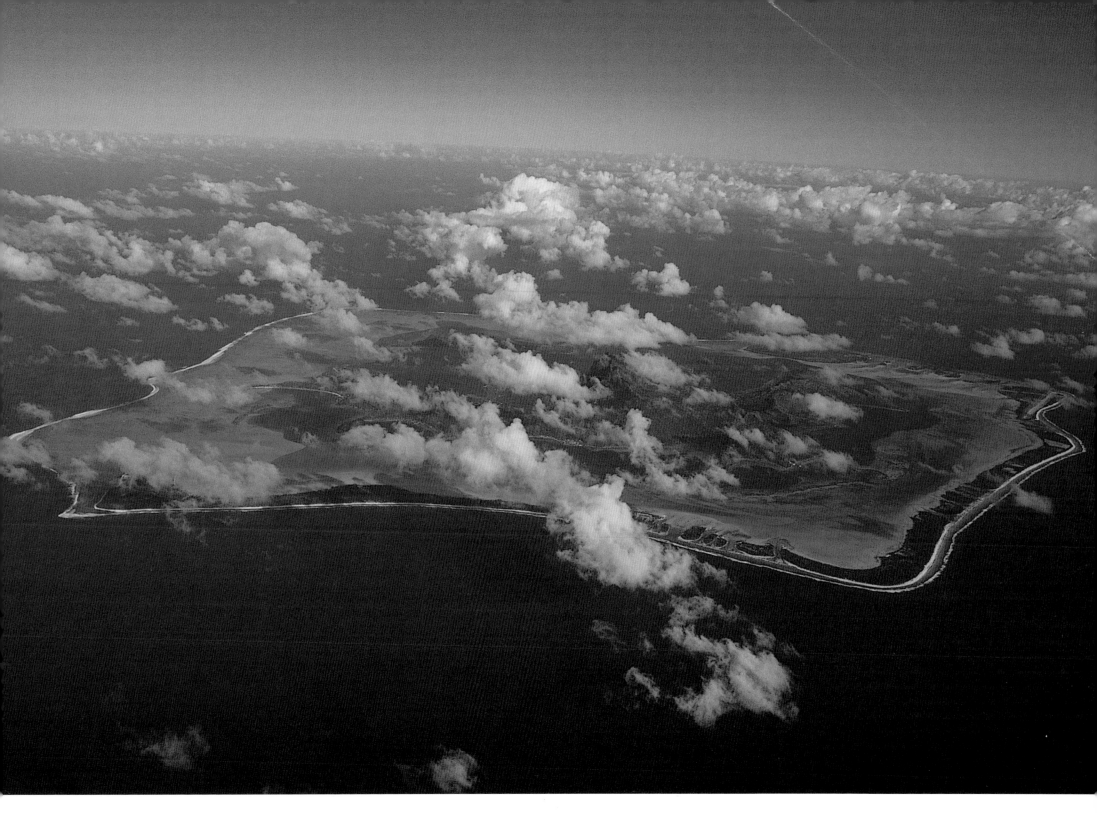

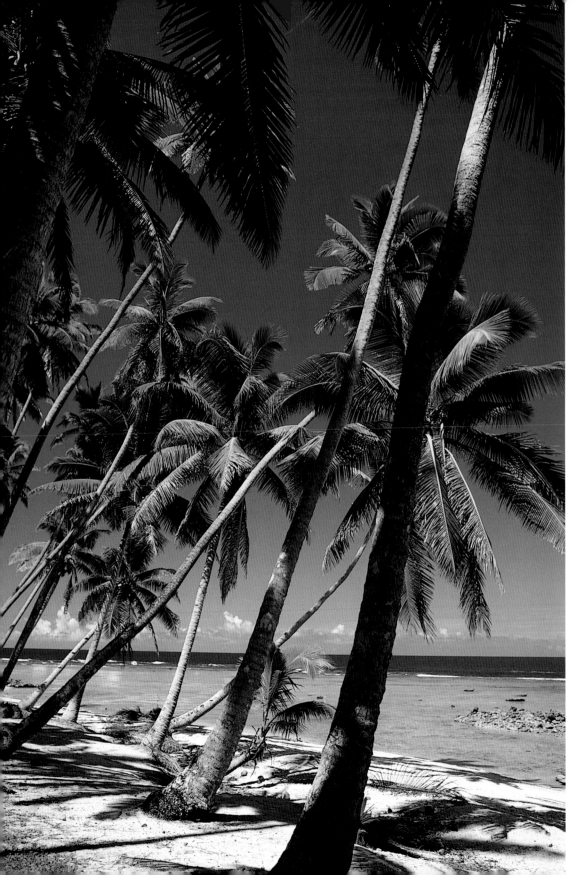

1200 mile (2000 by 2000 kilometer) expanse of the Pacific Ocean. The islands are clustered into five archipelagos or groups that include the Tuamotus, the Marquesas, and the Society Islands whose focal point for most people is Tahiti.

French Polynesia is an archetypal tropical paradise, where coconut palms sway over warm sheltered lagoons. A typical scene from some of the atolls would include a noisy flock of vibrant blue birds crowding the palm fronds and jostling for nectar from the flowers. High overhead a jet full of tourists would be leaving a vapor trail across the sky. A land crab wearing a cast-off seashell might wrestle with a cracked coconut, trying to tear into the creamy flesh, while out on the ocean a rusty freighter loaded with cargo comes into view, heading for the nearby port.

The coconut palms, the blue Tahitian lorikeets, the land crabs and the tourists are all travelers, that have voyaged long distances by air or by sea, to reach isolated outposts of land. The difference is that the tourists have made a deliberate choice to get away from it all on a tropical island paradise—they have looked at the brochures, booked their ticket, and they know how long their vacation will be. The coconut palms, the lorikeets and the land crab, however, have arrived here serendipitously. Their ancestors probably left home by accident, chanced upon favorable winds or currents and then had the sheer good fortune to land on an island at the right time in history. And there was no going back. The likelihood of successful colonization is infinitesimally small, not the sort of odds to gamble on. Dispersal is a sweepstake with a very high failure rate.

And what of the tramp steamer? Nothing specialized, just a good general design, adaptable, resourceful, plying its trade from one island to the next. The same traits, in fact, that make a species a good traveler. There are a few species which excel at traveling—these are the super-tramps, which have colonized many islands through the Pacific. The coconut palm is a super-tramp par excellence. It has large durable seeds that float well and survive in salt water, and are able to germinate and take root above the tide line of any beach they wash up on. Little wonder the coconut is such a ubiquitous feature of the Pacific islands.

The coconut palm probably originated in South-east Asia. So too, it seems, did the Polynesian people, who spread right across the Pacific via Melanesia. The Polynesians are among the world's greatest ocean-going travelers, and they almost certainly would have helped the coconut to disperse by taking it with them in their canoes. Hitch-hiking with people or on animals is, after all, another time-honored way of getting to your destination.

French Polynesia From Simple Beginnings

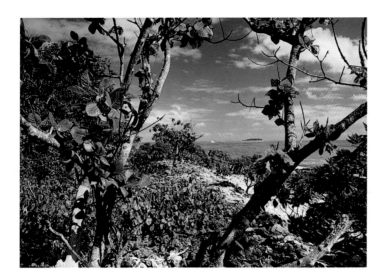

The Polynesians had many uses for the versatile coconut. Fresh nuts provided food and drink, and dried kernels made copra. The shells could be burnt as charcoal, used as cups or carved into body ornaments, and the palm leaves were made into baskets, mats, brooms, hats, fans and a myriad other items. Houses and furniture were built out of the wood, and oil from copra was used for cooking, heating, lighting, or mixed with perfume as a body lotion or hair tonic. By itself the coconut palm could turn an inhospitable atoll into a place fit for habitation. And, once the coconut palm was in residence, other species could follow. Red-footed boobies, for instance, are oceanic birds that make their livelihood from the sea but require trees to roost in. Other species of trees and bushes that establish once the coconut palms have softened an island, allow red-footed boobies to also take up residence.

Land birds such as Tahitian lorikeets are less of a certainty on a remote oceanic island than seabirds such as the boobies. However, they have features that lend themselves to survival in the dispersal sweepstakes, even when they end up as far from home as Tahiti, in the eastern reaches of the Pacific. Most lorikeets are found in the far west of the Pacific Ocean, in New Guinea, which has the greatest diversity of parrots in the world. The twenty-one species of lorikeets there make up nearly half of the total number of this parrot group. Gregarious birds, they feed together in flocks and are strong fliers. Their brush-tipped tongues, covered in papillae, are an adaptation to feeding on nectar and pollen. Pollen is a great source of nitrogen while nectar is full of carbohydrate, and just a few hours' feeding on these rich food sources gives a bird a day's worth of energy.

The Tahitian lorikeet is one of three species of *Vini* lorikeets that made it to French Polynesia. *Vini* lorikeets feed on the nectar of coconut palms and nest in hollow cavities or rotting coconuts still attached to the tree, so they are often found at the backs of beaches. And they are strong, active fliers, often flying above the tops of the trees, so it is not inconceivable that small groups of them might get swept out to sea by a tropical storm. Most flocks would probably die at sea, or mis-time their adventure and arrive on an island too early in its succession, before the coconut palms and other plants that would suit them were well established. But the occasional group obviously hit the jackpot—an island complete with

As well as displaying the ever-present coconut palm, OPPOSITE, atoll forests frequently contain a variety of beach strand plants whose seeds are distributed by the sea, LEFT. They provide shade, shelter and food for a variety of terrestrial crabs and nesting seabirds. The smaller the island the simpler the plant and animal communities to be found on them.

Sea turtles such as this hawksbill turtle (Eretmochelys imbricata), BELOW, are ocean-going reptiles that have dispersed right across the Pacific. While males spend all their time at sea, females seek out quiet sandy beaches where they come ashore to lay their eggs.

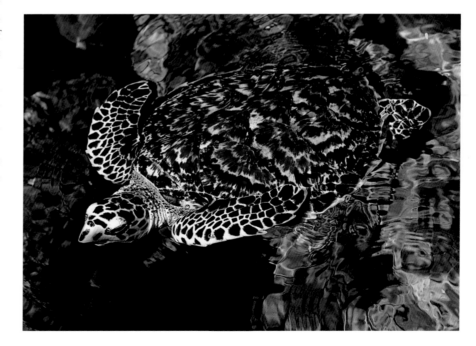

palms. And since the lorikeets almost certainly arrived in ready-made groups of males and females, they were all set for the next step, breeding.

If only a small founding group arrives in a new location, there is a stronger chance that the characteristics of a single individual in that group may come to dominate a whole population. This probably explains the distinctive blue plumage of the Tahitian or blue lorikeet. In the Marquesas, another Vini lorikeet is a rich ultramarine blue; the third French Polynesian species is more typically red and green.

Some species do not have the option of a speedy air trip, possibly made in short hops between different island groups, and must make a longer ocean voyage. Sea travel requires a different set of survival features. Marine turtles, for example, are archetypal ocean wanderers that spend their whole lives at sea. The only time the females need to make landfall is to haul up on a sandy beach to lay their eggs. Other species such as land crabs are terrestrial but have the attributes to survive long ocean voyages. Their lives are the complete reverse of those of the turtles: they begin at sea and are completed on the land.

Most crabs are aquatic species, although a few have adapted to life on land. Among them is a family, the Coenobitidae, that belongs to the group called Anomurans, the tailed crabs. This family includes fifteen species of land hermit crabs, with adults that live in discarded gastropod shells, and the robber or coconut crab, which doesn't inhabit a shell. All crabs have five pairs of legs, but in the robber crabs the fifth pair, located

*The blue lorikeet (*Vini peruviana*), ABOVE, is one of several species of Vini lorikeet that have dispersed far to the east in the Pacific. Once widespread in the Society Islands, today they survive on only a handful of small motus, or coral atolls, RIGHT, such as Motu Taeo'o on Rangiroa Atoll in the Tuamotu archipelago.*

Corals flourish in the warm shallows of this beautiful area, known as the location of the Hollywood movie Blue Lagoon, *FAR RIGHT and OPPOSITE. The small motus surrounding the lagoon are still rat-free and are therefore some of the last homes of the blue lorikeet.*

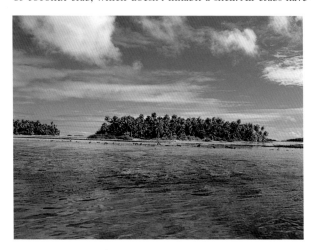

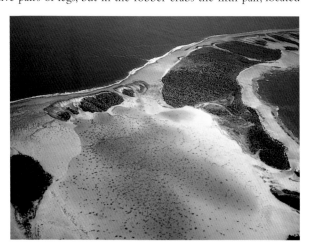

French Polynesia From Simple Beginnings

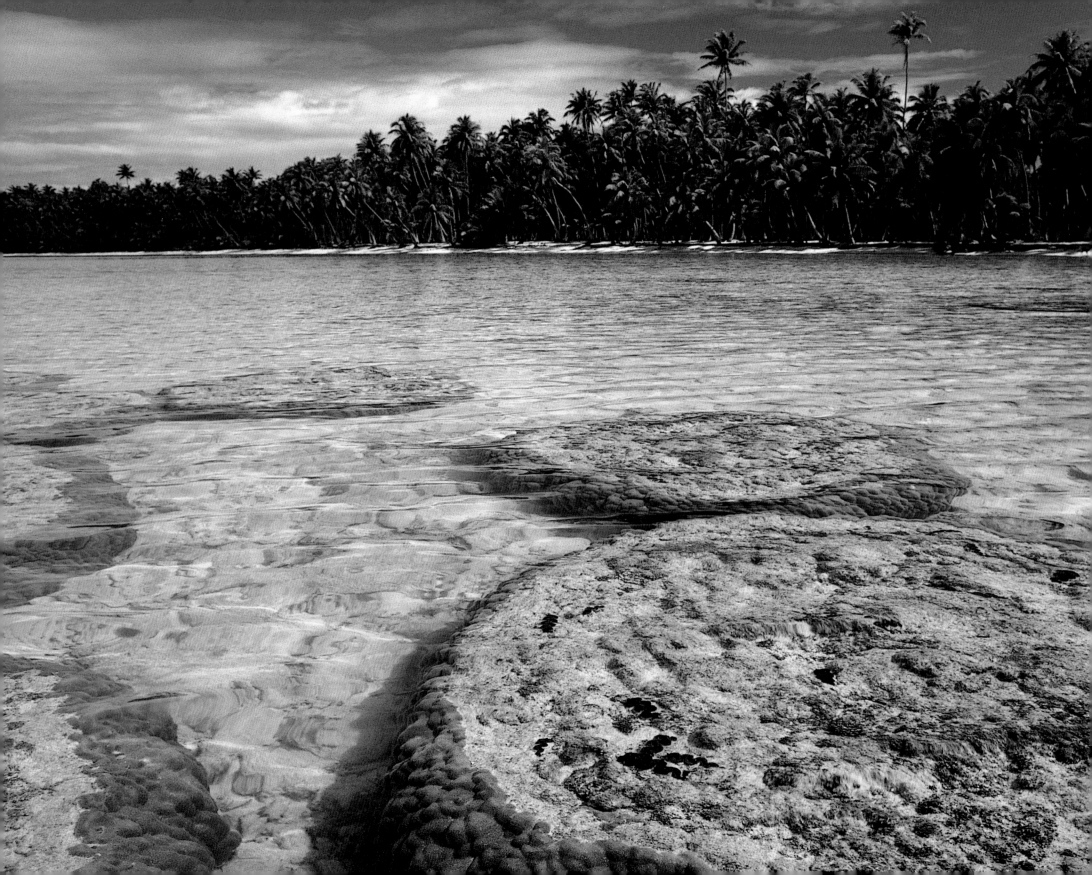

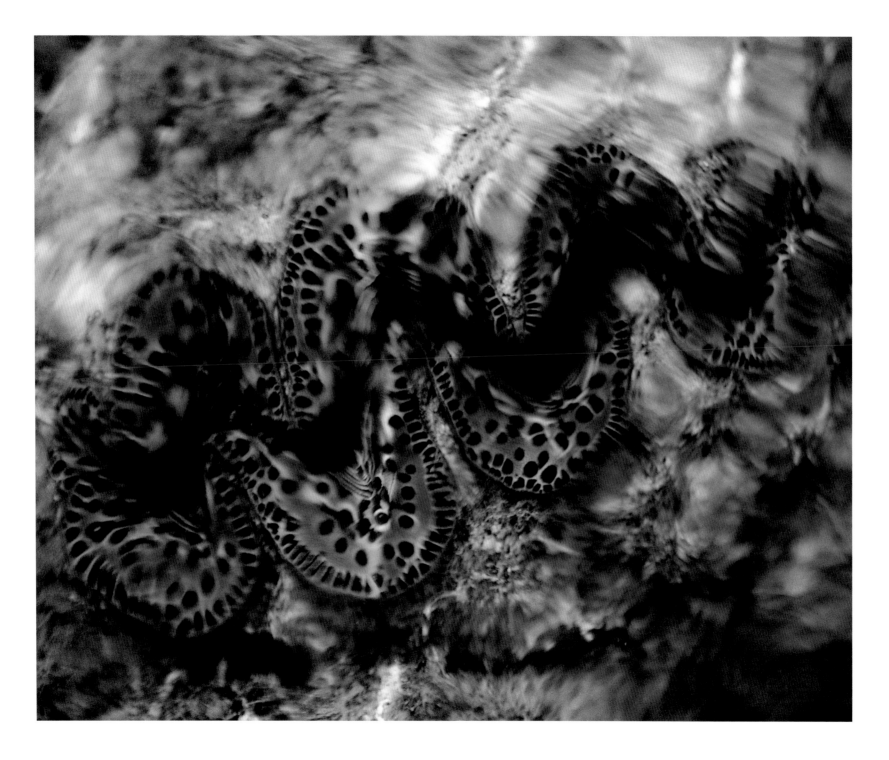

French Polynesia From Simple Beginnings

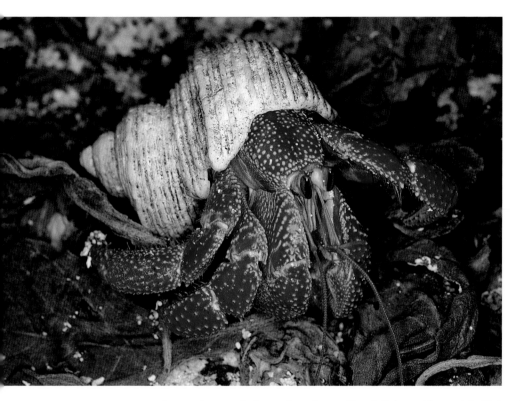

under the tail, is very small. These legs work constantly to keep the gills clear of dirt and debris—part of the crab's adaptation to breathing in air instead of under water.

The widespread giant robber crab has the most reduced gills and its gas-exchange system is one of the most sophisticated in land hermit crabs. Complex folded tissue hanging from the roof of its gill chamber is covered in extensive gas-exchange surfaces and blood-rich tissues. And its gills have become so reduced the crab can survive without them; indeed, the robber crab is so well adapted to life away from the water that an adult drowns in water after a few hours.

Only when they reproduce do land crabs revert to their marine ancestry. At a new moon, the females line up along the shore, facing the water and holding onto rocks or cliffs with their strong front legs. They are waiting for a single wave to wash over them and sweep their eggs into the sea. The shell-less robber crab holds its tail down with the fertilized eggs exposed to the sea. The hermit crab's tail is inside her shell, so she has to hold the shell entrance open and shake and vibrate to ensure her eggs get free of the shell. This brush with the sea is short, however—the moment the female crab's eggs are gone she returns to land.

The eggs hatch as soon as they hit the water, and the young larval crabs float in the ocean as plankton for up to eight weeks. Still less than one quarter of an inch (3 millimeters) long, the transitional larvae look for small shells or holes in the coral. Once they grow to about a third of an inch (7 millimeters) they return to the land, although when they haul out they may well be on a different island from their parents. The young hermit crabs continue to use shells as shelter—it is not until they are well on their way to becoming the largest terrestrial invertebrates in the world that robber crabs abandon the safety of their borrowed shells.

A crab's strong grip, which allows it to cling onto rocks and withstand waves, stands it in good stead in the forest, too. Hermit crabs can perch more than 3 feet (up to a meter) off the ground, tightly gripping small saplings, well out of reach of possible predators. Robber crabs have taken this one step further: they are good climbers that can scale coconut palms or palm trees. Being omnivores, a very useful trait for a dispersing species, they will eat carrion, palm and pandanus fruit, and even cannibalize their own kind. What they are famous for, however, is eating coconuts—and they will even climb a palm to reach the coconuts if necessary.

Breaking open a coconut is a difficult task, however, one that usually takes a number of crabs a number of nights. The first step is to tear the outer husk away, beginning at the top end. A hungry crab will often eat some of this fiber. The

*A giant clam (*Tridachna maxima*),* OPPOSITE, *now uncommon in many places in the Pacific because of demand for clam meat, thrives in the clear waters of the Blue Lagoon (see page 41). Its brilliant mantle comes in many colors. When undisturbed the clam's valves open, allowing sunlight to filter through the clear water to reach symbiotic algae in the mantle that manufacture additional food for the filter-feeding clam.*

*Another giant, less common now because of the demand for its flesh, is the coconut or robber crab (*Birgus latro*),* BELOW, *the world's largest terrestrial invertebrate. This gigantic landlubber has become so specialized for a land-based existence that it now drowns in seawater. Another crab adapted to a terrestrial lifestyle is the closely related land hermit crab (*Coenobita perlatus*),* LEFT, *that carries a shell around to protect its soft body.*

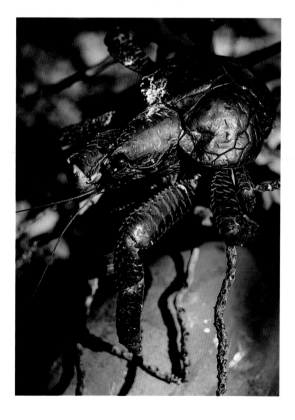

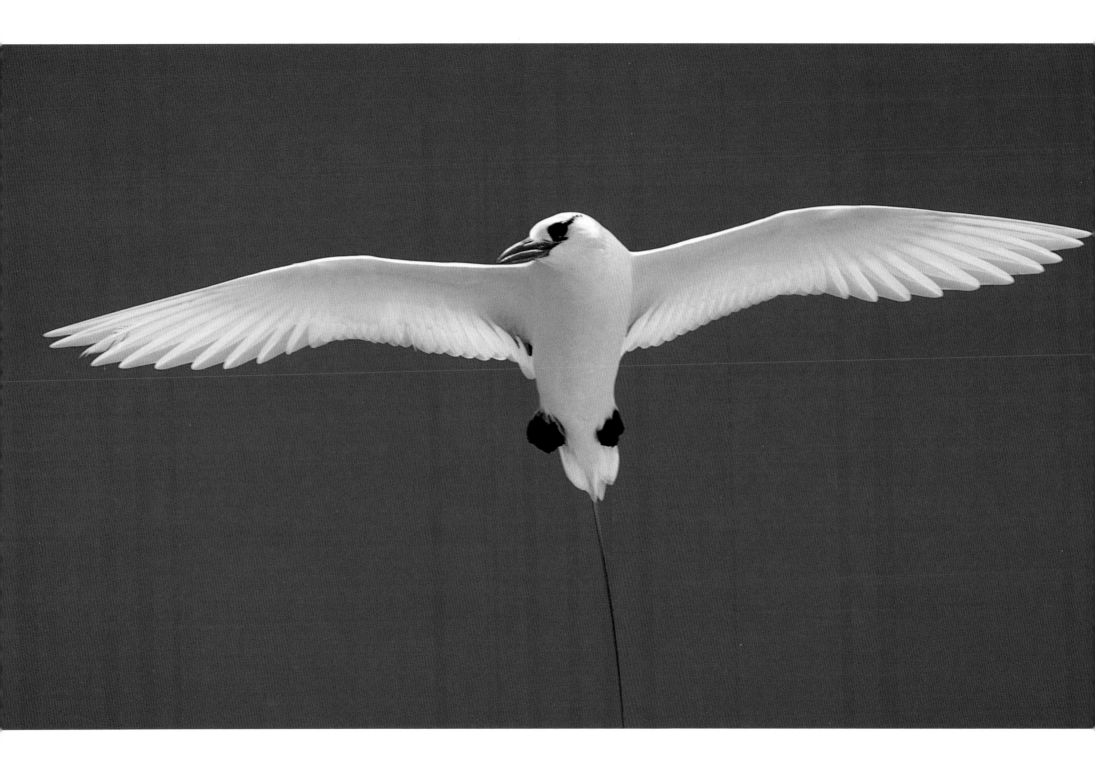

French Polynesia From Simple Beginnings

next step is to begin to open the three germination holes at the end of the nut that are the softest part of the shell. Usually a crab inserts the tip of one of its front walking legs into a hole and begins to work away at it. Once some progress has been made, a larger crab is required. Using its massive front left claw, it can apply a pressure of up to 13 pounds per square inch (90 kilopascals); by comparison, a biting human can manage only 9 pounds per square inch (60 kilopascals). Eventually the shell breaks, and all the crabs—robbers and hermits—get their just rewards.

The robber crab's massive nut-opening left claw is a legacy that is related to its early shell-wearing habits. The discarded shells that the hermit crabs and young coconut crabs live in all have a right-handed whorl. As the young crabs climb inside they draw their whole body in, except for one pincer that blocks the entrance of the shell—this weapon is the over-developed left pincer.

Robber crabs are nocturnal, a behavioral adaptation that helps ensure they are active in the high humidity environment they need. The crab's peak foraging activity often occurs at the new moon—perhaps this is a throwback to times of good shore foraging. Timing is everything. The early stages of a coconut forest are usually too dry for a robber crab to survive in. Only when it has become dense and moist enough to maintain a humidity of 70 to 80 percent does the forest become an attractive possibility for a dispersing crab or other species needing a mature habitat.

Marine species and species that fly aren't the only ones capable of reaching remote oceanic islands—even terrestrial species may find themselves being accidental travelers. Such voyages might begin in a storm, with a large wave sweeping a pile of leaves and branches, or even entire trees, out to sea. This floating raft can become a temporary home for reluctant passengers caught up in the debris. If the passenger can survive long periods without food and water, they have a slim chance of rafting to a possible new home. Perhaps the mourning gecko caught the occasional lift like this, as well as later hitching rides in Polynesian canoes.

Mourning geckos have a huge advantage in the dispersal sweep-stakes. Usually a single castaway has no chance of breeding, but nearly all mourning geckos are females, and reproduce asexually. A single female produces eggs without needing a male to fertilize them, and all her offspring are perfect genetic replicas of herself. The lorikeets succeeded because they arrived in mixed sex flocks. The mourning gecko succeeds all on her own.

On their own or together, it is the next step that determines what the future will hold for the travelers. The mourning gecko will succeed so long as she is the only gecko: as soon as sexually breeding geckos arrive on an island, they outcompete the asexually reproducing and genetically identical mourning geckos, whose numbers then decline. Sexually reproducing travelers such as the lorikeets are much better equipped to make the most of the new environment in which they find themselves. Sex rearranges genes, and creates variability between individuals—and that variability is what allows species to adapt and change, and evolve into new species.

*During the breeding season male red-tailed tropic birds (*Phaethon rubricauda*), OPPOSITE, perform spectacular aerial courtship flights over breeding islands scattered across the Pacific. These experienced ocean travellers are so adroit and acrobatic they can even fly backwards, the only seabird able to do this.*

*The extraordinary mourning gecko (*Lepidodactylus lugubris*), BELOW, is one of only four vertebrates able to reproduce asexually. Nearly all mourning geckos are female, and produce eggs parthenogenetically. As a result the hatchling young emerge as identical genetic replicas of their mother.*

 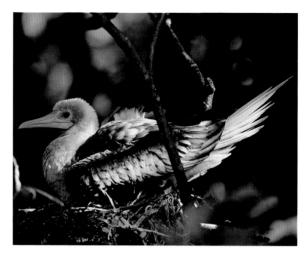

*Red-footed boobies (*Sula sula*), ABOVE LEFT and ABOVE RIGHT, are the smallest of the tropical gannets. Although they come in color forms of either brown or white, they are readily distinguished from most other seabirds by their characteristic red feet. These ocean-going super-tramps range over most of the world's tropical seas, requiring little from an island beyond a resting place and a nesting platform. And they are particularly unusual in being one of the few booby species to roost and nest in trees, rather than on the ground.*

On the underwater flanks of sunken volcanic islands, corals flourish in the warm, clear sunlit shallows, RIGHT. As the volcanic part of the island erodes and shrinks it drags old coral down with it, but just as quickly new coral grows on top of the old. In time the original volcano disappears, leaving just a fringing coral reef marking its outline, as can be seen in this aerial view, OPPOSITE, of the high volcanic island of Borabora, now little more than a volcanic skeleton surrounded by a vast fringing reef.

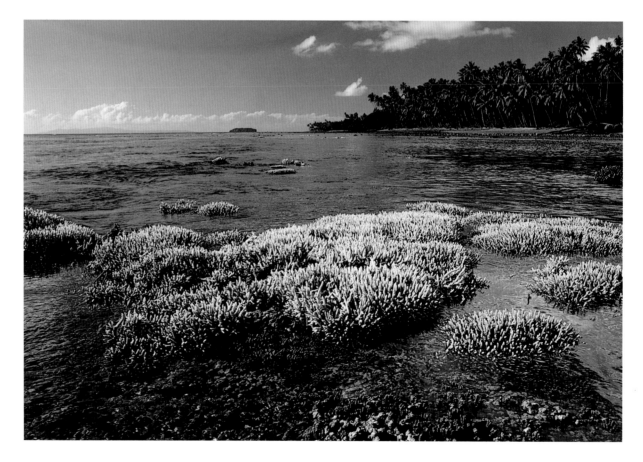

French Polynesia From Simple Beginnings

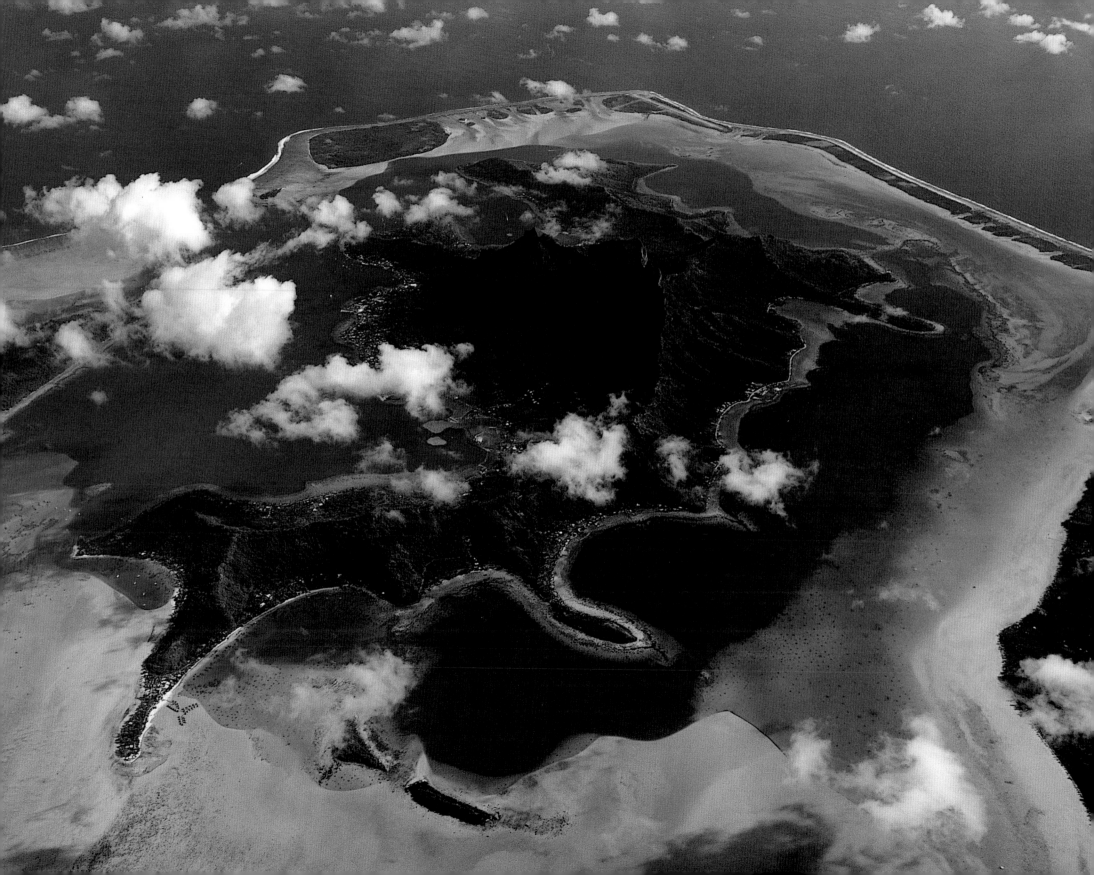

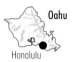

Na Pali Cliffs

Alakai Swamp

Kauai

Niihau

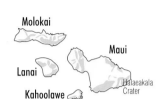

Oahu

Honolulu

Molokai

Maui

Lanai

Haleaekala
Crater

Kahoolawe

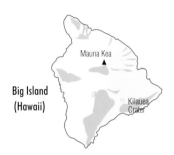

Mauna Kea

**Big Island
(Hawaii)**

Kilauea
Crater

Hawaii

An Evolving Land

*On Hawaii's Big Island new land is still being
created as fresh molten lava emerges from
Kilauea volcano and creeps towards the coast,
RIGHT. As it cools, molten lava becomes a solid
rock platform on which plants and animals
can land and evolve.*

*Despite its apparent harshness, volcanic rock is
surprisingly easily eroded. The result can be
spectacular jagged ridges such as these along
the Na Pali cliffs on the island of Kauai,
OPPOSITE, that are typical of many of the
Pacific's older volcanic islands. Wind and rain
have eroded the original smooth volcanic
cone, leaving bare, steep ridges that look like
skeletal ribs. As the rock is stripped of
vegetation and soil, the process of erosion will
accelerate, and eventually the island will
erode away completely.*

THE GREAT JOURNEYS that plants and animals have taken to reach French Polynesia pale beside the massive undertaking of getting to the Hawaiian islands. This is the most remote archipelago in the world, more than 2000 miles (3000 kilometers) from the nearest continent. These are truly oceanic islands—they rose out of the ocean and have never been connected to any other land mass. But despite the incredibly low odds, a few species have hit the jackpot and made it to paradise. And once they got here they became raw material for some of nature's greatest experiments: Hawaii today is one of the great testaments to the miraculous power of island magic. Thousands of years of island living have transformed the arrivals into fantastic new species, and sometimes into many different species.

Even though the individual islands of Hawaii have come and gone, there has been land in the same place for more than 65 million years. And about once every 25,000 years a new species has managed to cross the ocean and establish itself on land. The most extensive forest in Hawaii was formed by a traveler that we have already met in New Zealand, Fiji and in French Polynesia: *Metrosideros*. What's particularly remarkable is that recent genetic work has shown that the

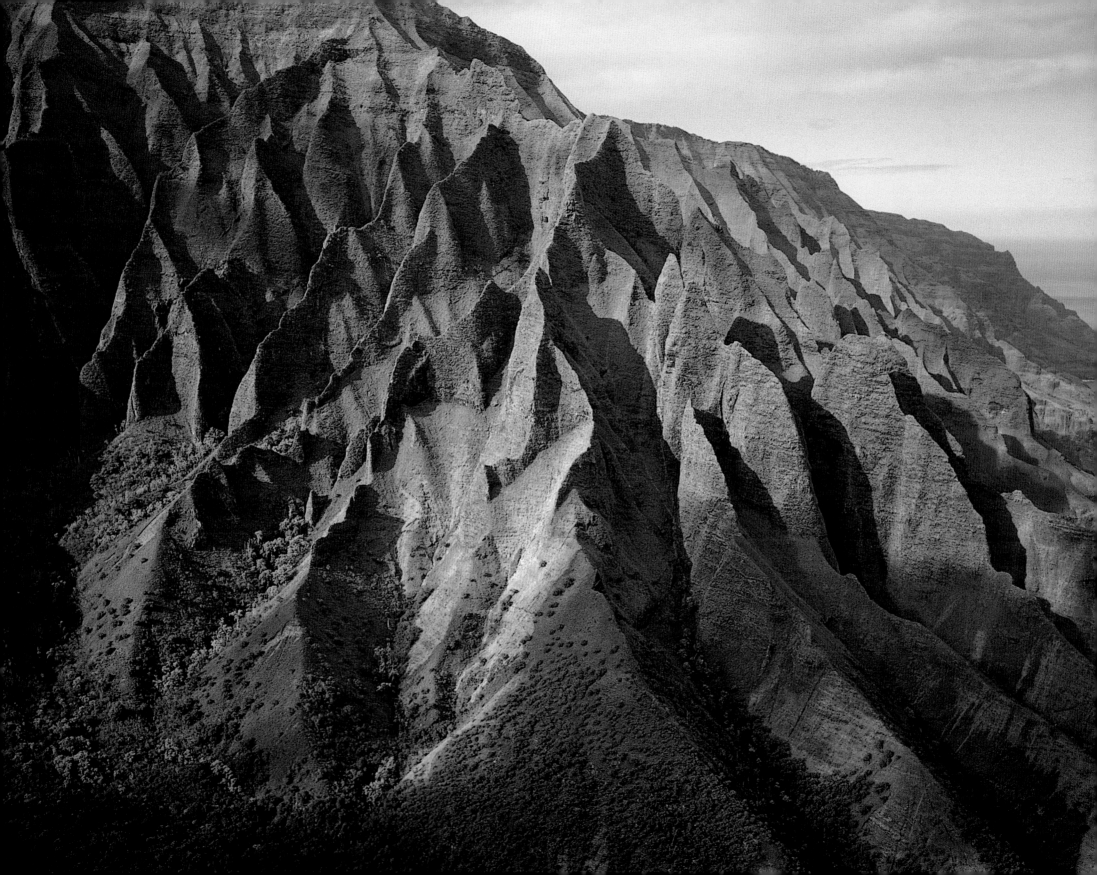

*An important pioneer plant that has colonized Hawaii's bare lava rock is ohia (*Metrosideros collina polymorpha*), ABOVE and ABOVE RIGHT, whose spectacular red brush flowers are a rich source of nectar for pioneering birds and insects. Over time the protective shade provided by the leaves of this tree provides a cool moist environment, RIGHT, for a diversity of other plant species as well as a home for countless birds and insects.*

Hawaiian *Metrosideros* species are direct descendants of the New Zealand pohutukawa, and that the colonizing plants arrived only about a million years ago.

Like any super-tramp, the pohutukawa has clever survival mechanisms to help in its travels. Its seed is very abundant and very light: a zephyr of breeze, moving at just $2\frac{1}{2}$ miles (4 kilometers) per hour, is enough to lift it off the ground and carry it through the air. Once airborne, the seed can survive temperatures as low as -22°F (-30°C), much lower than anything it ever needs to survive on the ground but the kind of temperatures it might find high up in the jet stream.

Germination can take place even after the seed has been soaking in sea water for up to three months, and the pohutukawa is also one of the few tree species able to germinate on inhospitable, bare lava rock. Because the wind and ocean currents at the equator are usually a very effective block to species moving between hemispheres, the pohutukawa's journey to Hawaii would have had to be made in two stages. First of all it traveled east, establishing itself in the Marquesas Islands in French Polynesia. The next part of its journey north across the equator probably happened courtesy of an El Niño weather event, when the usual patterns of wind and ocean become disrupted. Perhaps seed was swept high into the jet stream, carried across the equator, and dropped in the doldrums near Hawaii.

In New Zealand, pohutukawa faces stiff competition from many other plant species, so it does best on coastal cliffs where other plants cannot survive. In Hawaii, however, there are fewer competitors and in less than a million years *Metrosideros* has evolved into five different species, ranging from a forest giant to a low spreading alpine bog dwarf, occupying a wide range of habitats at every altitude. The Hawaiian name for all these forms is ohia.

Ohia forest is the dominant forest on the hot, dry lava fields of Hawaii's Big Island. This is a very familiar environment for the pioneering pohutukawa—Rangitoto Island near Auckland, New Zealand, is very similar. The ohia begins the process of softening the harsh landscape, providing shade and humus, which eventually allow other trees to establish. Rather more unexpected is the

HOTSPOTS

The Hawaiian archipelago is testament to another kind of magic: eternal youth. Its secret is a hotspot in the ocean floor over which the Pacific Plate is slowly moving, like a factory conveyor belt. This hotspot is constantly building new volcanic islands—over the last 65 million years more than eighty islands have been formed. These are the Hawaiian islands, stretching 3700 miles (6000 kilometers) in a chain north-west from the island group we currently call Hawaii. The newest island, Loihi, is still just an active seamount; the oldest, the 65 million-year-old Suika, is in the North Pacific's Aleutian Trench. The youngest of the "High Islands" is the Big Island, which is about three-quarters of a million years old. With its continually active volcanoes, the archipelago is a perfect example of island-building still in progress. Around the hotspot, the sea-floor crust is quite thin, and as the islands begin to slide away from the hotspot they start to sink under their own weight. At the same time, the islands begin to be eroded by wind and water. Twenty million-year-old Laysan Island, in the leeward chain, has sunk and shrunk until is it now just an atoll. Further to the north-west, once high islands now just exist as seamounts along the Emperor Seamounts chain.

Hawaii's volcanic heritage has resulted in remarkable changes to some of its wildlife. The endangered nene goose (*Nesochen sandvicensis*), RIGHT, is thought to be an island descendant of the Canada goose, but whereas the Canada goose is a wetland bird, the nene is an inhabitant of the dry volcanic lava fields of Hawaii and Maui. A smaller bird than the Canada goose, it has greatly reduced webbing between the toes and stronger, more robust legs than its ancestor. Now confined to the high volcanic slopes, it was once widespread in the lowlands.

Emperor Seamounts

Leeward

Pearl and Hermes Reef

Laysan Island

Chain

Hawaii

▲ Loihi Seamount

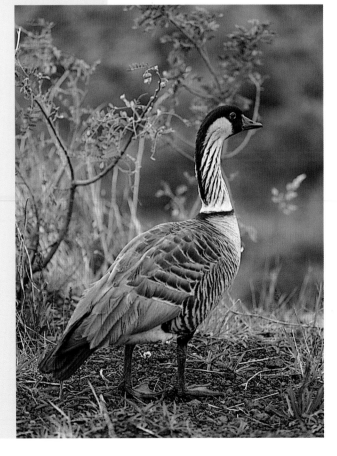

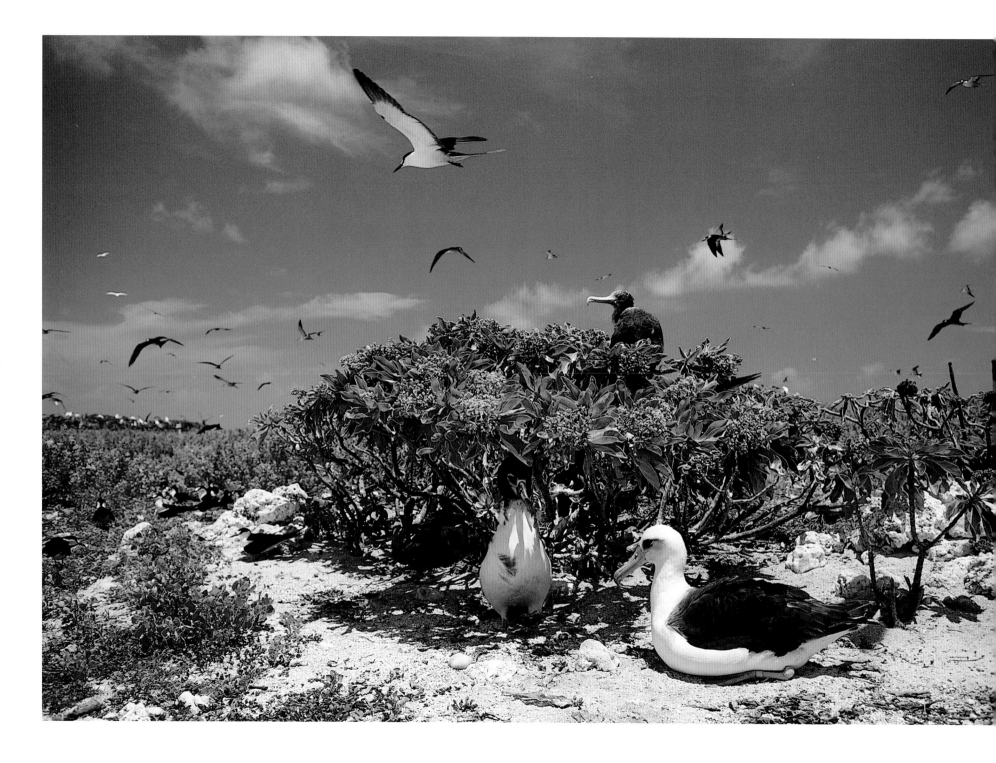

Hawaii An Evolving Land

niche that *Metrosideros* has exploited on the island of Kauai, forming a dark, dank rainforest in one of the wettest places on earth. On the slopes of Mount Wai'ale'ale, the ohia forest is an impenetrable tangle of moss-covered branches and rotting logs. *Metrosideros*'s very survival here is a tribute to both the plasticity of the plant and to the possibilities that the environments and climates of the Hawaiian islands offer.

The complexities of Hawaii's environments are created by two features: the topography of the islands, and their position on Earth. The main islands of Hawaii are very high. The highest, Mauna Kea, is nearly 14,000 feet (over 4200 meters), and that's just the bit that sticks out of the water—it rises more than 33,000 feet (10,000 meters) from the sea floor, making it taller than Mount Everest. For much of the year the top of Mauna Kea is snow-covered, even though it is so close to the equator.

These sharp, jagged peaks sit in a belt of easterly trade winds that sweep around the equator. As the wind is forced to rise over the islands, it cools and dumps its moisture as rain. As a result, the windward eastern slopes are much wetter than the leeward slopes on the west, and rainfall can vary hugely over very short distances. Coastal Honolulu gets 2 feet (60 centimeters) of annual rain. Just 5 miles (8 kilometers) away, and still within Honolulu city limits, the head of the Manoa Valley gets on average nearly 13 feet (4 meters) of rain a year. In the Alakai swamp on the slopes of Mount Wai'ale'ale, on Kauai, the average annual rainfall is 40 feet (12 meters), making it one of the wettest places in the world.

On Maui, Haleakala's incredibly wet greensword bogs are just a few miles away from the crater's very dry leeward slopes, where another phenomenon creates deserts in unexpected places. An inversion layer, caused by the precipitous steepness of the volcanic peaks, keeps the gathering clouds well below the summits; above this cloud layer a hot and dry atmos-

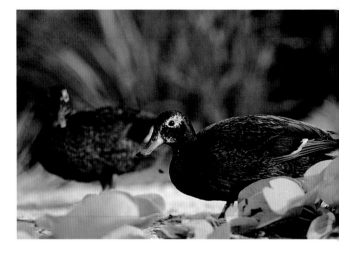

*Laysan is an ancient low-lying coral atoll in the Hawaiian Leeward Islands group. Although it is now very eroded, it is still an important breeding ground for seabirds, such as these Laysan albatross (*Phoebastria immutabalis*), OPPOSITE, as well as some other very ancient species.*

*A pair of endangered Laysan teal (*Anas laysanensis*), ABOVE, hunt for flies on their remote island home. These small ducks are descendants of North American mallards that colonized Hawaii hundreds of thousands of years ago. Subfossil evidence shows that the teal was once widespread throughout the younger, higher Hawaiian islands, until humans arrived.*

*Hawaii's north-western island chain is also still home to the endangered endemic Hawaiian monk seal (*Monachus schauinslandi*), LEFT, the oldest existing seal species in the world. Formerly widespread in the Hawaiian islands, by the time it was described in 1905 its population had already been severely depleted by sealers. Despite the seal's rarity, the remoteness of this Hawaiian archipelago has meant it is safer than its relatives, the Caribbean and Mediterranean monk seals.*

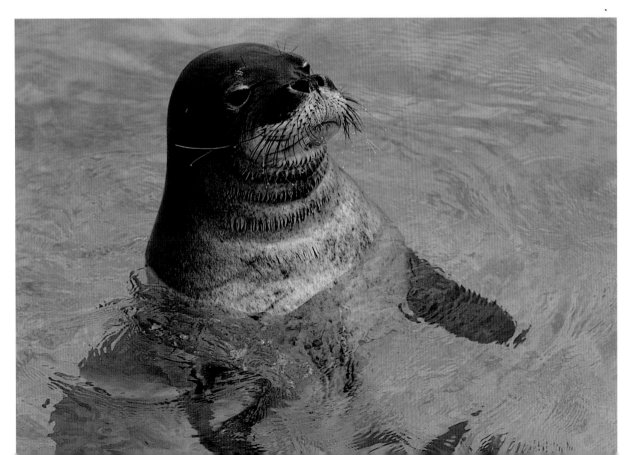

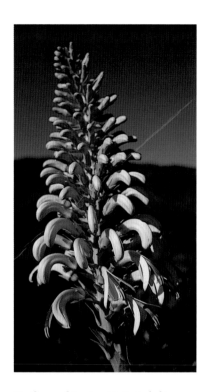

The flowers of the giant lobelia (Lobelia gaudichaudii *var.* gloria-montis), ABOVE, *are arranged on gigantic spikes. Other Hawaiian Lobeliads also exhibit a bewildering array of flower shape, texture and color, ranging from the small, easily overlooked greenish flowers of* Clermontia kakeana, ABOVE RIGHT, *through to the pendulous pinkish-green flowers of the* oha wai (Clermontia grandiflora), RIGHT. *And there are many, even more bizarre examples—what other plant group, for instance, has black, prickly flowers?*

Hawaii's birds and flowers have developed some remarkable associations. The i'iwi (Vestiaria coccinea), OPPOSITE, *is actually a finch that has evolved a honeyeater's bill in order to feed on the beautiful flowers of the koli'i, or cartwheel lobelia* (Trematolobelia macrostachys), FAR RIGHT, *and its perfectly curved beak fits into the Lobelia flower as a hand fits a glove.*

phere creates alpine deserts on the tops of the peaks.

Temperature doesn't vary as dramatically as rainfall, but a big variation still occurs between the beach and the high peaks. Honolulu, for example, averages 62–89°F (17 to 32°C), while Mauna Kea is down between 17–50°F (–8 to 10°C).

This climatic complexity overlaying a varying landscape has created a huge patchwork of local environments, among them some of the wettest and some of the driest places in the world, all in close proximity to one another. When *Metrosideros* arrived, there were a number of potential habitats in which it could evolve, and various climatic extremes to shape and mold the plant differently in different places.

Metrosideros was not the only plant to arrive and evolve in Hawaii: an estimated 270 plant species have managed to make the journey, and these have evolved and multiplied into more than two thousand endemic species. Many of the founding plants came from Asia and Australia, although some came from the Americas, in the direction of the prevailing wind. Each of these new arrivals represents an astounding feat of chance and survival against the odds.

Among the newcomers from South America were three kinds of *Lobelia*, plants that we usually think of as small annuals with bright blue flowers. In Hawaii, Lobeliads diversified into a group of seven genera containing a hundred species, living in the mixed mesic rainforest beneath a canopy of *Metrosideros*. Hawaii's Lobeliads range in size from epiphytes that perch on *Metrosideros* trunks to 40-foot (12-meter) high giants that look like tropical palms. Most fall somewhere in between and are woody candelabra-type shrubs. One species, *Brighamia citrina*, lives on coastal cliffs. It has very succulent leaves and looks much like a cabbage on a stalk.

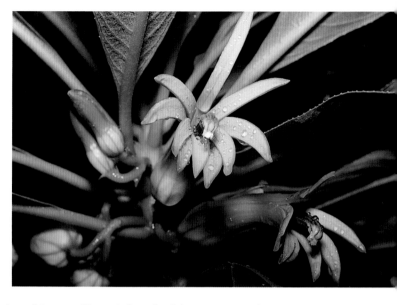

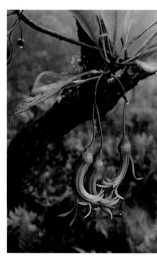

But it is what has happened to the flowers of the Lobeliads that is really spectacular. Up to 6 inches (15 centimeters) long and tube-like, the flowers are a mad rainbow assortment, ranging from pink, white, red, green, purple to yellow and even black. They can be gaudily bright or delicately pastel, plain or striped. Their texture is even more unexpected—these flowers can be warty, knobbly, lumpy, ridged or even prickly. The Lobeliads leaves are very varied too, ranging from narrow straps to fern-like.

Such a huge diversity of shape and form is the very essence of island magic—released from the constraints of a continental environment where they are forced by competition and predation to do just

Hawaii An Evolving Land

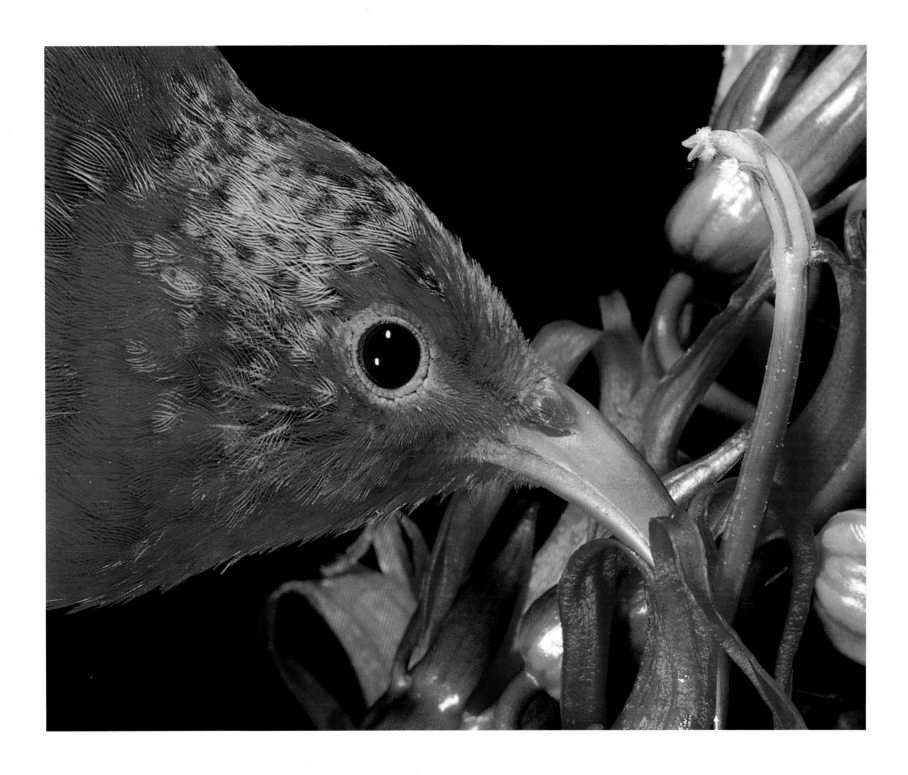

TARWEEDS

The most striking example of adaptive radiation in the plant world—where one species becomes many—is found in Hawaii. The nondescript plant that founded the silversword dynasty started as a small sticky annual in North America known as the tarweed. Perhaps parts of a plant were carried to Hawaii stuck on the feathers of a bird or its parasol-like seeds may have been blown there.

That founding tarweed has evolved into a spectacular array of plants with a huge diversity of forms: mats, cushions, rosettes, upright shrubs and sprawling shrubs, trees and climbers. Some have evolved to live in extremely wet places with an average annual rainfall of over 40 feet (12 meters), while others thrive in high desert where less than 15 inches (40 centimeters) of rain falls each year.

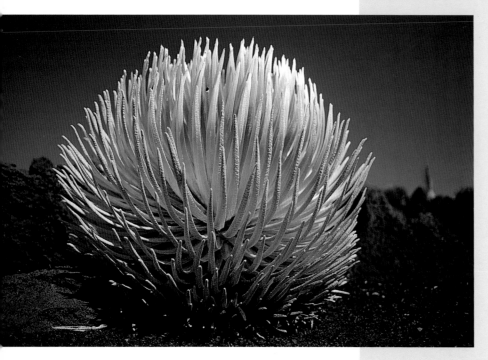

The extraordinary Maui silversword (*Argyroxiphium sandwicense*), LEFT, dots the high desert, looking like a large silver sea urchin, or perhaps a strange silver hedgehog. Its 20-inch (half-meter) long, sword-shaped leaves are fat and fleshy, filled with gel, and covered in silver hairs to protect it from bright sunlight. The only reliable source of moisture is the dew that falls each night, so the plant has evolved fine hair-like roots very close to the surface that allow it to greedily collect and store the dew.

It can take up to twenty-five years before a plant has stored enough energy to flower. Then it sends up a single 4-foot (1.2-meter) flower spike, covered in thousands of bright purple, aster-like flowers. This dramatic flower spike is an extreme piece of advertising for pollinating insects, which are scarce in the harsh alpine desert. Given the slim chance of finding another plant, any insect that does manage to get blown onto a flower spike probably stays there for the rest of its life.

When flowering is over, the plant dies—this once-off approach harkens back to its origins as a annual plant. The flower spikes are also covered in sticky hairs, with a strong sweet fragrance, that capture some hapless insects. When the inflorescence dies the rotting stem and trapped insects may provide nutrients for seedlings in a nutrient-poor environment.

Less than 12 miles (20 kilometers) away lives a closely related tarweed that has been shaped by very different climatic extremes. The Maui greensword grows in a bog, having evolved to deal with the problem of too much moisture. Its leaves are smooth with furrows designed to shed water, and bright green to maximize its ability to harness energy from the sun, and its flowers hang upside-down so that they don't fill with water and rot. Because there are lots of pollinators around, the plant doesn't waste energy on ostentatious flowers and instead has only nondescript yellow-green blooms.

Occasionally, however, a greensword will produce pink flowers while yellow-green flowers appear in the silversword desert. This is not an example of the plants cross-pollinating. Rather, it is a sign that the genetic variation and potential that allowed the original tarweed to diversify into so many different environments is still present.

one thing and do it well, island species are free to develop all their genetic potential and diversify. This is called adaptive radiation, when one species becomes many.

The liberating effect of islands applies not just to plants: in Hawaii twenty-five kinds of land snail became more than a thousand new species, and about 250 different insect species became more than seven thousand new species. Along the way some very specialized partnerships have developed—between, for instance, insects and plants.

One such intricate relationship exists between Lobeliads and members of a group called picture wing flies, some of which have specialized to feed and lay their eggs on the rotting bark of particular Lobeliads. Picture wing flies are giant members of a genus of fruit flies called *Drosophila* that includes more than 600 described species in Hawaii, more than a quarter of the world's total. Picture wing flies are the largest and most eccentric of Hawaii's *Drosophila*, with more than a hundred species.

Male picture wing flies have intricately patterned wings, which some species use in one-on-one fights, holding their wings out parallel to their body and rushing at each other, as they try to deliver a winning head butt. In what is known as a lek breeding system, the males try to out-display and out-compete one another. At stake is the right to court a female. Once the males have established a hierarchy they turn their attention to courting. The female will respond only to a male of her species that conforms to an exacting list of requirements: he must have the right wing shape and pattern, vibrate his wings at the right frequency, know the right dance moves, have correct eye color and head shape, and exude the perfect pheromones. Even that may not be enough: sexual selection is all about female choice, and nearly a third of females are so fussy about their suitors that they end up not mating at all. But a male with the right stuff may end up being very successful—just one-third of the males achieve more than half of the matings. These picture wing flies are a glorious example of the power of sexual selection favoring the evolution of highly decorative males that indulge in complex mating rituals.

Another classic example of adaptive radiation is that of an extraordinary group of birds, the Hawaiian finches, some of which are tightly linked to members of the Lobeliad family.

High on a windswept ridge koli'i, a plant in the genus *Trematolobelia*, produces a cartwheel of bright pink flowers. Only one creature can pollinate those flowers—a scarlet-red bird with black wings and a pink curved bill called the i'iwi. The i'iwi is one of a group of at least fifty-five native finches that evolved in Hawaii following the chance arrival of a single species. Both the plant and the bird are so fantastic it is hard to believe the bird is just a finch and the plant is just a Lobeliad.

The bird's beak fits into the flower like a hand into a custom-made glove. The curve of its bill is exactly what is needed to make the plant's stamens dip down and touch the back of the bird's head, leaving a dab of pollen to be picked up from exactly the same spot by the next flower the bird visits as it searches for nectar. Several special finches and plants are so tightly linked that the Hawaiian name for Lobeliads—ha'ha—means "food of the birds."

The spectacular, colorful Hawaiian finch tribe can trace its evolutionary story back 3.5 to 4 million years, probably to a Cardueline finch such as the goldfinch. As they began to occupy empty niches in Hawaii's forests the finches evolved a diverse range of bill shapes and took on new roles such as woodpeckers, warblers, parrots and honeyeaters. The exquisite partnership between finches

Well-camouflaged in order to escape being eaten by honeycreepers visiting ohia blooms, the bright scarlet Hawaiian inchworm (Eupithecia monticolens), ABOVE, *is unusual in that it feeds on flowers and pollen, rather than leaves. But it has close relatives that are even more extraordinary—predatory caterpillars such as* Eupithecia orichlori, LEFT, *which is one of about nine species that don't eat any plant material at all, preferring to wait in ambush for insect prey such as picture wing flies. No other caterpillars in the world are known to be predatory.*

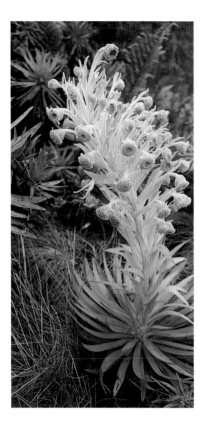

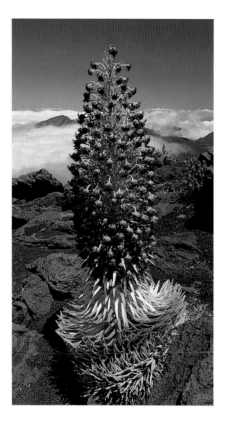

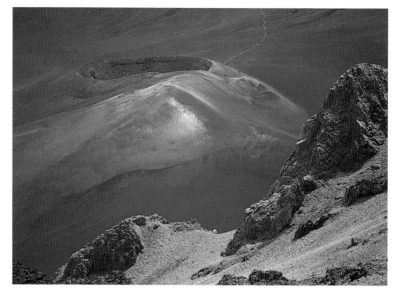

and plants contains within it the germ of a possible tragedy: if one half of the partnership disappears then the other half is also doomed. This is exactly what has happened: forty of the known Hawaiian finch species are now extinct and more are threatened. At least a quarter of the Lobeliads, too, have disappeared. And in 1988 researchers Storrs Olson and Helen James began to find the bones of other, previously unknown species. Their finds included a finch with an almost swallow-like beak that would have hawked insects on the wing like a flycatcher, and another with a massive, crow-like bill—more examples of how incredibly diverse this group of birds once was.

Adaptive radiation in Hawaii's finches is easily the most spectacular example of diversification in the bird world, but it is not the best known—that distinction belongs to a group of "finches" on another group of islands, the Galapagos.

*These three remarkably different-looking plants are all related members of the silversword and greensword alliance. Their differences are the result of the varied environments they grow in. The East Maui greensword (*Agyroxiphium virescens*), ABOVE, grows in a habitat of drizzle and mist. The silversword (*Argyroxiphium sandwicense*), ABOVE MIDDLE, is perhaps Hawaii's most exotic looking plant. It lives in the dry, barren alpine desert of the Haleakala Crater, ABOVE RIGHT. The iliau (*Wilkesia gymnoxiphium*), RIGHT, of Kauai is a tree-like member of the same "silversword alliance." Each of these spectacular island endemics are descendants of just one colonizing plant, a small, nondescript, mat-forming tarweed called* Carlquistia muirii, *from California's Sierra Nevada mountains.*

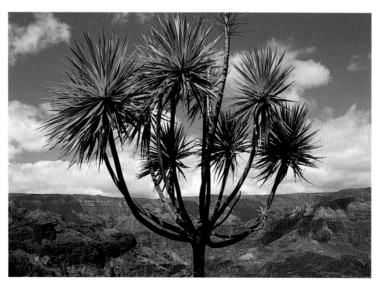

Hawaii An Evolving Land

THE LAYSAN FINCH
AND THE TRIBULUS PLANT

The finch that is most like the ancestral Hawaiian finch lives on the low-lying, sandy island of Laysan, in Hawaii's northern chain of islands. Laysan finches (*Telespyza cantans*), RIGHT, are jacks of all trades. They are ordinary-looking birds with extraordinary behaviour, and to watch them is to gain an insight into the traits that the pioneering finches must have had.

They use their modest finch-like bill to tackle a wide range of food: insects, seeds, flowers, pollen, leaves, and even seabird eggs that they break open to drink the yolk. Inquisitive opportunists with monkey-like minds, the Laysan finches are constantly checking everything out in case it is edible—including people and their belongings.

Aside from their smart bird brain, the clue to their success lies in a small plant they feed on when everything else fails. Tribulus (*Tribulus fortis*), BELOW LEFT, is also known as the caltrop plant—its round spiky seeds look very like caltrops, four-spiked iron balls that were thrown on the ground to impede an enemies' cavalry horses. Tribulus seeds are composed of six mericarps, each containing a row of nutty seeds. The mericarps are difficult to break open, but even in a hard year Tribulus plants produce them abundantly. Laysan finches prefer other, more accessible foods, but when the chips are down they rely on Tribulus seeds.

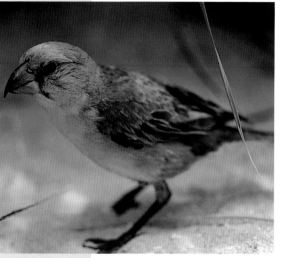

In the 1960s some Laysan finches were released on another Hawaiian island, Pearl and Hermes Reef, which has Tribulus plants with mericarps that are nearly 30 per cent thinner than those on Laysan. Within just twenty years the finches on Pearl and Hermes Reef had evolved thinner bills, proof that evolution can be a remarkably speedy process.

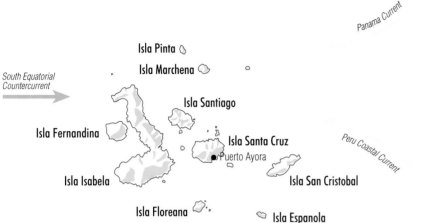

South Equatorial Current

Panama Current

South Equatorial
Countercurrent

Isla Pinta

Isla Marchena

Isla Santiago

Isla Fernandina

Isla Santa Cruz

Peru Coastal Current

Puerto Ayora

Isla Isabela

Isla San Cristobal

Peru Oceanic Current

Isla Floreana

Peru Coastal
Countercurrent

Isla Espanola

Galapagos
Darwin's Dream Islands

Despite a climate that is able to support cactus on land, BELOW RIGHT, the shores of the Galapagos Islands are bathed in cold ocean currents rich in food and able to support penguins—such as the three in the foreground—almost on the equator.

The Galapagos marine iguana (Amblyrhychus cristatus), OPPOSITE, is the quintessential Galapagos animal. The only truly marine lizard in the world, it is common around the coastline of most of the islands, where it feeds almost exclusively on marine algae. Large males such as this are able to hold their breath for 20 minutes as they dive more than 30 feet (up to 10 meters) underwater to graze on algae growing on the seabed.

H ALF AN OCEAN away from Hawaii lives another group of small seed-eating birds that, like Hawaii's finches, are descended from a single ancestor. An ancestral bunting that once made its way to the Galapagos Islands, an archipelago in the equatorial Pacific, about 620 miles (1000 kilometers) from Ecuador, has evolved over time into thirteen species. These finches now comprise an entire subfamily—the Geospizinae—within the bunting family, Emberizidae, and are known as Darwin's finches, referring to the birds collected by the naturalist on his visit to the islands.

Six of the thirteen are ground finches, and what sets them all apart from one another is the size and shape of their beaks. In most other respects—body size and plumage, for instance—they are very similar. This contrasts with the Hawaiian finches that are much more variable, partly because the Hawaiian finches have had a much longer period in which to evolve. As well, Hawaii's honeycreeper finches have evolved to take advantage of large nectar-bearing Lobeliad flowers. In the Galapagos, however, there aren't many nectar-rich flowers so there are no honeycreepers.

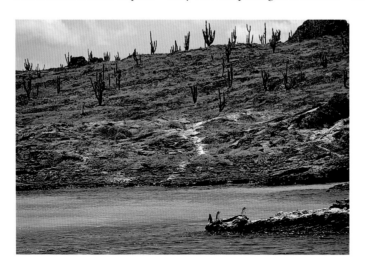

But despite these differences there are strong points of similarity between the two island groups—the two largest ground finches in the Galapagos have a lot in common with Hawaii's Laysan finch, as they are the only finches capable of efficiently tackling the ubiquitous caltrop seed. The same species of *Tribulus* that grows on the

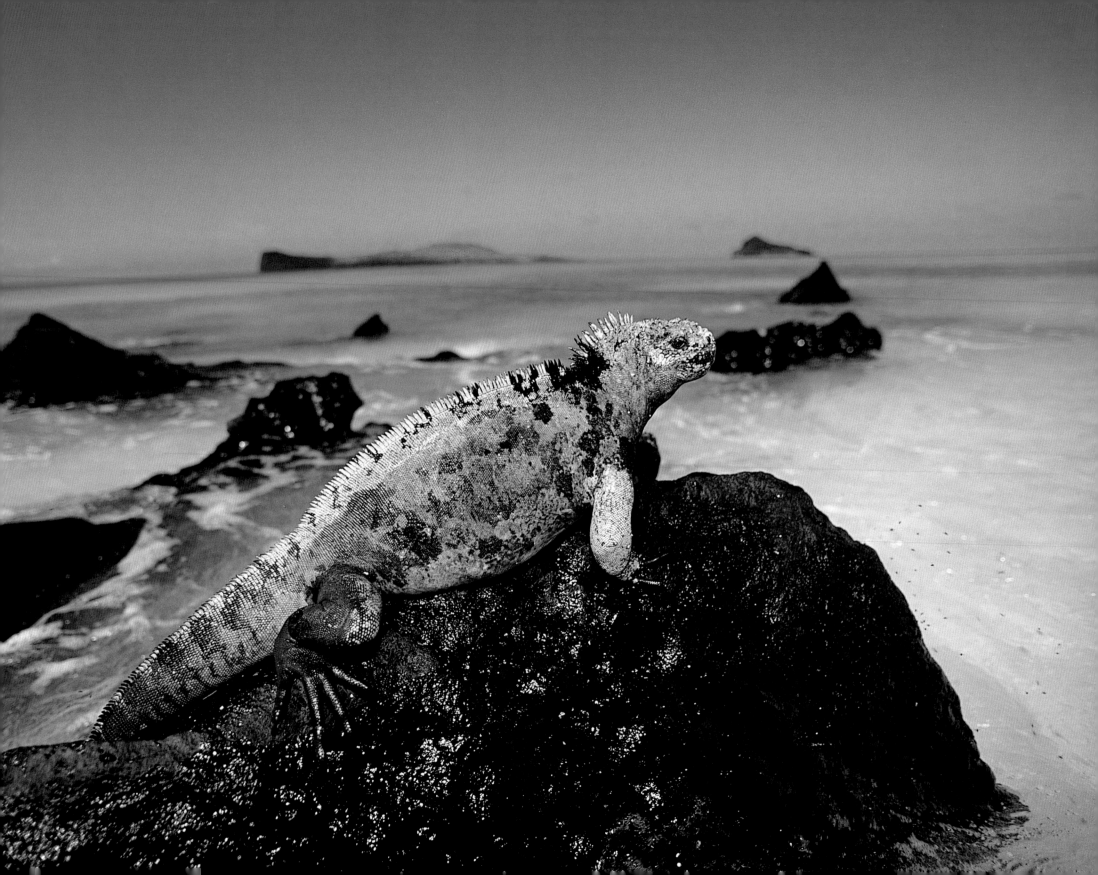

Hawaiian islands (see box on page 59) occurs on the Galapagos, and it is the trump that the finches play during times of hardship on the low-lying islands. The large and medium ground finches can extract and eat three times as much *Tribulus* seed as other smaller, finer-billed species that struggle to obtain even one or two seeds. Even though occasional smart, small individuals survive by stealing seeds once a larger bird has opened them, in a very hard year it is often only the two largest finch species that survive on a low, dry island.

What this shows is that while the ground finches might look similar, their subtle beak variations make the difference between life and death in times of hardship. In an ordinary year the look-alike finches are, in fact, a birdwatcher's nightmare: most islands have a mix of finch species, and the ground finches often hang around together in big mixed-species flocks, looking for all the world like a group of sparrows. But unlike sparrows, the birds don't all take off together—individuals come and go as they want. And after a while the subtle variations distinguishing the species become clearer.

The ground finch group includes two specialist species that are known as cactus finches—their bills can pierce cactus fruit to get at the seeds, and it is this ability that makes the difference between surviving or perishing in a mean year. On Wolf Island the sharp-beaked ground finch has a very specialized feeding strategy indeed in dry years. Sometimes called the vampire bird, it will peck seabirds and drink their blood, and rock and push eggs over ledges in order to break them because its beak isn't strong enough. Once again, beak shape coupled with a clever specialization have given the sharp-beaked ground finch a real "survival edge" over its relatives.

Identifying Galapagos finches can be a birdwatcher's nightmare, if they are feeding in mixed flocks as ground finches often do. Perhaps most puzzling of all are the medium ground finches, whose bills vary in size and shape both individually and between islands. This male medium ground finch (Geospiza fortis), ABOVE, from Santiago is just one of thirteen species of a group known collectively as Darwin's finches. This common cactus finch nest, RIGHT, in an Opuntia cactus on South Plaza Island is typical of most Darwin's finch nests.

The startling blue feet of the blue-footed booby (Sula nebouxii), OPPOSITE, are an important signal during its elaborate courtship display. Three-quarters of the world's blue-footed boobies, ground-nesting tropical gannets, breed on the Galapagos.

Among the five tree finches are the rare mangrove finch and the extraordinary tool-using woodpecker finch. Once it has chosen where to forage, the woodpecker finch moves 50 to 60 feet (15–20 meters) away, chooses a twig or cactus spine and cuts and trims it to size. It then returns to where it was foraging, and uses its newly made tool to winkle grubs out of hollows. The tool enables it to feed in a way its beak would never allow, giving it an edge during tough times. At just over an ounce (34 grams), the vegetarian finch is the largest of the tree finches. It has a cutting beak and is a leaf eater. The warbler finch, which weighs only 8 grams (just over a quarter of an ounce) is the smallest and commonest finch, found on every island in the Galapagos group, yet it looks so unlike a finch that even Charles Darwin found it hard to believe it was one.

Darwin's finches all use dry grass and small twigs to make bulky, cup-shaped nests with roofs and

Galapagos Darwin's Dream Islands

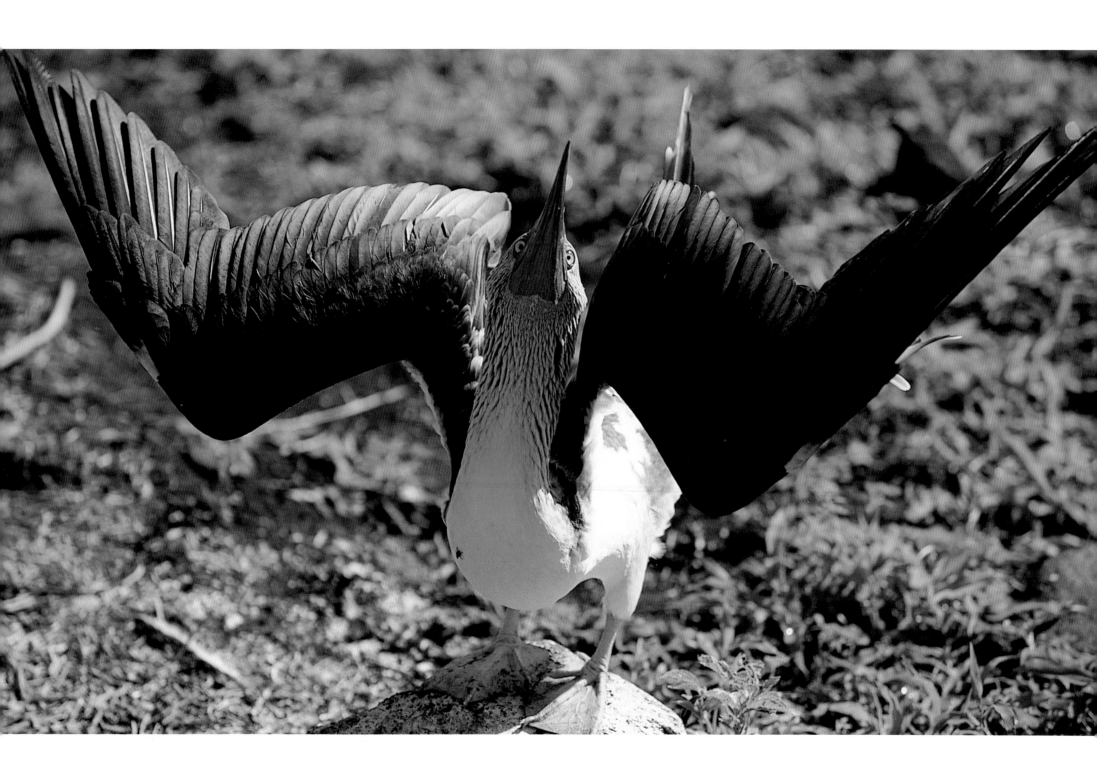

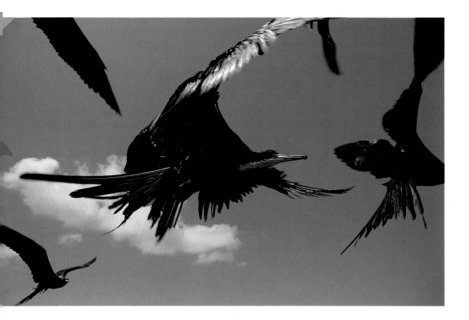

*The magnificent frigate bird (*Fregata magnificens*), or man o' war bird,* ABOVE, *is an aerial pirate which lives by stealing food on the wing from other seabirds. Its light body and long wings give it a very light wing-loading, which enables it to be a very strong and aerobatic flier.*

*The Galapagos hawk (*Buteo galapagoensis*),* ABOVE RIGHT, *is a powerful predator on the Galapagos but its total population probably numbers only around 250 birds. A female holds a large territory and may mate with up to four males, all of whom will help rear her chicks and defend the territory against intruders. The plumage of this young bird will darken as it ages.*

*The swallow-tail gull (*Creagrus furcatus*),* RIGHT, *is the only nocturnal gull in the world. Distinctive large eyes enable it to feed at night at sea on squid and fish that come to the surface after dark. By day a pair display at their chosen nest site on the sea cliffs of North Seymour Island.*

side entrances. Males start building nests as part of courtship rituals to impress prospective mates: they are not above temporarily "borrowing" another finch's nest—even one belonging to another species—to impress females.

Although some of the finer beaked finch species may become locally extinct on low elevation, drier islands during harsh, drought years, they can survive on the more diverse high islands where they can still find a greater range of food, moisture and shade. Here their numbers boom during productive wet years, and their populations soon overflow and disperse back to the low, dry islands. These alternating wet and dry years, and the changing fortunes of the finches, are the result of a weather phenomenon known as the Southern Oscillation. Its best known feature is an extreme event known as El Niño, the Christ Child, named for its appearance around Christmas. On the Galapagos, an El Niño event causes a wet year, which favors the finches.

El Niño events usually occur every four to seven years and the increased rainfall causes tremendous plant growth, and major habitat change. Terrestrial species such as the finches, land iguanas and invertebrates thrive in the more luxuriant conditions. But an El Niño year is bad news for seabirds, marine iguanas and sea lions: thousands die, and in a very wet year up to half of their populations may perish.

The opposite of an El Niño is La Niña, which brings a cold, dry season, referred to by locals as the "garua." La Niña years occur almost as frequently as El Niño years. There is more drizzle than usual, but the heavy rains of the hot season fail completely. In an extreme La Niña year, when rainfall can be up to ten times less than in an El Niño year, the low islands can be badly affected by drought. This opposite weather event has an opposite effect on the wildlife: La Niña is bad news for terrestrial species, but is a bonanza for marine species.

In a normal year—with neither an El Niño nor a La Niña event—westward trade winds blow away from South America, pushing warm surface water towards the west: sea levels in the western Pacific can end up stacked 20 inches (half a meter) higher than in the east. The lower eastern sea levels mean more beach area is exposed around the

Galapagos Islands. With the warm surface water pushed away, upwellings of cold, rich water from the Peru Oceanic Current and the Peru Coastal Current bathe the Galapagos and the western coast of South America. Also at play are nutrient-rich upwellings from the Equatorial Counter Current. All this cold water supports an unexpected wealth of southern species on the equator: albatrosses, penguins, fur seals and sea lions, as well as other marine species such as boobies and marine iguanas, all of which thrive in these normal conditions.

In an El Niño year, the west-blowing trade winds relax and, instead of being blown away, warm surface water accumulates around the Galapagos and South America. This water is clear and sterile, compared with the usual rich, cold water, which is why many of the marine animals suffer. More clouds build up during an El Niño year, and the result is more rain, benefiting the land animals.

As the intertidal areas around the islands warm up, an entirely new species of algae grows. The marine iguanas, that feed on the seaweed growing in normal years, starve because, like the water, the algae is nutrient poor. The iguanas gorge themselves, but even with full stomachs they starve to death. However, during a recent hard year, scientists observed a few

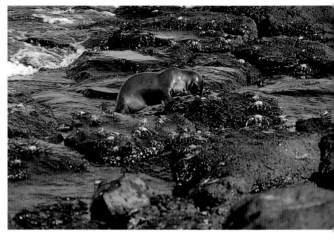

*The Galapagos sea lion (*Zalophus californianus wollebacki*) is a small subspecies of the Californian sea lion, but a full-grown bull can still reach 660 pounds (300 kilograms) in weight. Here a youngster on South Plaza plays amongst the Sally Lightfoot crabs,* ABOVE, *while a bull rounds up a cow and her pup in the shallows of Bartolome Island,* LEFT.

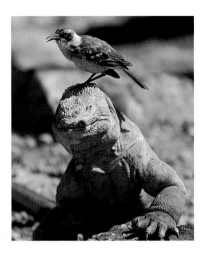

marine iguanas on Seymour Island eating the salty succulent leaves of the shore iceplant, a habit they have continued. This food shift is an example of evolution in action—of individuals adapting to changing circumstances. If the adaptation confers a survival advantage, then those individuals will thrive, produce more offspring and in time their behavior will become the norm rather than the exception.

Terrestrial plants that are well adapted to drought years are the *Opuntia* or prickly pear cactus.

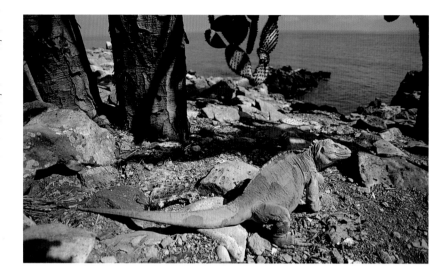

They store water in spongy pads that probably evolved from stems, and are protected by spines that evolved from leaves. On the northern-most islands where there are no tortoises or iguanas, the *Opuntia* have soft spines. Their bright yellow flowers and fruit are a favorite food of the cactus finch.

Fourteen unique forms of *Opuntia* are found on the Galapagos, and they vary widely between islands. The *Opuntia* on North Seymour is a shrub that grows to about 16 feet (5 meters). On Santa Cruz it is a giant tree that can reach 50 feet (15 meters). On Santa Fe these trees have huge girths, with trunks over 3 feet (up to a meter) across. Like the tarweeds in

*Two endemic species of land iguana are found on the Galapagos—*Conolophus pallidus, ABOVE *and* ABOVE RIGHT, *lives only on Santa Fe, while* Conolophus subcristatus, BELOW, *lives on six islands. Land iguanas are vegetarians. They particularly like yellow cactus flowers, and are often attracted to tourists wearing bright yellow clothing. Like many Galapagos animals, land iguanas are confiding, and are particularly tolerant of finches and mockingbirds, which often clamber over them in search of ticks.*

*Marine iguanas (*Amblyrhychus cristatus*) are widespread around the coast of the Galapagos, and although there is only one species, tremendous variety occurs between islands. Male iguanas found on Espanola,* OPPOSITE LEFT, *seen here sharing the rocks with a sea lion and a Sally Lightfoot crab, are a distinctive turquoise and tomato red during the breeding season. On other islands the best color breeding males can muster is a dull blackish-brown,* OPPOSITE RIGHT. *Marine iguanas spend a lot of time basking on the sun-baked volcanic rocks to warm up after feeding dives in the cold water.*

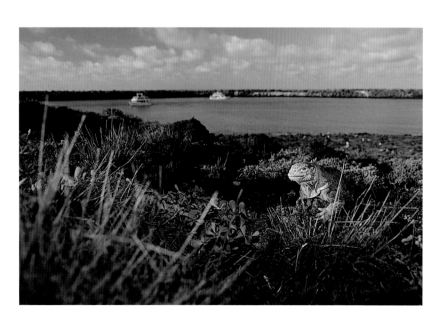

Hawaii, a single small cactus on the Galapagos has evolved in diverse ways to become many kinds of island giants.

Opuntia may have become giants as a result of competition with other plants, but the more traditional explanation is that it was their way of avoiding being browsed by giant herbivorous tortoises. During tough times the tortoises eat the pads of all the forms of cactus, oblivious to even the fiercest spines. Land iguanas also feed on cacti, eating the pads, flowers, and fruits. To remove the spines they roll the fruit around on the ground using

Galapagos Darwin's Dream Islands

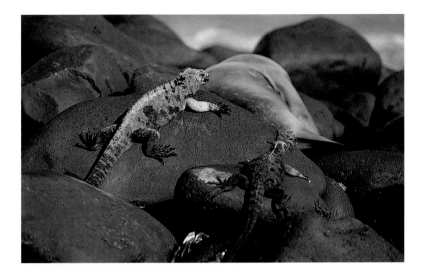

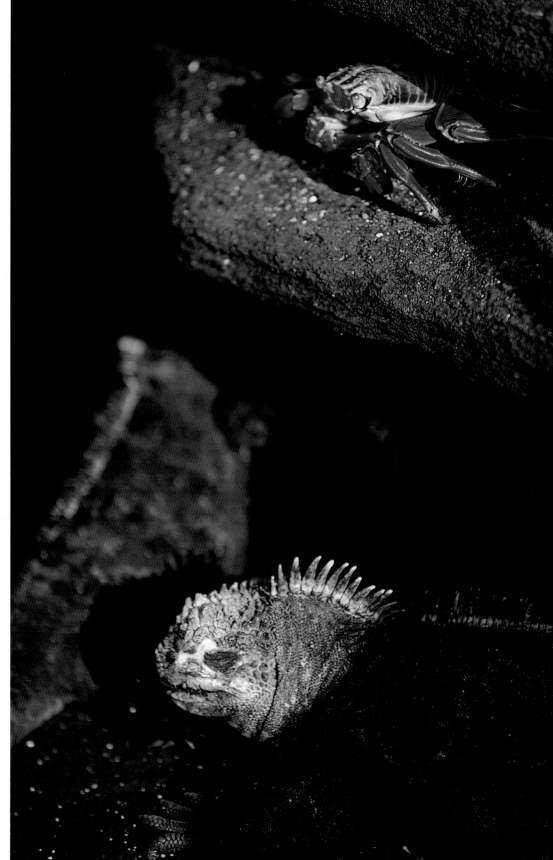

their front feet. They are also very tuned in to the sound of fruit falling from a cactus: when they hear one drop, the smarter individuals make a rapid beeline for it.

The ecosystem of the Galapagos Islands is very unusual: the top herbivores are all reptiles. Perhaps this came about because, like Fiji's iguanas, reptiles have a number of features that make them well-equipped ocean travelers: they have dry, waterproof skin, they can survive long periods without drinking fresh water, and iguanas in particular can excrete excess salt.

There are twenty-one species of reptile on the Galapagos. Once there were fourteen different island forms of giant tortoise, two kinds of land iguanas, and the marine iguanas (which seem as if they are evolving separate traits on different islands—some are small and some large, and others have brilliant courtship colorization). All the iguanas evolved from a single ancestral species, and past periods of hardship have led to specialization. The marine iguanas began to feed on marine algae, diving and walking around underwater, and using their tails to swim; in contrast, land iguanas evolved to rely on cactus.

Of the fourteen forms of tortoise, several are now extinct. Giant tortoises, which can weigh up to 600 pounds (270 kilograms) in the wild, have two extreme kinds of carapace shape: dome-shaped and saddleback. The islands are, in fact, named after the saddleback tortoise: the Spanish word "Galapagos" describes a riding saddle with a high pommel.

The low arid islands have harsh vegetation with no dense undergrowth and suitable leaves to browse are often high up on bushes, but the saddleback

CHARLES DARWIN

On 15 September 1835 Charles Darwin arrived at the Galapagos Islands from South America, on board the *HMS Beagle*. He would spend just five weeks there, visiting four of the islands—San Cristobal, Santiago, Floreana and Isabela—but his brief experience in the archipelago would help him immensely in the development of his novel ideas about evolution. He was impressed by the complex world he found in these tiny islands, and deduced much about their formation and the biology of its plants and animals. He collected a number of finches, without realizing how many species there were—it was only later that the ornithologist John Gould looked at his specimens and was able to discern that they included a number of different species.

Fourteen years after his trip to the Galapagos, Darwin published his theory of evolution in *The Origin of Species*. The book was a controversial best-seller that sold out on its first day of publication. In it Darwin provided evidence for plausible mechanisms that could cause species to change, a process he termed natural selection. Darwin realized the importance of variation between members of the same species, and recognized that even subtle differences, such as the shape of a bird's bill, can have a huge impact on an individual's success. He saw that even minute differences between two individuals might be the difference between thriving or dying. He also argued that favorable adaptations were more likely to be passed down through generations. Subtle variation that helped an individual to be better equipped for its habitat or lifestyle meant it was more likely to breed successfully. This advantage might in turn be inherited by its offspring and, gradually, over many generations acquired by the whole population. In this way, natural selection at work on individuals could eventually lead to evolution over generations.

Although Darwin's name is synonymous with the Galapagos Islands, he never actually visited Bartolome Island, home to the island group's best-known view, at Sullivan Bay, a popular destination for tourist boats.

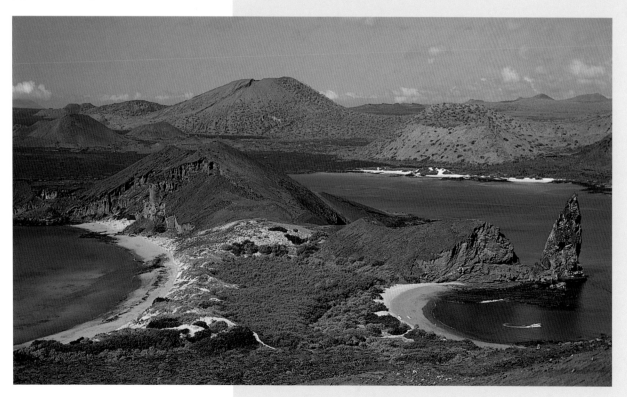

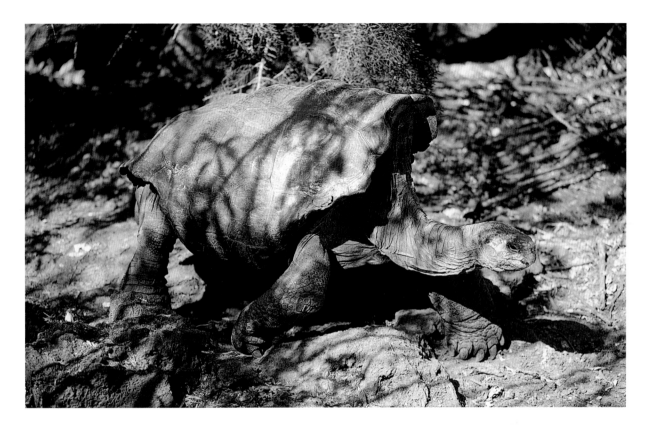

On the drier islands of the Galapagos the tortoise's shell is greatly modified at the front to allow the animal to stretch high into trees to feed during a drought. It is this form of shell which gave the saddleback tortoise (Geochelone elephantopus hoodensis), LEFT, and the islands their Spanish name: Galapagos, referring to the high pommel of a riding saddle.

On the larger, moister islands, tortoises with dome-shaped shells grow much larger and heavier than their saddleback cousins. Despite its gigantic size, a Galapagos tortoise (Geochelone elephantopus vandenburghi), BELOW LEFT and BELOW, is a gentle giant.

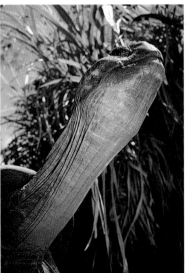

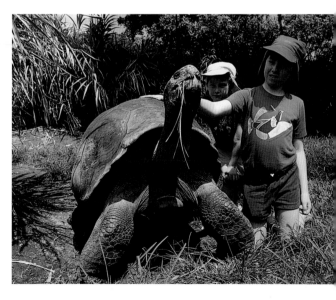

tortoise has evolved a raised front to its shell so it can stretch up its neck and head, like a giraffe browsing high leaves. The soft exposed skin on the back of the neck doesn't need to be protected because there is no damaging undergrowth and no predators exist. However, there is intense competition for food and shade—perhaps this is why saddleback tortoises are very aggressive with one another. When two males meet, they will push their front legs up, stretch their necks and open their mouths. This ritualized encounter involves no fighting: the taller one wins. He wins because he can reach higher into the food trees and is therefore better suited to survive, especially in times of hardship when food is hard to find.

The dome-shaped tortoise is the true giant—it lives on the higher, moister islands, and is the world's biggest, heaviest tortoise. The front of its carapace curves down over the back of the neck, and protects the head and delicate skin as it barges like a small tank through dense low undergrowth. Compared with the saddleback it is very docile, except during mating disputes when one may barge into another like an oversized water barrel.

As a rule, Galapagos tortoises respond to strangers very differently than continental tortoises, which have to deal with a whole suite of enemies. If something approaches, rather than withdraw like most other tortoises, a Galapagos dome-shaped tortoise stretches its head up and out, and stands up on its toes, as if greeting a friend. What it is doing is inviting finches and mockingbirds to pick ticks off it. As tourists to the islands will tell you, this fearlessness is characteristic of a number of other Galapagos animals and is a trait that is also shared with other species on many other islands.

Unfortunately, early nineteenth-century visitors to the islands realized that the tortoises were good eating, were a usefully large size and could be kept alive on long boat journeys until they were needed. Fresh meat was hard to find in the days before refrigerators and deep freezes, so tortoises were at a premium. All the species of giant tortoise were hunted and many are now extinct.

The tortoises were not the only island species to suffer in this way. The dodo was also hunted for fresh meat. As has so often been the case, when fearless island species encounter humans the result is often extinction.

A view across Puerto Ayora harbor on Santa Cruz Island is framed by a sculpture of a waved albatross, ABOVE. Santa Cruz is one of five inhabited islands in the Galapagos, and has the highest immigration rate—the permanent population has increased fourfold since 1980, and is still growing rapidly.

Standing as tall as forest trees the giant Opuntia *cactuses (*Opuntia echios var. barringtonensis*), RIGHT, of Santa Fe Island are thought to have evolved bare, tree-like trunks in order to protect their fleshy pads from browsing giant tortoises and land iguanas.*

*Two brightly colored Sally Lightfoot crabs (*Grapsus grapsus*), OPPOSITE, scamper across the volcanic rock of a wave platform on Espanola Island. The detritus-feeding crabs are the most obvious crustacean in the Galapagos, and are named after a Caribbean dancer, from their habit of leaping gracefully from rock to rock.*

Today, one Galapagos tortoise species is represented by a single individual, an old male called Lonesome George. Lonesome George is from the island of Pinta, but since 1972 he has been kept at the Charles Darwin Research Station. Scientists have tried in vain to get him to mate with females from closely related species, but Lonesome George is an aggressive male saddleback tortoise and won't tolerate other tortoises, even females. Given his behavior he seems doomed to lead a long and lonely existence, and when he dies his species will die too. He is a sad symbol of all that can go wrong when an island is ransacked by humans and its delicate balance of life upset.

People involved in groups such as the Charles Darwin Foundation, however, have not given up hope that somehow they will come up with a technique or method that will allow them to breed from Lonesome George and ensure the survival of his species. The odds are not great, but they're better than nothing. And although giant tortoises may not be the great reptile rulers of the Galapagos Islands they once were, on the island kingdom of Komodo a different giant reptile still reigns supreme.

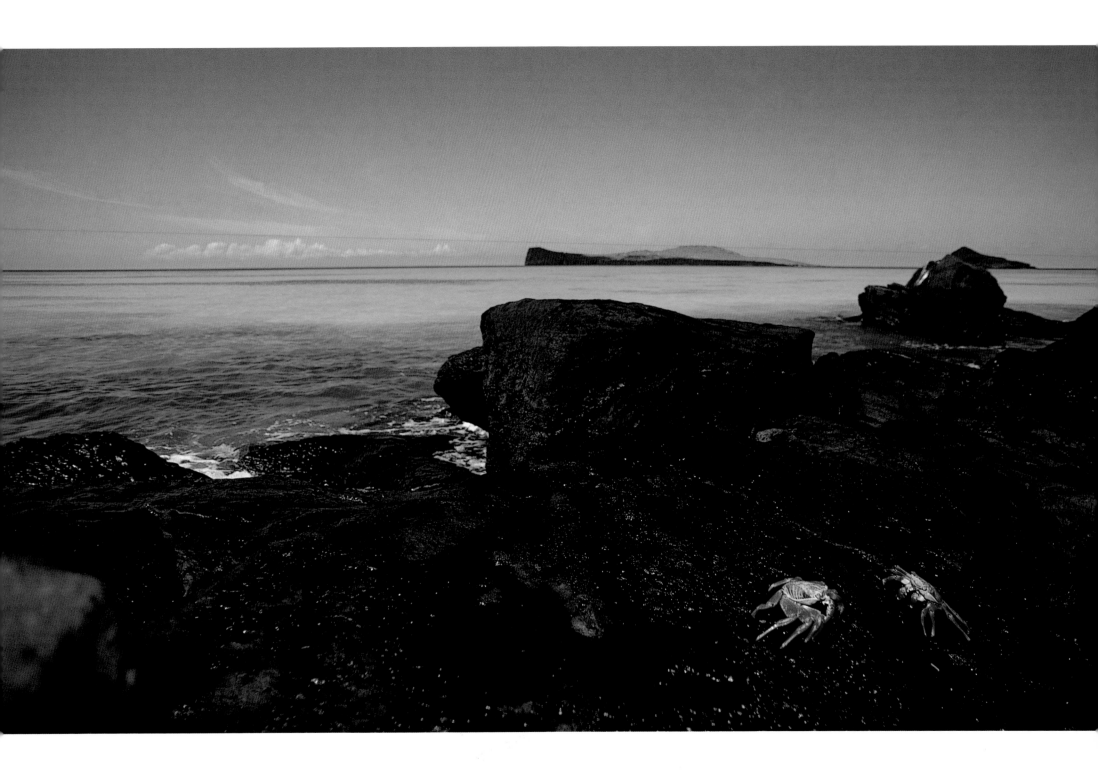

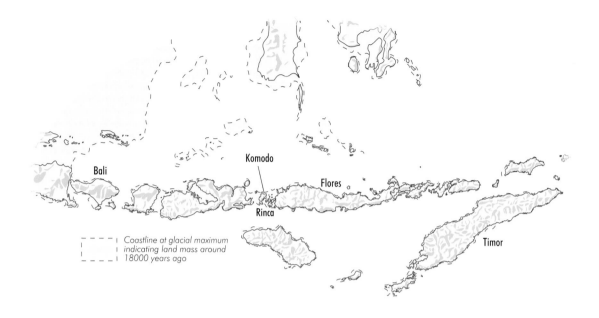

Komodo
Dragon Island

Bali

Komodo

Flores

Rinca

Timor

Coastline at glacial maximum indicating land mass around 18000 years ago

One of the more commonly encountered reptiles on the island of Komodo is the tokay gecko (Gekko gecko) RIGHT, an inhabitant of buildings as well as the savannah forest. Tokay geckos are very vocal animals— both day and night they make a distinctive repeated "to-kay" call.

The large monitor lizard Varanus komodoensis, *OPPOSITE, easily lives up to its common name of "dragon"—this male is over 9 feet (over 3 meters) long. Although not poisonous, its mouth contains a lethal brew that is part saliva, part bacteria and part decayed food, which combine to infect any wound the dragon inflicts. Dragons often produce copious quantities of saliva when they first sight their prey.*

HALFWAY ROUND THE WORLD from the Galapagos Islands, but still almost on the equator, is the island of Komodo in the Indonesian archipelago. This chain of islands is volcanically very active, and every twenty or so years an eruption covers the islands in clouds of ash. Komodo is very dry: the Asian monsoon runs out in Java and Bali to the west, long before it reaches the island. It can be a hot, harsh place and, like the Galapagos, it's a place where reptiles do well. Although its giant land tortoise was hunted to extinction by humans, Komodo still has thirty or so species of

reptiles that thrive in the heat. *Cryptoblepharus* skinks leap among the crabs and crashing waves down by the shore, and tokay geckos lurk among the rafters of houses. Tiny male flying lizards, *Draco volans*, known as dracos, glide from tree trunk to tree trunk when they feel threatened. There are about ten species of snakes, including highly poisonous vipers and cobras, sea turtles that come ashore at night, and even the occasional visiting crocodile.

The top plant eaters on the Galapagos are reptiles, but that honor on Komodo and nearby Flores Island used to belong to mammals. The Stegodonts were two species of elephants: one a pygmy the size of a water buffalo, the other nearly

72

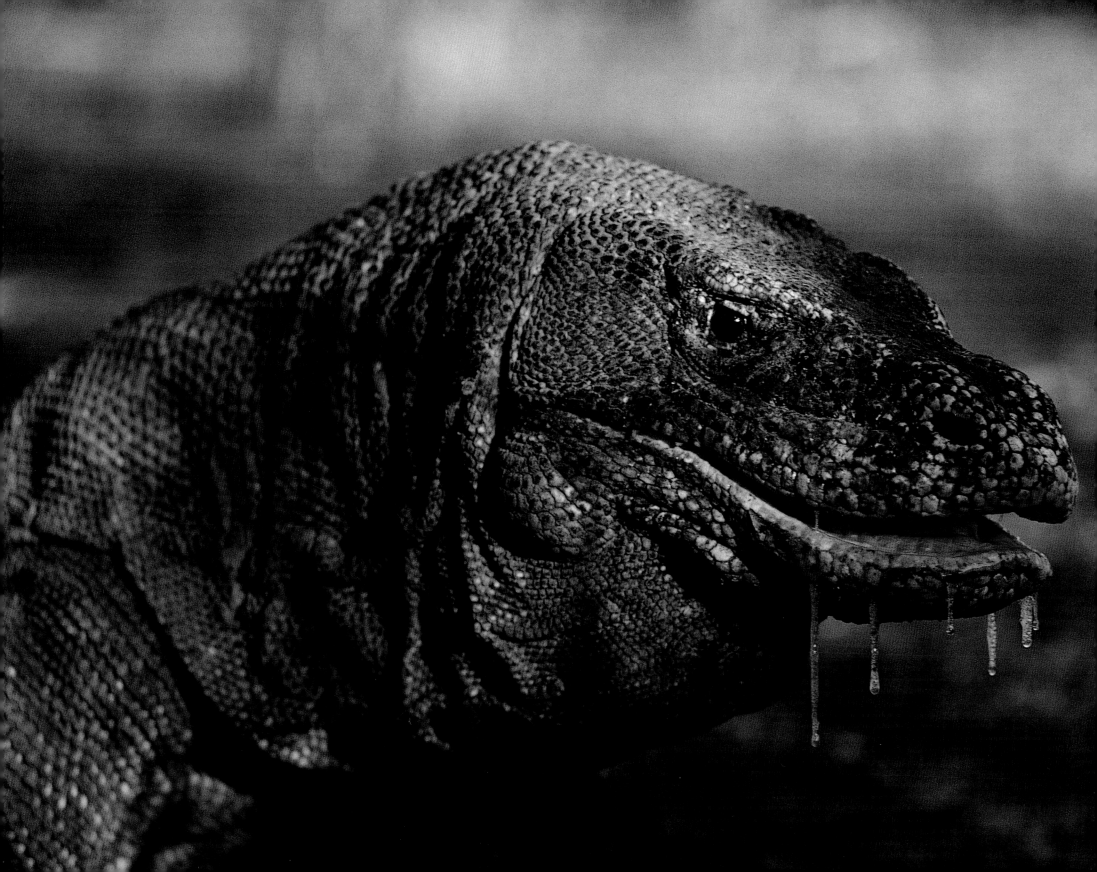

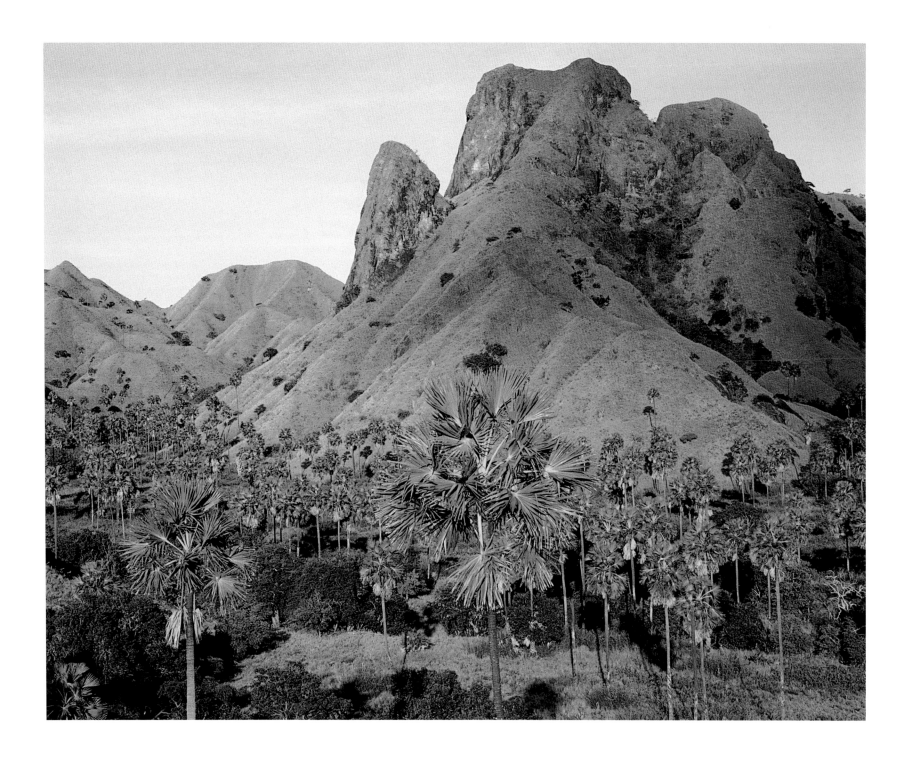

Komodo Dragon Island

full-sized. As so often happens on islands, island magic made the animals here shrink or grow in unexpected ways—the dwarf elephant lived alongside giant rats the size of small pigs. Both elephants are now extinct, but there are still ghosts of the disappeared to remind us that they once lived here and helped to shape their island home. A species of bamboo still sports 3-inch (8-centimeter) long spines at its base: perhaps they once served to deter browsing Stegodonts.

The limited resources of their island home may have driven the evolution of the elephants, favoring small individuals needing less food. But they were still big prey, worthy of a big predator. Indeed, this is what sets these unusual ecosystems apart from any other.

The top predator on the islands of Komodo, Rinca, Flores, Gili Dasami and Gili Motang is a giant lizard: the Komodo dragon (*Varanus komodoensis*). Their elephant prey is long gone, but the humans who probably hunted the elephants to extinction replaced them with deer, pigs, goats and buffalo, allowing the dragons to maintain their place as rulers of these island kingdoms. The story of Komodo really is the story of the world's largest lizard.

There are many reasons why being a big carnivorous reptile on a small island makes sense. Like Fiji's iguanas, the dragons are good dispersers. But that alone isn't enough to explain why, for example, tigers aren't the top predator on Komodo, when they once occurred on the island of Bali, not that far away. It is much more energy-expensive being a warm-blooded mammal relying on food to power a complex metabolism than it is to be a more thermally efficient reptile that draws its warmth from the sun. A Komodo dragon can get away with eating much less than a similar sized mammal—it needs only about one-tenth the food—and it can survive remarkably long periods without eating at all. Biologist Walter Auffenberg, the first person to study the dragons, once followed a dragon for eighty-one days, and in all that time it only killed and ate twice. This is an ideal strategy for an uncertain environment where periodic volcanic eruptions and frequent fires can destroy large areas of forest. The dragon is an excellent scavenger as well as a hunter, and it does well out of the death that accompanies the destruction. It can smell a dead animal from 2½ miles (4 kilometers) away.

The little fishing village of Komodo, ABOVE, *is frequently visited by dragons from the interior, particularly when the squid fishers spread their catch on the beach to dry. For many years a carver named Haji Nuhung,* LEFT, *from the village of Komodo, has specialized in carving life-like dragons for sale to tourists.*

The Komodo dragon inhabits dry monsoon forests and open savannah, OPPOSITE, *sprinkled with lontar palms (*Borassus flabellifera), *where it hunts Rusa deer, wild boar and occasionally feral buffalo. This coastal lowland forest is at Loho Kalo, on Komodo Island.*

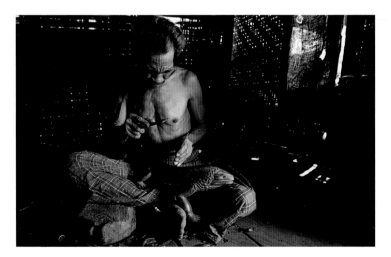

In the past it has also done well out of human deaths. Dragons have not only killed the occasional person, but they have an unpleasant habit of raiding graves. The villagers who live on Komodo and Rinca, however, have learnt to take their dragon neighbors into account and have moved their cemeteries away from sandy ground to hard clay ground. Piles of rocks on top of the graves are another deterrent.

On Komodo, the villagers and the dragons live alongside one another pretty well. The fishing village is at the back of the beach, facing out to sea, which is where the

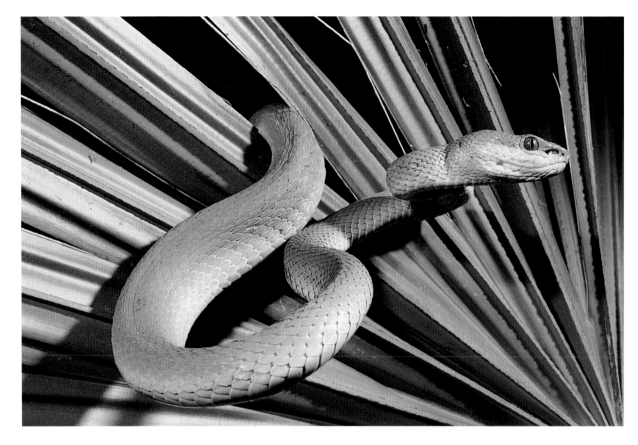

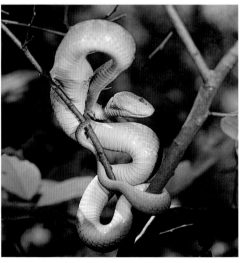

An easily overlooked but rather beautiful inhabitant of Komodo is the striking yellow Komodo tree snail (Amphidromus laevis), ABOVE. It is one of several brightly colored species that can be found on foliage in the wet season.

The green bamboo viper (Trimeresurus albolabris), RIGHT, is a common poisonous snake in the savannah woodlands but is more frequently encountered during the wet season. A high proportion of Komodo's green bamboo vipers are blue, instead of the usual green, ABOVE RIGHT.

villagers make their livelihood. Goats and chickens roam freely around the stilt houses: the villagers have learnt from experience that their domestic livestock need to be able to escape out of the way of dragons, which occasionally come into the village to raid squid left out to dry in the sun. But most of the time the dragons avoid humans, and remain in the dry woodlands and savannah grasslands of the island's interior.

Not everything is stacked in the dragons' favor, however. They spend their lives walking a precarious thermal tightrope: too cold and they can't move; too hot and they will die. The dragons' day begins sluggishly with a bask in the morning sun to warm up. The challenge is to anticipate when it might begin to be too hot: because of their huge body mass, their temperature continues to rise for a while even after they have moved out of the sun. Even though they can operate at temperatures greater than a mammal can, if they delay moving into the shade too long they risk being cooked.

Komodo Dragon Island

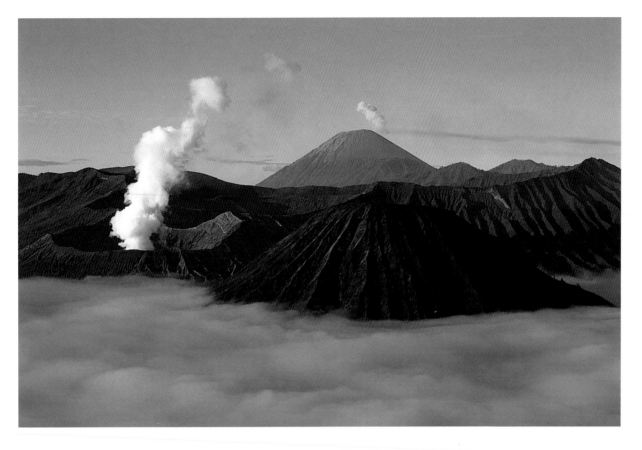

Mount Bromo at first light, seen from the edge of the Tengger caldera (volcanic crater) in eastern Java, LEFT. *Volcanic activity is frequent in the Indonesian archipelago, and like many islands Komodo is often dusted by volcanic ash, which kills plants and stresses large herbivorous animals. For predatory scavengers like the dragons such times are a bonanza.*

*Matius Ndapawunga, a ranger from Komodo National Park, proudly holds two freshly hatched wild Komodo dragon babies (*Varanus komodoensis*),* BELOW. *He is kneeling in a freshly dug burrow with discarded egg shells in the foreground.*

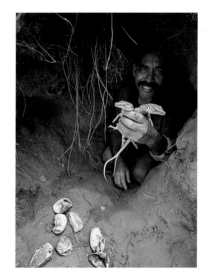

Dragon thermoregulation is behavioral—they cool off by moving into the shade. This contrasts with mammals which self-regulate their temperatures internally. Dragons often favor sites in the shade of trees on ridges that catch a cooling sea breeze. These resting places, which are well marked with droppings and are scraped clear of vegetation, serve a dual purpose: they are also strategic spots from which to ambush passing deer.

At night the dragons have to conserve body heat, and animals will often pack themselves into a tight burrow, out of the wind, with the soil acting as insulation to trap stored body heat. This is a very efficient system—a big dragon that has spent the night in a burrow can start the morning with a 9°F (5°C) temperature advantage over one that has slept in the open. At other times the dragons just go to sleep wherever they find themselves at the end of the day. Animals that spend the night in open grassland, for instance, are well positioned to catch the first rays of sun the next morning. The dragons' inability to function during the cool of night makes the night forest a much safer place for potential prey such as deer and Sunda porcupines, and the largest mammalian predator on the island—a species of civet the size of a house cat.

Patience is a virtue with which dragons are well endowed. They can rest almost motionless in the same shady spot for hours, just waiting for the right moment. Prey such as deer or buffalo are gradually lulled into a false sense of security, feeding closer and closer to the waiting dragon. When they do decide on action the dragons move surprisingly fast—they

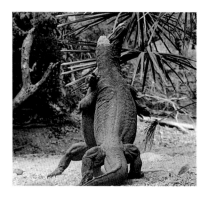

*Two rival male komodo dragons (*Varanus komodoensis*) fight over the right to mate with a female during the breeding season,* ABOVE. *If they are evenly matched in size, as these two giants are, a fight may culminate with the two rivals standing up on their hind legs like sumo wrestlers. Such contests are rare and dangerous for the contestants. Should one of these animals fall awkwardly, the fallen dragon could easily dislocate a shoulder and become crippled for life. Such injuries are often a death sentence.*

A Komodo dragon emerges at dawn from its sleeping burrow on the banks of a dry riverbed, ABOVE RIGHT. *Dragons that sleep underground on cold or windy nights stay warmer than those that sleep in the open, and this allows them to be active earlier in the morning. Several male Komodo dragons gather in a forest clearing at Banung Gulung to catch the early morning light,* RIGHT. *Dragons are dependant on their surroundings for much of their warmth, and throughout the day they will move between sunlit and shady areas to regulate their body temperatures.*

While dragons are capable hunters, some individuals scavenge a high proportion of their diet by beachcombing. They possess such a keen sense of smell they are able to locate carrion from several miles away—these two adults, OPPOSITE, *have tracked down the decaying carcass of a rusa deer.*

lunge for a leg or the belly, using serrated teeth to rip at the flesh. A dragon is capable of killing a buffalo that is much larger than itself: all it needs to do is bite a hamstring, then back away to wait. The dragon doesn't have to kill its prey—bacteria which thrive in bits of rotten meat caught in its teeth make its bite notoriously infectious. An animal that is bitten will usually die of infection. All the dragon has to do is follow and let nature take its course.

Low to the ground and with only average eyesight, dragons rely on an acute sense of smell to track their prey. Their forked tongues whisk air past Jacobson's organs in the roof of the mouth, allowing the dragons to analyze the air for scent. Effectively smelling in stereo, dragons can tell exactly where their dying prey has wandered. It's a tracking ability rivaling that of a bloodhound. This "strike-then-wait-patiently" strategy works because there are no other large scavengers on Komodo: on a continent the dragons would lose their dying prey to vultures or hyenas.

One of the most memorable things about Komodo dragons is their eating style. Absolutely nothing goes to waste—a mammal such as a leopard will manage to eat only about two-thirds of its kill, but the only bits a dragon won't touch are the vegetable contents of the stomach and intestine. They are big on speed and low on manners: food is gulped, before any other dragons can steal it, using mouths that are hinged like clasp handbags and can open really wide. The first dragon we ever saw having dinner was eating a goat. We arrived only a few minutes after it had begun, but it was already swallowing the goat whole, head first, horns and all. However, it had bitten off more than it could chew—the legs and back half of the goat were sticking out, and as it stood there trying to swallow more, a small dragon climbed onto its shoulder and began to rip small bits of meat right out of the dining dragon's mouth. The big one began to shake its head violently from side to side until eventually the goat snapped in half, leaving a grotesque funnel of ribs sticking out. The dragon crossed to a tree and began to ram the ribs against the trunk, forcing the goat further down its throat. When it had pushed it in as far as it could it went to sleep, still with its mouth wide open and full of goat ribs. After a few hours when its digestive juices had begun to eat away the goat's head it moved back to the tree to ram more of the meal in. The dragons are so forceful they've even been known to push over trees.

They can eat enormous meals in startlingly short periods of time: a 110-pound (50-kilogram) dragon can consume a 66-pound (30-kilogram) pig in just fifteen minutes. Blessed with a

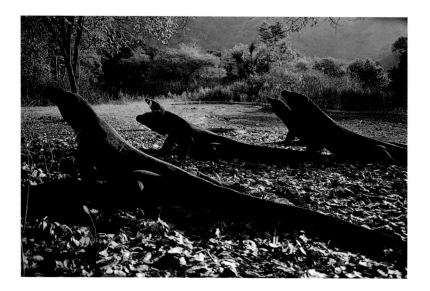

Komodo Dragon Island

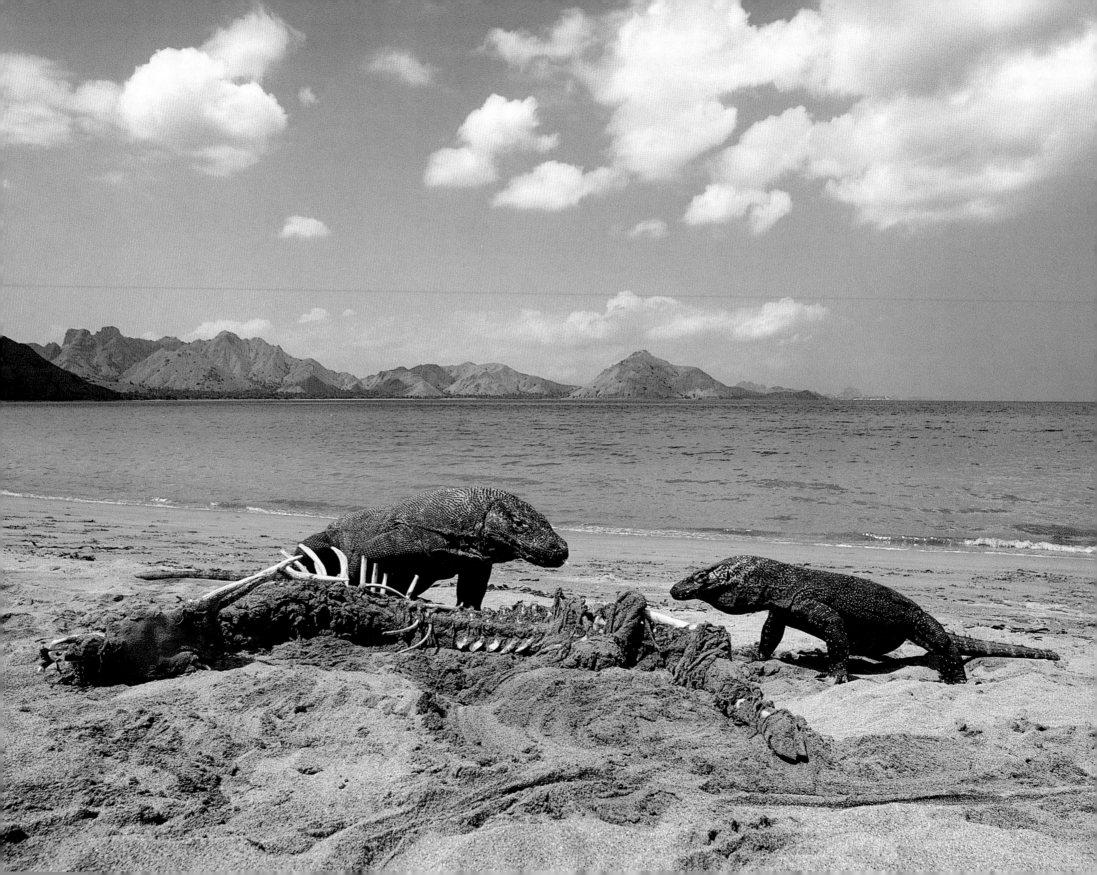

Although they are modern lizards, the Komodo dragon's style of hunting and feeding on prey larger than itself is reminiscent of the carnivorous dinosaurs, ABOVE *and* ABOVE RIGHT. *Dragons are the only lizard capable of carving large prey into manageable chunks, some of which are still so large they require force and patience to consume. Dragons have jaws that hinge like a clasp handbag, allowing this male to engulf the entire foreleg of a water buffalo.*

A female Komodo dragon excavates her nest in a large megapode mound, BELOW RIGHT. *Such mounds are among the few places a female can dig a burrow several feet below the surface where her eggs will be safe from marauding males that would eat them if they found them. Such sites are in high demand, and the largest females frequently fight over ownership.*

Water monitors (Varanus salvator togianus), OPPOSITE, *are widespread, ranging across Asia from Bengal to the Philippines and Indonesia and while found principally in humid forests and along riverbanks their tolerance of salt water readily explains their wide geographic range. Because it is hunted by the Komodo dragon, on the island of Komodo the water monitor lives only in the mangroves.*

capacious, distensible stomach a Komodo dragon can easily eat a meal that is 80 percent of its own body weight in a single sitting.

Another extraordinary feature of Komodo dragons is their courtship rituals, which take place in July and August. Male Komodos, which can reach over 9 feet (3 meters) in length and weigh more than 150 pounds (up to 70 kilograms), chase each other and fight dramatic battles in real-life Jurassic Park struggles. Two opposing males will rear up on their hind legs and wrestle like sumo wrestlers, each trying to use his bulk and strength to twist and push over his opponent. At battle's end the victor lies at right angles across the loser, noisily raking his long claws across the other's back as a symbol of his victory. Once rivals are dealt with he may then begin to follow a female. She can be over 6 feet (up to 2 meters)-—only the largest male will be able to overpower her and pin her to the ground to mate.

Until we filmed on Komodo no one knew for certain where the females laid their eggs. Walter Auffenberg, the one biologist who had done research on dragons, suspected they nested on steep hillsides that would be too difficult for the cumbersome males to reach. One September we used radio telemetry to track three female dragons and made an unusual discovery: all three nested in mounds belonging to megapode birds. The chicken-sized birds dig over huge, friable heaps of dirt to incubate their own eggs, and in their off-season female dragons use the mounds as well, burying their eggs 3 to 6 feet (1–2 meters) below the surface, at the end of 6- to 13-feet (2- to 4-meter) long tunnels. The mounds appear to be particularly valuable nesting real estate for female Komodos.

A female dragon guards the nest mound for three months after she has laid, defending it against humans, pigs, deer and other dragons, even large males. She'll chase away males and other gravid females trying to take over her nest site, and these chases can last well into the night. After she has seen off any intruders she goes into a frenzy of digging. By the time she finishes, the mound is pock-marked with a confusion of fake nest holes, making it unlikely that anything could locate and destroy the eggs. Eventually the female must leave the mound to feed, by which time rain has usually fallen and obliterated

Komodo Dragon Island

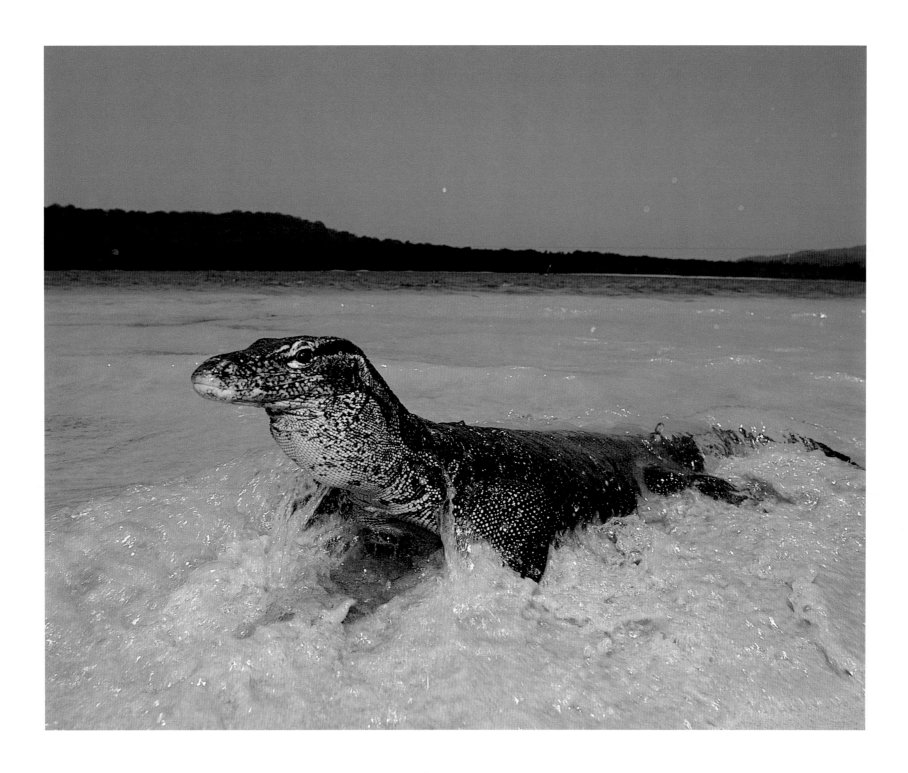

Komodo Dragon Island

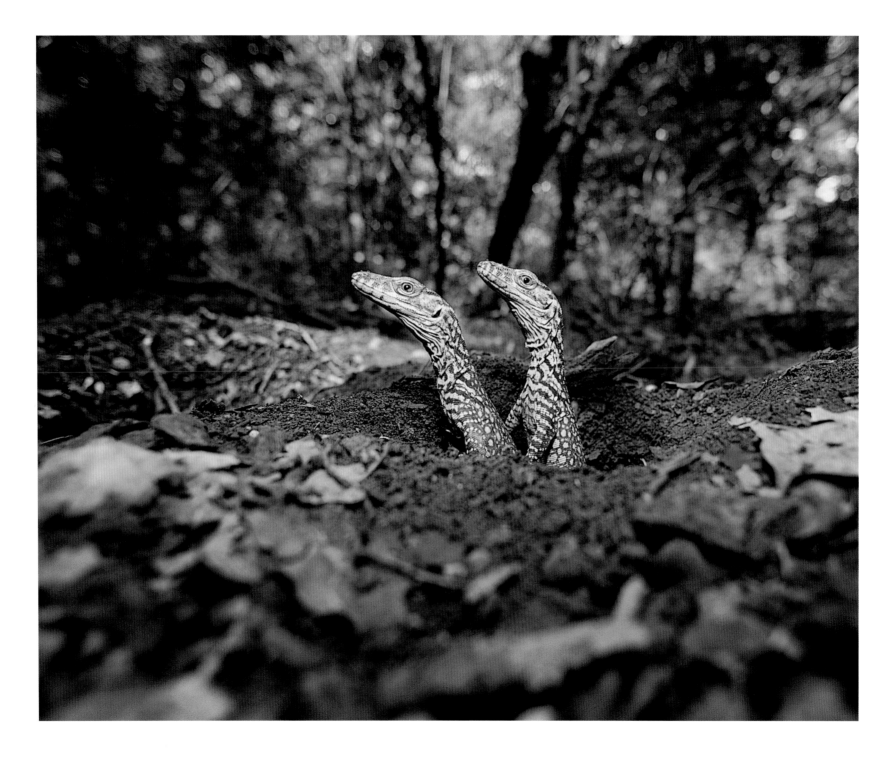

Komodo Dragon Island

all evidence of the eggs. They are on their own until they hatch more than seven months after being laid. Nearly thirty babies will hatch from a single nest, and at 16 inches (40 centimeters) long they are already larger than most of the world's lizard species. Born with teeth as sharp as razorblades, they are competent predators from day one. They go straight up trees, and stay there for up to six months hunting lizards and grasshoppers and raiding birds nests.

After six months they return to the ground. Now the size of monitor lizards, they hunt rats and snakes as well as lizards and grasshoppers, but they have to be very wary—they are at risk from adult dragons who would happily snack on them. If they are brave enough to join big adults around a carcass they will often roll in its discarded gut contents, because fecal material is one thing dragons are programmed not to eat. The young ones can't possibly gulp whole parts of beasts the way adults do, but they will gnaw at little bits of meat and snap at flies, as do the rest of the world's lizards. It is only large, fully grown dragons that have the distinction of being the sole living reptiles able to consume prey much larger than themselves. Unusually, these modern lizards share this distinction with long extinct, great meat-eating carnosaurs such as *Tyrannosaurus rex*, which also carved their much larger prey into bite-sized chunks.

As huge and mighty as Komodo dragons are, they are not the largest lizard that ever lived. That honor belongs to *Megalania*, which survived in Australia until about 20,000 years ago, and may have been a staggering 20 feet (6 meters) long. Both *Megalania* and the Komodo dragons belong to a group known as monitor lizards. Despite their dinosaur-like appearance they are relative newcomers—their evolutionary history goes back only twenty-five to forty million years. Like mosasaurs to which they are related, monitor lizards are efficient swimmers: water monitors, which also occur on Flores and Komodo, can stay submerged for more than ten minutes. Dragons are also strong swimmers, although they most likely reached Komodo and Flores by walking from a much larger island such as Timor during glaciations, when sea levels would have been much lower than they are today.

Komodo dragons have the most limited distribution of any of the world's big predators, although they were probably once more widely distributed. Only an estimated 3500 or so dragons exist on the four islands and thirty islets that make up Komodo National Park, with 1700 of those found on Komodo itself, although up to two thousand dragons may live on Flores. Surprisingly rare for such a famous animal, at least they are well-known. On another Indonesian island nearby—Sulawesi— the top predator is a seldom heard of beast.

A yellow-crested cockatoo (Cacatua sulphurea parvula), ABOVE, *may seem out of place on the Indonesian island of Komodo. However, Komodo is just one of several islands lying in the biogeographic region of Wallacea, at the edge of Asia, where Australasian species such as the cockatoo mingle with Asian plants and animals.*

When they first emerge from their eggs, which are the size of large potatoes, hatchling Komodo dragons are boldly colored and marked, LEFT. *By lizard standards they are already giants, 16 inches (40 centimeters) long and capable of inflicting a nasty bite with their razor-sharp teeth.*

Alert to the dangers of the surrounding forest, two wild Komodo hatchlings pause at the entrance to their nest, OPPOSITE, *before dashing across the open ground to climb the nearest tree. For the next few months they will live and hunt in the canopy, feeding on insects and small birds, safe from dangers such as hungry adult dragons on the ground.*

Sulawesi
Between Two Worlds

Borneo
Philippines
Wallace's Line
Manado
Palu
Sulawesi
New Guinea
Ujung Pandang

The ornate lorikeet (Trichoglossus ornatus), RIGHT, *is the most flamboyant of Sulawesi's nine species of parrots. It is one of only three nectar-feeding parrots here—the remainder all eat seeds. Parrots may pollinate flowers and feed on fruit, but with their hooked beaks they frequently crack and destroy more seeds than they disperse.*

One of the world's least known carnivores, the giant or Sulawesi palm civet (Macrogalidia musschenbroeckii), OPPOSITE, *is the largest predatory mammal in Sulawesi's forests. Despite its ferocious appearance this meat-eater enjoys a rich diet of fruit. This male consumes a palm fruit with its head tossed back so it doesn't spill any of the juice.*

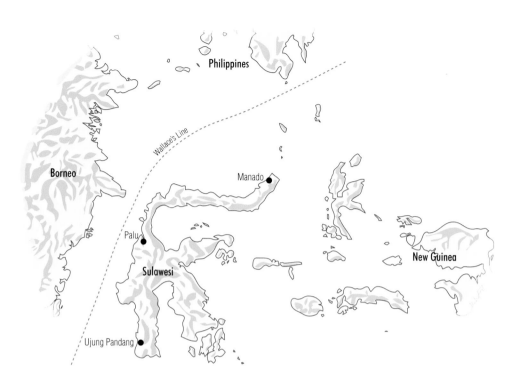

NO REGION BOASTS more islands than Asia—Indonesia alone has more than 13,000. Some, like Anak Krakatau off the western end of Java, are brand new and still very raw. Others have a much more venerable history: the sprawling, many-fingered island of Sulawesi, for instance, is at least 25 million years old and one of the oldest islands in Asia.

Sulawesi is the perfect illustration of the idea that islands truly are crucibles of life, where the alchemy of island magic can create amazing transformations from basic ingredients. It also highlights how different islands can end up with surprising variations on old themes. Whereas the top predator on Komodo is a lizard, on Sulawesi it is a fruit-eating mammal—the giant civet. The elusive giant civet is an ancient relict, related to Madagascar's fossa, as well as weasels and mongooses. Civets are an early line of predators that were once found throughout the world, but they have mostly given way to "improved" modern predators—big hunters such as lions and wolves. Today most continents have a modern cat or dog as top predator, but on islands that role can be taken either by more primitive mammals, reptiles such as the Komodo dragon, or even birds such as the Philippine eagle or New Zealand's extinct *Harpagornis* eagle.

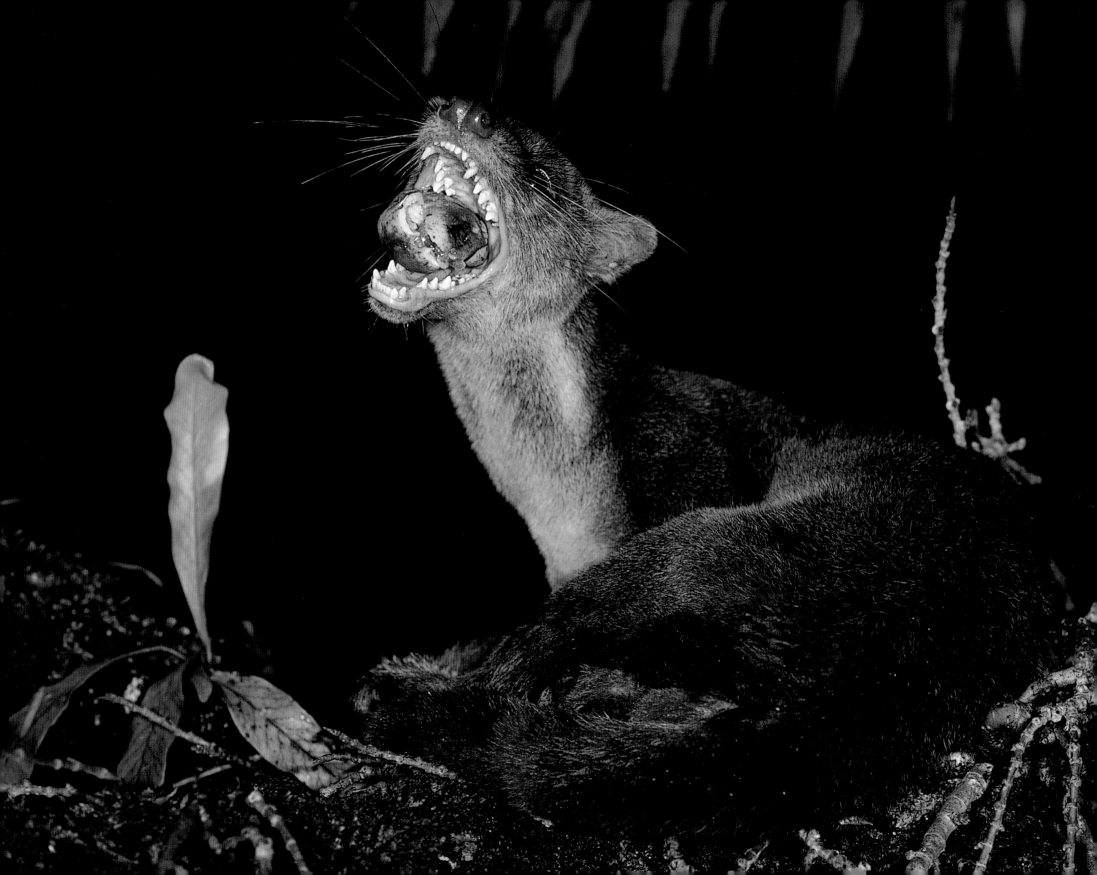

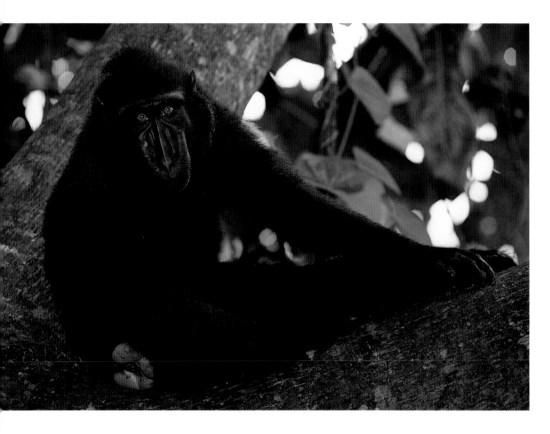

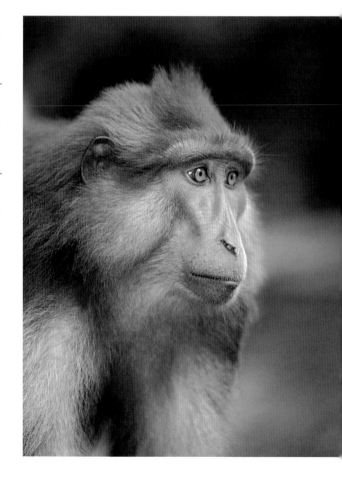

Islands are ideal places for meeting relicts because their isolation in time and space is an excellent protective mechanism. But sometimes it is possible for modern species to arrive on an island and evolve alongside the existing species without automatically causing the relicts to disappear. This is what has happened on Sulawesi, where the tiny relictual primate, the tarsier, has been joined by a group of modern monkeys.

A single species of macaque monkey that arrived in southern Sulawesi perhaps two million years ago, evolved into the seven distinctive species that exist on the island today. Even though it is a large land mass, Sulawesi comprises less than 1 percent of the range for the genus of macaque monkeys, yet such is the power of the species factory that it contains more than one-third of the total species. The ancestral macaque looked much as the Moor macaque of southern Sulawesi does today: a grayish animal with a gorilla-like face. The most distinctive of the island's now diverse macaque group is the baboon-faced crested black macaque, which sports a jaunty mohawk hairstyle and is found at the island's furthest northern tip. What happened to the macaques on Sulawesi is in some ways a parallel story to that of Darwin's finches—if Darwin had come here instead of the Galapagos, it is quite possible he would have reached the same conclusions and the world would have learnt of Darwin's macaques instead of

*Had Darwin visited Sulawesi instead of the Galapagos Islands, we might well think of Sulawesi's macaques as "Darwin's monkeys." From an ancestor that probably looked much like a pig-tailed macaque, seven distinct species evolved. They range from the most divergent species, the crested black macaque (*Macaca nigra), ABOVE, *of northern Sulawesi, to the gray, gorilla-like moor macaque (*Macaca maura), RIGHT, *of southern Sulawesi.*

*An adult spectral tarsier (*Tarsius spectrum), OPPOSITE, *pauses on a palm frond with a freshly captured forest mantid. At little more than 3½ ounces (100 grams), tarsiers are one of the world's smallest primates. They have been in this region of Asia for more than 40 million years.*

finches. The single founding species evolved into many species as a response to fluctuating sea levels during the glaciations. Rising sea levels flooded low-lying valleys, and various "fingers" of Sulawesi were isolated as smaller islands. The secluded monkey populations each evolved independently, a process known as allopatric speciation. When sea levels fell and the different monkey populations were able to intermingle, they were already so different from one another, both in behavior and appearance, that they largely remained separate. However, just to confuse the picture, their separation is not always exact—where ranges overlap they are actually capable of hybridizing. Even though macaques are the only modern monkeys to have made it here, the island species factory has more than compensated for the lack of diversity in the founder species.

Sulawesi is a striking example of another beautiful speciation story: that of the fig trees. Figs are the second largest group of woody plants in the world, and the tropics is home to more than 600 species. Over 100 of these are found on Sulawesi, living in places as diverse as rocky shores and mountain tops, and even in

cracks on city buildings. They have a wide diversity of form, from multi-trunk strangler figs to single-trunk trees and shrubs. In Tangkoko Reserve in northern Sulawesi there are forty-five species of fig tree. With about five trees per acre, this is the highest density in South-east Asia, possibly even the world.

Although Sulawesi has sharply defined rainy and dry seasons, individual fig trees have their own preferred flowering and fruiting seasons, which can be at any time of year. Their aseasonal cycles are tied to the life cycle of their pollinators, the fig wasps. Because the trees fruit at different times in different parts of the forest, they provide a constantly shifting smorgasbord for semi-nomadic birds and animals, such as macaques, hornbills and fruit doves. A single fruiting fig tree is an absolute bonanza, with more than half a million fig fruits ripening at one time. The sugary, calcium-rich fruit, which are actually fleshy, inverted flowers rather than real fruits, are highly sought after.

Fig fruits present in all sorts of ways, depending on species. Some are produced on the tips of outer branches, others are arranged along branches like seeds on a corn-cob. There are pendulous 6½-feet (2-meter) long tassels of fruit, and big cauliflower-like clusters that protrude directly from the trunks. Several species produce most of their fruit low down on the trunks, with some clusters so low they are actually buried in leaf litter. Unusually, these hidden fruit are often green and, instead of being sweet, they are full of latex or other strange flavors.

Like *Lobelia* flowers in Hawaii, fig fruit comes in a manic rainbow array of colors. Different species have fruit of white, yellow, red, orange, black and purple as well as green. Macaques and Sulawesi's fig-eating red-knobbed hornbill have become masters at determining ripeness by color—on a tree where ripe figs are cherry red, for instance, they will ignore yellow or orange fruit.

Color is so important to the red-knobbed hornbills, in fact, that the males even echo the palette of ripe fig fruit colors on their face, in a sexually selected display. Figs are the very foundation of the hornbill's life, and a hornbill chick is fed a diet that is 85 percent fig fruit.

Fig trees provide more than just food for Sulawesi's inhabitants—tiny tarsiers live deep in the crevices of strangler figs. Tarsiers derive their name from the elongated tarsal bones in their ankles that allow them to make long leaps, just like lemurs, and like the lemurs they are precursors of modern monkeys. Two of the six species of these rat-sized predators are found on Sulawesi. They are nocturnal insectivores, with grasping human-like hands for catching prey, and enormous forward-facing eyes—each eye is larger than its brain. Because tarsiers can't rotate their eyes, their vertebrae have evolved to allow them to swivel their head 180 degrees in either direction, like an owl.

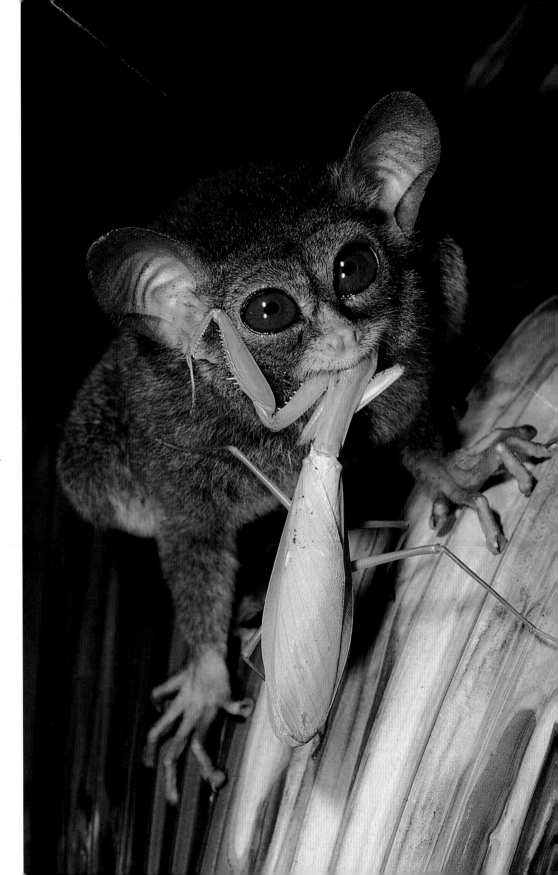

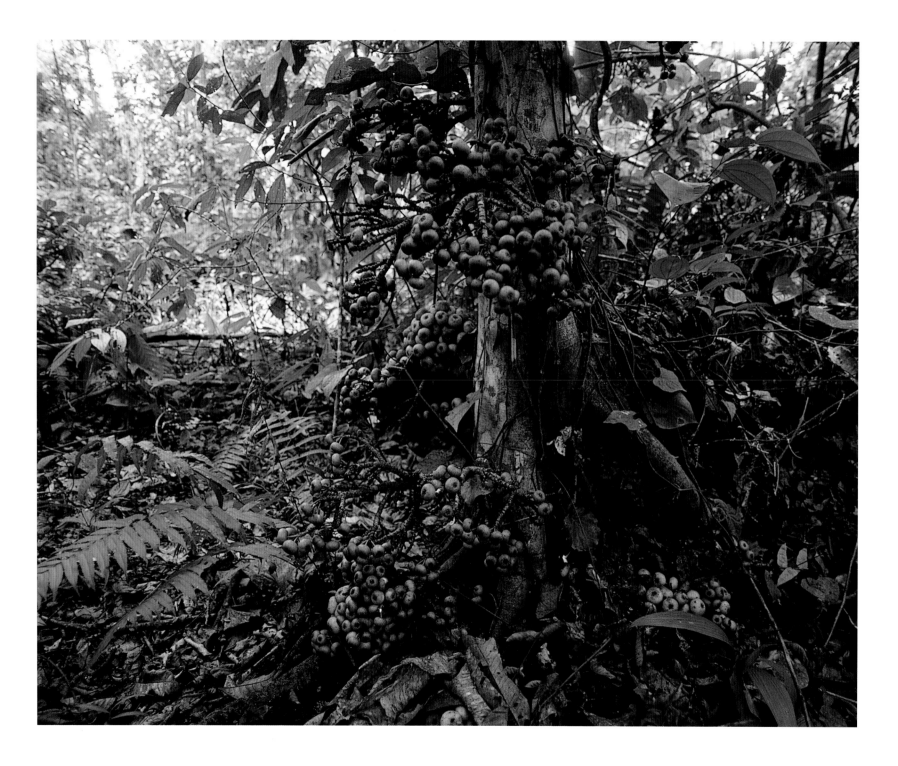

Sulawesi Between Two Worlds

Each family group of tarsiers has a home range of about 10 acres (4 hectares) that encompasses a number of fig trees. At night, family members forage independently, hunting large insects such as crickets by sight and sound, and making long pounces to catch them. They keep in constant touch with other family members using long-distance chirps. At dawn they reassemble, and retire as a family into their fig tree. The adult male and female tarsier in the group duet with each other when they meet at dawn, and the duet probably serves as a territorial announcement.

Tarsiers are just one of the strange motley crew of mammals that makes Sulawesi's fauna so unique—in fact, more than 60 percent of its mammals are endemic. Not surprisingly, many are fig eaters, and one of the most unusual mammal species makes sense of the low-growing, green latex-flavored fig fruit.

The barbirusa—known locally as the deer pig—is an ancient, early branch in the mammalian family tree, and is almost a missing link between pigs and hippos. Unlike most pigs, which dig for roots, barbirusa forage, usually at night, in the forest litter for low-growing fig fruit and fallen fruit. They are peculiar looking creatures—the males have strange decorative tusks, one pair of which pierces their upper jaw and curves back towards their eyes.

Other unusual foragers also inhabit Sulawesi's forests, supplementing their major diet of leaves with fallen fig fruit and low-growing green fruit. The anoa, the largest mammal in Sulawesi, is a dwarf of its kind. These tiny buffaloes are delicate browsers that feed in the early morning and late evening. It appears as if the fig trees have specially produced fruit close to the ground to cater for the anoa and the barbirusa.

Other species of fig tree and palm trees produce fruit that are attractive to the carnivorous giant civet. Very little is known about the giant civet, and prior to our filming one in January 2000 the last sighting had been in 1972. By supplementing its meager meat diet with large quantities of fruit, this predator is able to survive long lean periods in the forest. The civet is a tree-dweller the size of a small leopard, and is the only part-time hunter of this size on Sulawesi. This is

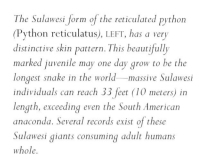

The Sulawesi form of the reticulated python (Python reticulatus), LEFT, *has a very distinctive skin pattern. This beautifully marked juvenile may one day grow to be the longest snake in the world—massive Sulawesi individuals can reach 33 feet (10 meters) in length, exceeding even the South American anaconda. Several records exist of these Sulawesi giants consuming adult humans whole.*

A cauliflorous fig (Ficus variegatus), OPPOSITE, *produces green fruit close to the ground for large leaf-eating animals that can't climb trees. Two species that benefit from this arrangement are the anoa and barbirusa.*

The lowland anoa (Bubalus depressicornis), BELOW LEFT, *is a dwarf buffalo, little larger than a domestic goat, that prefers to browse on leaves and fruit rather than graze on grass. Its small size and rear-facing horns are probably adaptations to living in dense rainforest.*

The barbirusa (Babyrousa babyrussa), BELOW RIGHT, *is one of the world's most primitive pigs. Males possess ornately curved tusks which pierce the roof of the snout and curve back towards the eyes. This highly visible ornamentation seems to serve little practical purpose and may be nothing more than a visual sign of age and strength. Today, bush meat hunting has made barbirusa among the most endangered mammals in all of Sulawesi.*

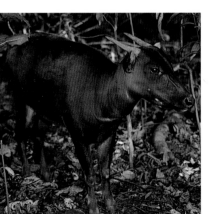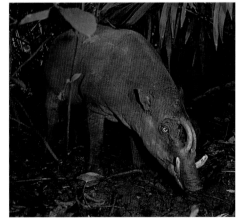

The bear cuscus (Ailurops ursinus), BELOW, is the largest and most primitive of all the world's possums. Curiously, the giant bear cuscus and a related species, the dwarf cuscus, live far from their ancestral home. These formerly Australian animals are now the western-most of all marsupials and live on the very edge of Asia.

quite different from the situation on nearby islands—Borneo has true meat-eating leopards and other leopard-sized cats, and Java and Sumatra to the south-west have leopards and tigers. These modern cats never reached Sulawesi.

Another of Sulawesi's extraordinary ancient relicts that depends on fig fruit is the endemic dwarf cuscus. Remarkably, the nocturnal cuscus is a marsupial, or pouched mammal, and its presence here is a reminder of where Sulawesi sits in the world. It is at the edge of Asia, and is the largest and most central island in an area referred to as Wallacea. Named after the famous nineteenth-century English naturalist Alfred Russel Wallace, who described the animal and plant life of the region, Wallacea contains a strange blend of Asian and Australian biotas. Many species are at the extreme geographic limit of their range in Wallacea. This pivotal location between two rich biotas, and a long period of isolation that allowed relicts to survive and new species to evolve, combine to make Sulawesi the ultimate island, a veritable treasure trove.

The dwarf cuscus, a small reminder of Australia, made an epic journey to reach the edge of Asia, possibly by rafting and island-hopping. The cuscus is a slow-moving animal, ill-suited to dispersal—its presence on Sulawesi is really nothing short of a miracle, especially since these marsupials made the journey not just once, but twice. Because as well as the fruit-eating dwarf cuscus—the smallest cuscus in the world, Sulawesi is also home to the largest species—the primitive bear cuscus.

The bear cuscus is the largest and heaviest cuscus in the world. It feeds by day, largely on leaves, a niche that in most other places in Asia is taken by specialist leaf-eating monkeys. It's a wonderful illustration of the vagaries of dispersal that a

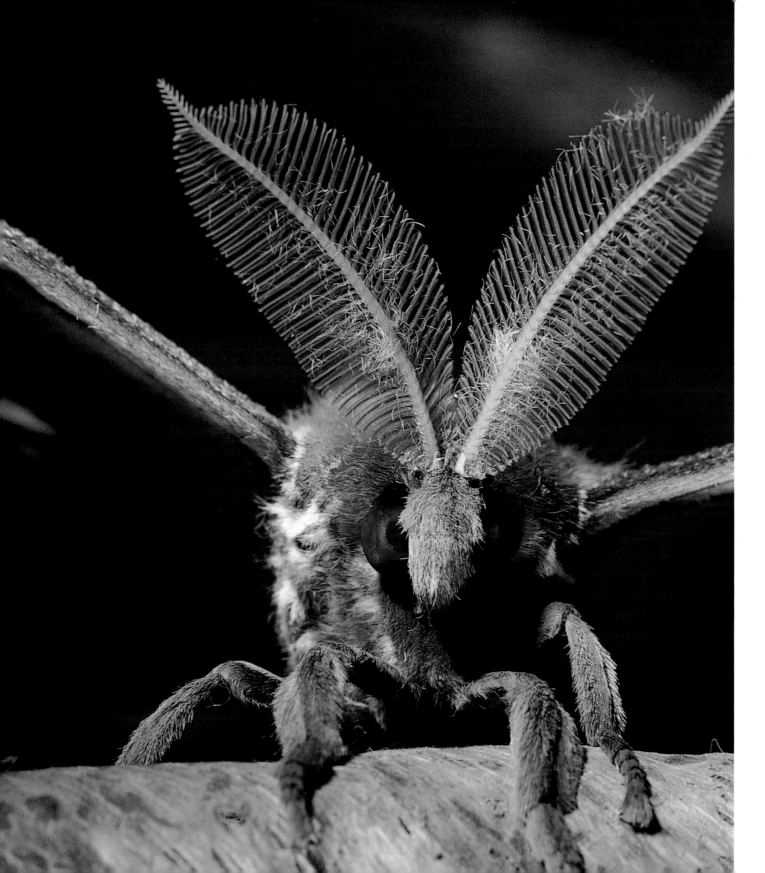

Sulawesi's tropical rainforest hosts an incredible diversity of invertebrates, many of them unknown and unnamed. In central Sulawesi a small wasp-mimicking stick insect (Orthomeria forstenii), OPPOSITE, has bright coloration that is reminiscent of a parasitic wasp, an animal it mimics right down to its behavior, including a constant feverish waving of its antennae. Equally bizarre is a monkey grasshopper (Pseudomnesicles roseosignatus), ABOVE, with its extraordinary large eyes and pinkish wings. It is a forest dweller from northern Sulawesi. The feathered antennae of the male Atlas moth (Attacus atlas), LEFT, one of the world's largest moths, are used to detect the presence of female pheromones.

Strangler figs are parasitic trees that begin life in the crown of another tree. As the fig grows it sends its roots down to the ground, encircling the trunk of its host. The host tree may eventually die, its canopy shaded by the fig and its trunk crushed by the fig's tight embrace. In time a strangler fig like this Ficus altisima, ABOVE, may become a free-standing tree with an internal framework marking the dimensions of its deceased host.

There are nine species of pitcher plant in Sulawesi, five of which are endemic. Their distinctive hollow pitchers, which attract and trap invertebrates, are actually modified leaves. Identification of pitcher plants is difficult, because the lower pitchers, which appear first and form a rosette on the ground, look astonishingly different from later, higher pitchers which grow on tendrils rising out of the original plant. The two kinds of pitchers are so different they appear to come from separate species. The pitchers of this Nepenthes maxima, RIGHT, are upper tendril pitchers.

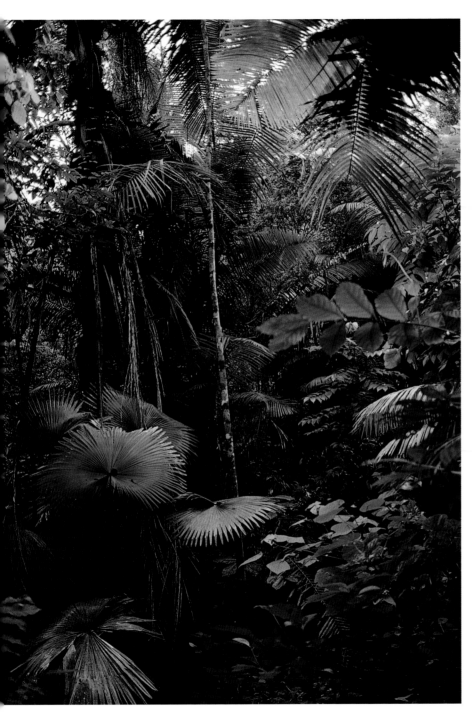

pouched mammal could make a long difficult journey from Australia, while leaf-eating monkeys from Asia failed to successfully make a much shorter journey.

Both of the cuscus species—a day-foraging giant leaf eater and a nocturnal fruit-eating dwarf—evolved in Greater Australia (the combined land mass of Australia and New Guinea) but are now endemic to Sulawesi. Exactly how or when they arrived in Sulawesi is a mystery. What is clear, however, is that they arrived in a land already well populated with successful modern monkeys, so they have always been marginalized and disadvantaged, a bit of a novelty sideline to the mainstream monkeys. What the two cuscus left behind in Greater Australia, though, was a wonderful tropical forest that monkeys never managed to reach. The absence of monkeys in New Guinea had profound consequences for its tropical marsupials—they had limitless opportunity to flourish and diversify, with spectacular results.

The tall round-leafed fan palm (Livistona rotundifolia), LEFT, *is the most common palm in Sulawesi's forests, and it lends a distinctive appearance to the forest interior. Its stems and trunks are ringed with a formidable array of spines for protection from browsing animals. Another species of forest palm, the rattan,* BELOW, *uses hooks and barbs to climb into the very canopy. Rattan palm vines are very strong, and highly prized for furniture making. Large-scale collecting in northern Sulawesi has severely depleted this plant.*

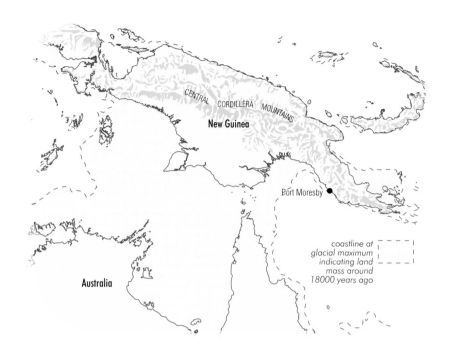

CENTRAL CORDILLERA MOUNTAINS

New Guinea

Port Moresby

coastline at glacial maximum indicating land mass around 18000 years ago

Australia

New Guinea
The Species Factory

Partly the product of the richness of life in a tropical rainforest, New Guinea's biodiversity is also the result of a creative blend of two great biotas, Asian and Australian, generously blessed with isolation. New Guinea is home to an astonishing wealth of butterflies, such as the green spotted triangle (Graphium agamemnon ligatum), RIGHT. While the more than 800 butterfly species may be the best known example, every insect group in New Guinea has had the same explosive radiation into a myriad forms of every conceivable color, shape and size. Even the usually modest stick insect, such as this spiny leaf insect (Extatsoma popa), FAR RIGHT, has taken its camouflaged patterns and shapes to wonderful lengths, and a weevil with blue-velvet slippers on its feet (Eupholus geoffroyi), OPPOSITE, is just one more bewildering creation of New Guinea's flamboyant species factory.

NEW GUINEA is the second largest island in the world, and the largest tropical island—a beautiful yet forbidding country of rugged cloud-covered mountains. At nearly 16,500 feet (5000 meters), the highest peak on the Central Cordillera mountain range that runs east-west is covered in ice and snow, even though the equator is only 250 miles (400 kilometers) away. Lower down, the jungle is hot and steamy, as you'd expect in the tropics. This is just one of many contradictions on this island of extreme contrasts.

It is home to hordes of deadly, voracious insects, and also to some of the world's most spectacular and beautiful insects. There are butterflies, in almost every color imaginable, flitting and dancing like extravagant cartoon creations. There are flies with antlers on their head, and *Eupholus* weevils painted sky-blue and green.

New Guinea is biodiversity-rich, having reaped the benefits of proximity to the continents of Asia and Australia, both

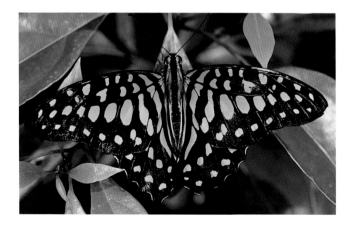

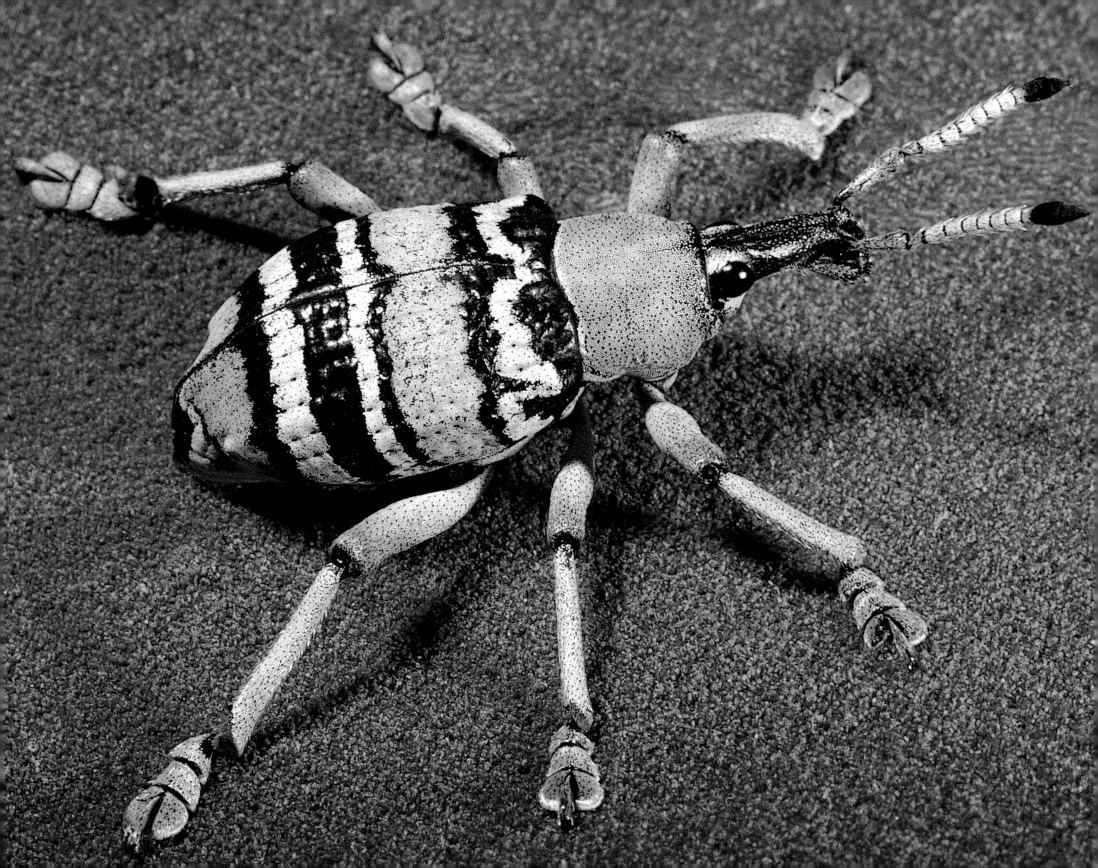

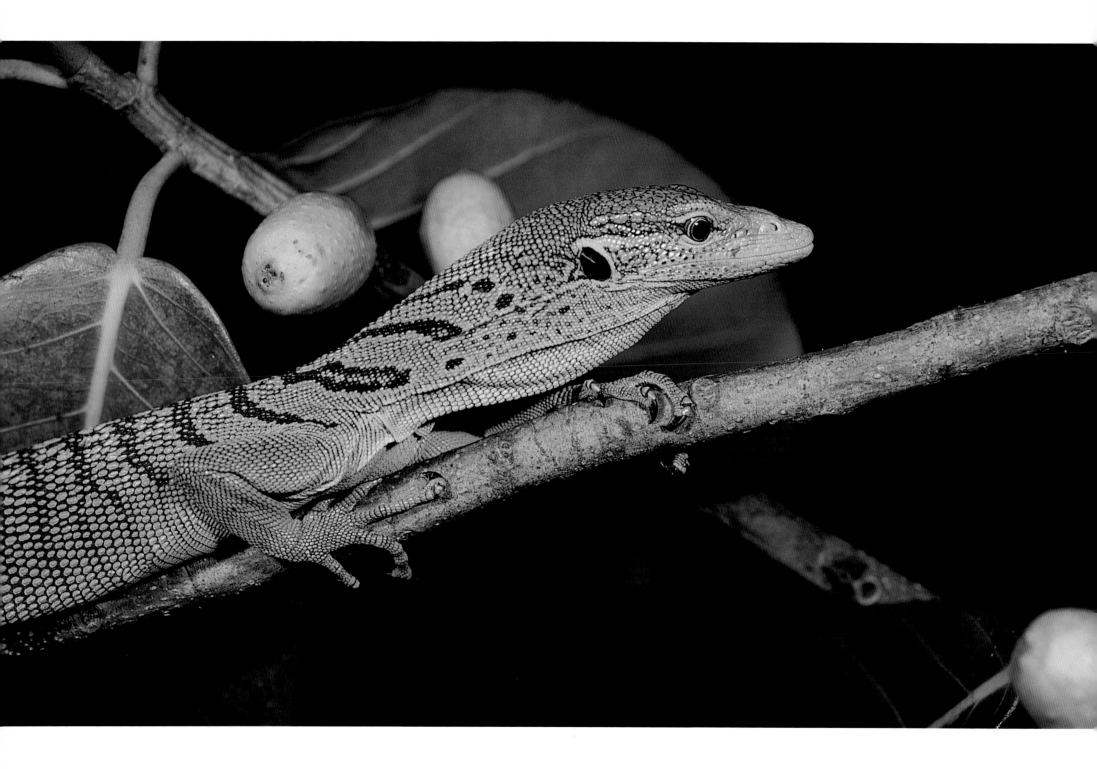

New Guinea The Species Factory

of which have provided ample raw material for the island's impressive species factory. And New Guinea has been as generous in giving as it has in taking: much of its wealth has in turn been exported to other islands. Cuscus went west to Sulawesi at the edge of Asia. Cockatoos and friarbirds traveled west, too, to Komodo, Flores and Rinca. And lorikeets and fruit doves reached as far east as French Polynesia, penetrating the very heart of the Pacific.

Several groups of birds achieve their greatest evolutionary diversity in New Guinea. It is home to forty-six parrot species, a seventh of the world's total. They range from the giant black palm cockatoo that reaches above knee height, to the dwarf hanging parrot that fits well in the palm of a human hand. The forty-five species of pigeon, a sixth of the world's total, cover an equally diverse range of size, form and ecology. The giant among them is the fowl-sized ground-dwelling crown pigeon, with its spectacular fan-shaped crest, and the smallest of the group is the dwarf fruit dove.

One of the most spectacular and world famous products of the New Guinea species factory are the birds of paradise. There are thirty-eight species on the island, the result of a combination of evolution driven by sexual selection and isolation, in tandem with abundant food and low levels of predation. What started as a single crow-like bird is now an astonishing group of birds—although the females are rather drab, the males are usually boldly colored and have showy courtship dances.

The "plumed" birds of paradise are among the most striking—in this group of seven species, the males have highly modified, brightly colored pectoral plumes. Interestingly, although the birds of paradise appear strikingly different from one another, the genetic boundaries between some of the species are surprisingly blurred. Different species can and do interbreed, and the resulting hybrids have perplexed many taxonomists.

All but one of the plumed birds of paradise have the same kind of competitive lek mating system that Hawaii's picture wing flies have: males gather together and try to out-perform one another in order to impress a critical audience of watching females. As with the picture wing flies, it is the males that have to make the effort to produce the most compelling display, while the final choice of which males get to mate rests with the females.

Lek mating systems usually occur in environments with few predators—where there are many predators few animals would make loud calls that can be heard over long distances or indulge in ostentatious displays that both attract attention and make its participants vulnerable. They certainly wouldn't risk performing on the ground, as do some of the birds of paradise. But New Guinea is a classical benevolent island: it does not have the large mammalian predators of continents, although snakes, small mammals and the New Guinea harpy eagle live here. The eagle is New Guinea's top predator—as so often happens on islands the absence of a particular group of animals can offer others opportunities to take on surprising and unexpected roles. Having a bird as top predator is a distinction that New Guinea shares with the Philippines and New Zealand.

Even a monitor lizard has been transformed into a delicate and agile insect and fruit-eating tree dweller in New Guinea. It's difficult to believe that the green lace monitor (Varanus prasinus), OPPOSITE, which is less than 3 feet (1 meter) long, is a relative of Indonesia's massive Komodo dragon.

While most people think of rhododendrons as coming from the Himalayas, the group is widely distributed down through Asia, with the vireya rhododendrons occurring in Southeast Asia, New Guinea and the Philippines. Unlike the Himalayan species, subtropical vireyas such as Rhododendron zoelleri, BELOW, are often characterized by yellow or orange flowers, instead of the more usual pinks and mauves.

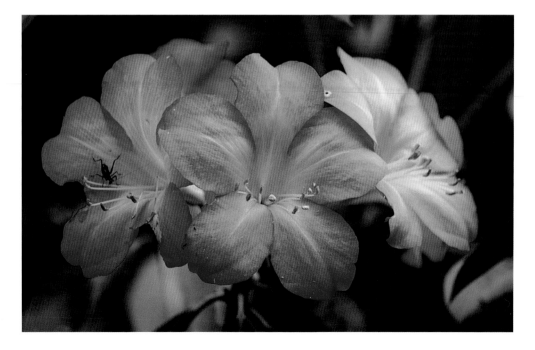

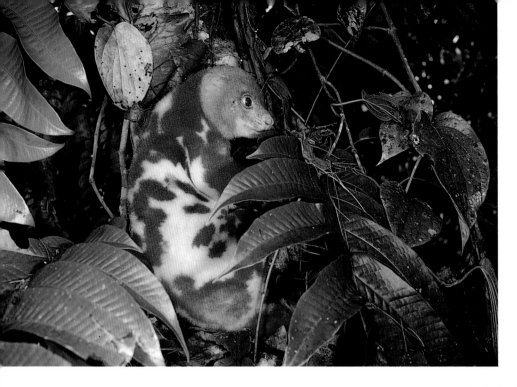

New Guinea is also home to the southern cassowary, a 5 foot-tall (1.5 meters) relative of Madagascar's elephant bird. New Guinea shares these gigantic flightless birds with Australia. Cassowaries usually feed on fallen fruit, but in the usual scheme of strange island goings-on they'll also eat carrion and dead animals. Unless they are cornered cassowaries are not dangerous, but when they feel threatened they will kick and slash with their sharp claw-like inner toe, and have been known to kill people.

Cassowaries have an unexpected and interesting connection to one of the parrots. The vulturine parrot eats figs and palm fruits, but also picks fruit and seeds out of cassowary droppings. Like true vultures, the vulturine parrot has a bald head so that its feathers don't get soiled as it forages through the larger bird's droppings or sticks its head into big juicy fruit.

Big predators are not the only mammals that are absent from New Guinea. Like its neighbor Australia, to which it was joined for a long time, it has no monkeys or squirrels, so it is a godsend for marsupials. More than a quarter of New Guinea's 200 mammal species are marsupials, and these come in a wonderful array of sizes and numbers that Sulawesi was never able to achieve because of the presence of modern monkeys there.

It's not just the lack of monkeys that have allowed marsupials to exploit a wide range of niches in New Guinea. In the absence of woodpeckers the striped cuscus has evolved to eat trunk-dwelling insect larvae, finger-tapping to locate them and using its stout chisel-shaped incisors to dig them out. It winkles out the prize either with an elongated fourth finger or its long tongue. The striped cuscus has skunk-like black-and-white markings, and like a skunk it has a strong smell.

Although the species in New Guinea and islands further north are known as cuscus while the Australian species are called possums, they all belong to the same group of marsupials. They evolved from a single ancestor, a tree-dwelling leaf-eater, probably much like Sulawesi's primitive bear cuscus. More than half of the world's sixty or so possum species are found in New Guinea, with as many as eighteen species co-existing in small areas of forest. It is not clear how so many species can co-exist, but it is probably a result of a combination of factors: a diverse and productive forest, a long period of co-evolution between forest and possums, and some very specialized feeding adaptations among the possums.

The slow-moving, bright-colored spotted cuscuses are the most striking of New Guinea's species. They are probably the equivalent of leaf-eating

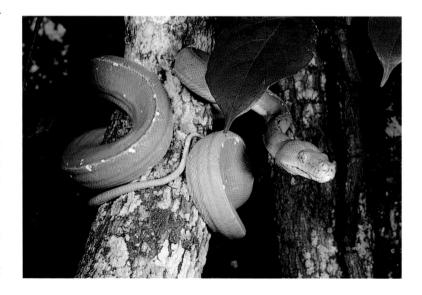

New Guinea is the true home of the cuscus. The beautifully marked spotted cuscus (Spilocuscus maculatus), ABOVE, is common and widespread throughout New Guinea and its offshore islands. This large cuscus can be extremely variable in color, ranging from all white through to brown, gray and even orange mottling, depending on location.

The green tree python (Morelia viridis), RIGHT, is a predator that kills by constriction. With its prehensile tail and powerful coils this strong climber moves through the trees with ease in search of small birds and rodents, its adult coloring proving a very effective camouflage amongst the leaves of the canopy. Remarkably, its young, OPPOSITE, don't share this color trait—for much of their first year of life they are either bright canary yellow or brick red.

New Guinea The Species Factory

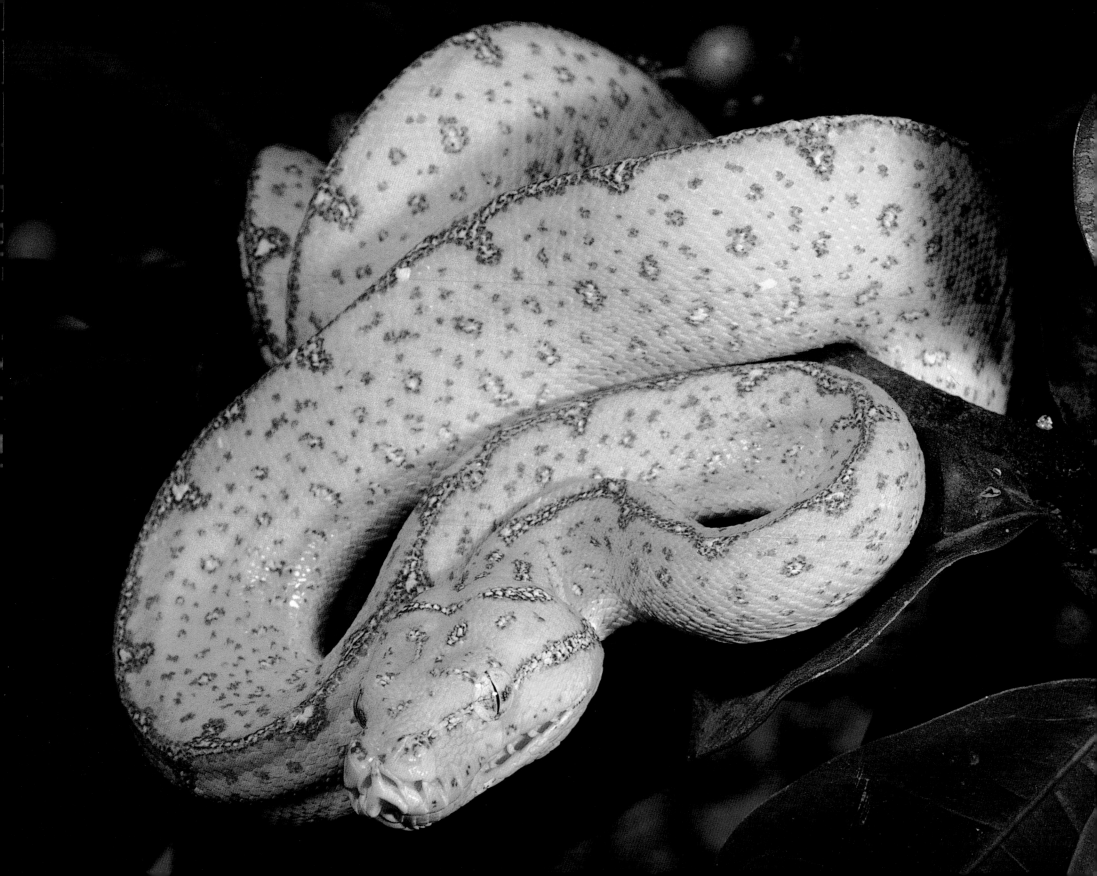

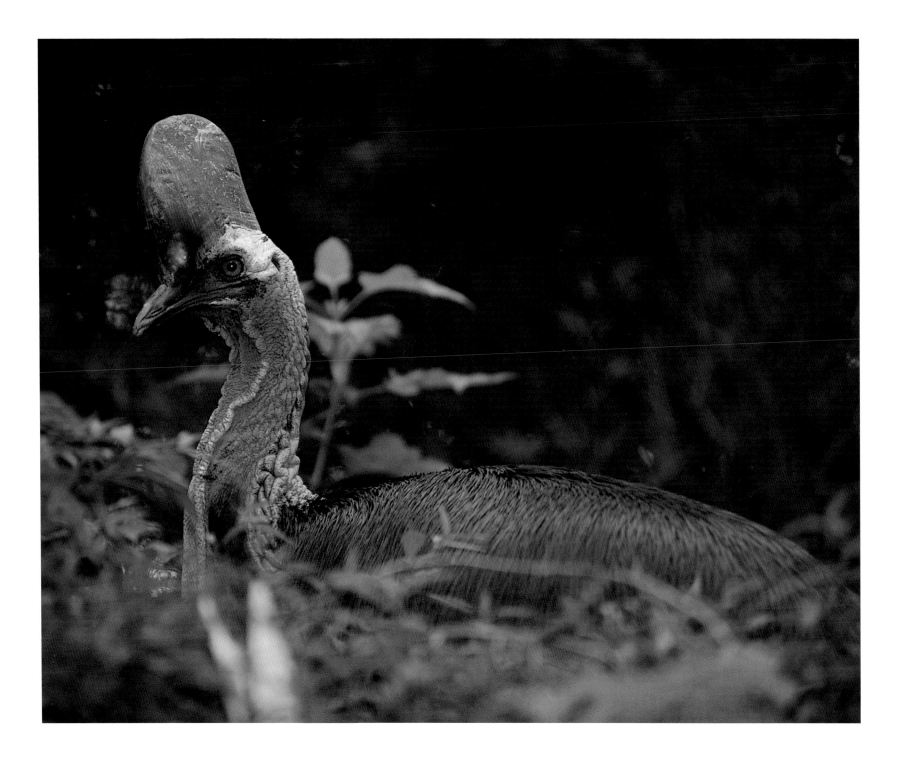

New Guinea The Species Factory

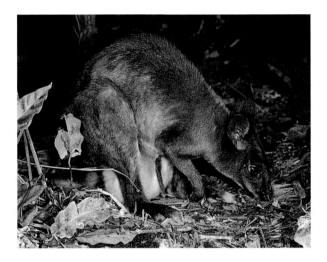

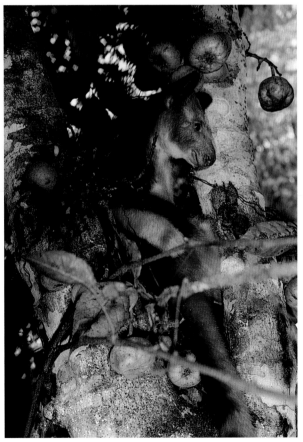

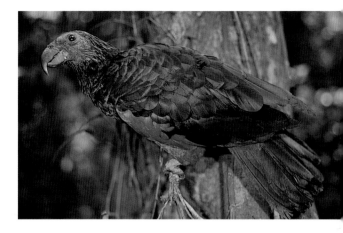

monkeys in the New Guinea forests, although some scientists have mentioned parallels with sloths, especially because of their low metabolic rate and fur with high insulation properties. Although the very distinctive ground cuscus rests during the day in holes in the ground, most cuscus species are arboreal with several adaptations that help them to be expert tree climbers. Their grasping hands and feet have rough surfaces patterned with fingerprint-like whorls for good grip, and their prehensile tails are partly naked on the underside, again for grip.

Possums are not the only creatures to benefit from the absence of primates—even the birds of paradise eat fruit and nuts that might otherwise feed monkeys. They hold and manipulate the fruit and nuts in strong feet that are almost as dextrous as primates' fingers.

Most of New Guinea is covered in forest and jungle, but there are several small areas of savannah in the south of the island that are havens for another group of marsupials. This open grass and woodland is one of the few places in New Guinea that pretty much matches prime wallaby habitat in present-day Australia, and agile wallabies lead a lifestyle here that is the same as that of their wallaby and kangaroo cousins on the Australian continent.

However, some wallabies have been transformed by a new set of circumstances and have joined the possums in the trees. Tree kangaroos probably evolved in northern Australia, when it was still joined to New Guinea, and they were well established by 4.5 million years ago. Two species of tree kangaroo are found in Australia, but the group is much more advanced and diversified in New Guinea, which has eight living species. Even though superficially they resemble bear-faced kangaroos, tree kangaroos have lots of adaptations to help them climb. Their forearms are much longer than the rock wallabies from which they evolved, and they have much more movement at the shoulder. A combination of long claws on their forearms and textured pads on their feet, like those that possums have, help them grip branches.

*Like so much of this island's wildlife, many of New Guinea's birds are truly extraordinary. Two such species are the spectacularly colored southern cassowary (*Casaurius casaurius*), OPPOSITE, which is a member of the large group of flightless birds known as ratites, and the remarkable vulturine parrot (*Psittrichas fulgidas*), ABOVE, with which it shares a remarkable relationship. It feeds mainly on palm fruit, but also forages in cassowary droppings for seeds.*

*For a long time New Guinea was part of the greater Australian landmass so it's not surprising to find members of the kangaroo family here, such as the New Guinea pademelon (*Thylogale browni*), ABOVE LEFT, a small forest dweller. What is perhaps more unexpected are the eight species of tree climbing kangaroo such as the Goodfellow's tree kangaroo (*Dendrolagus goodfellowi*), BELOW LEFT, seen here resting in a fig tree.*

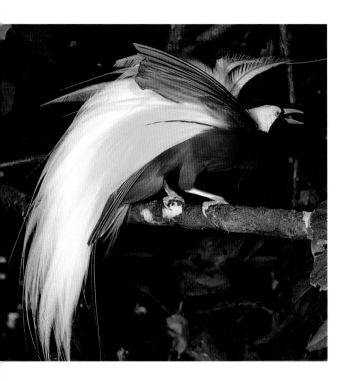

Unlike other kangaroos, that can only hop, tree kangaroos can also move all their limbs independently as well as twist their feet, which gives them much greater versatility for clambering through trees. Terrestrial kangaroos hold their strongly muscular tails out behind them as a counterbalance while hopping at speed, whereas tree kangaroos stiffen their tails and hold them vertically below their body as a counterbalance while climbing or arch them over their back when they hop on the ground.

Why did kangaroos go into the trees in the first place? Tasmanian tigers, a now extinct large marsupial predator that New Guinea once shared with the Australian mainland and Tasmania, stalked the forest floor and its presence would have been an added incentive to climb. Once again the absence of monkeys meant there was a large, relatively unexploited food source to be had up in the branches. And the lack of mammalian predators in the trees was an extra inducement— their absence allowed the tree kangaroos to manage with just a modest climbing ability. However, when necessary, they can put on surprising turns of agility—if threatened by carpet pythons, tree kangaroos will make flying leaps between trees in order to escape. They have the added bonus of being so solidly built that if things go badly wrong mid-leap and they crash to the ground they are unlikely to break any limbs.

In that wonderful topsy-turvy way of islands, having evolved to live in the trees, some of New Guinea's tree kangaroos have now come back down to the ground. Doria's tree kangaroo has lost its leaping ability and, when it has to come out of a tree, it tends to do it tail first.

New Guinea and Australia share many marsupial species because for a long time they were joined. About 150 million years ago the great supercontinent of Gondwana, of which they were a part, began to split apart. By seventy million years ago New Guinea, Australia and Tasmania had become a separate chunk of land called Meganesia, variously joined or separated by rising and falling sea levels. Unlike South America, whose early marsupials were pretty much swamped by the later arrival of modern mammals, Meganesia remained a haven for marsupials. From tropical New Guinea in the north to cool temperate Tasmania in the south, with an increasingly arid Australia in between, marsupials had many niches and environments to exploit. And in the relict Gondwana forests of Tasmania, small marsupials took a very divergent evolutionary path to that of the placid leaf-eating tree kangaroos and cuscuses of the lush tropics of New Guinea.

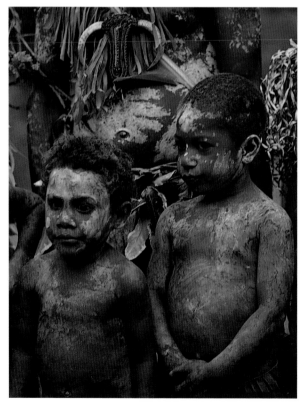

Despite its name, the lesser bird of paradise (Paradisaea minor), ABOVE, is a spectacular member of a group of birds that has one of the most striking and memorable courtship displays of any bird. The people of New Guinea have admired birds of paradise for thousands of years. They have adapted the bird's elaborate adornments and ritualized courtship dance in a ritual known as "sing-sing," when adult males adorn themselves with birds of paradise plumes, and sing and dance. Today such rituals are often performed for tourists, when even children may join in the dance, RIGHT. In spite of heavy hunting pressure for their highly desired plumes, the lesser bird of paradise still seems to be quite common and widespread.

New Guinea The Species Factory

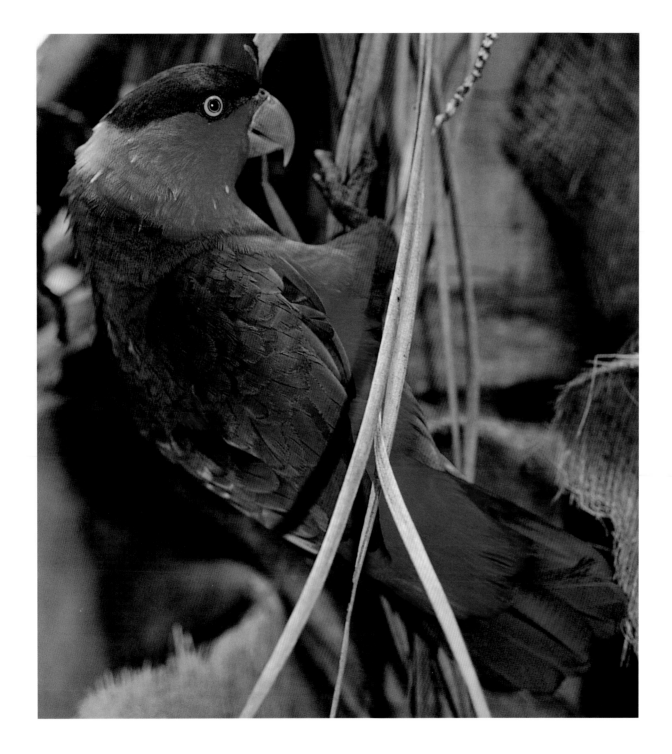

The black-capped lorikeet (Lorius lory lory), LEFT, is just one of 21 species of lorikeet found in New Guinea, which is home to nearly half the world's species in this brightly colored group. This medium-sized species is widely distributed through the island's forest lowlands, where they are quiet and inconspicuous feeders. Their brush-tipped tongues are covered in papillae, allowing the birds to feed on nectar and pollen.

The largest of New Guinea's forty-six species of parrot is the giant black palm cockatoo (Probosciger aterrimus), BELOW. Its massive beak allows it to crush even the largest rainforest seeds and nuts. When excited or alarmed it raises a crest of feathers and its cheek patches flush red. Once widespread and common throughout New Guinea this extraordinary parrot is now uncommon and even absent from many areas due to hunting pressure.

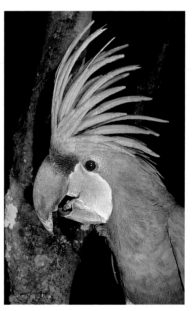

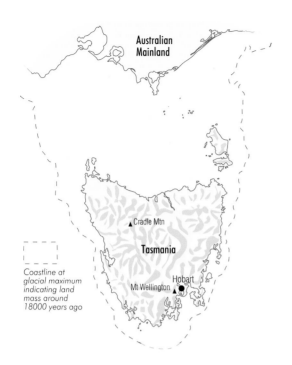

Coastline at glacial maximum indicating land mass around 18000 years ago

Australian Mainland

▲ Cradle Mtn

Tasmania

Hobart
Mt Wellington ▲●

Tasmania
A Topsy-turvy World

Tasmania's marsupials vary widely in shape and size, ranging from the diminutive and secretive little pygmy-possum (Cercartetus lepidus), BELOW, foraging among heathland flowers after dark in search of nectar and insects, to Tasmania's largest and best known marsupial, the eastern grey kangaroo (Macropus giganteus), OPPOSITE. Here a female grey kangaroo at dusk stays alert for danger.

WHEN YOU FIRST visit Tasmania and try to get a handle on how it works biologically, it feels as if you're in a scene from *Alice in Wonderland*—quite what is a quoll? And isn't a pademelon a kind of fruit? Nothing is exactly as it seems, until you remember that in every ecosystem there are ecological inevitabilities—niches and roles that some animal will invariably fill. Plants come in different sizes, and so do the animals that eat them. These herbivores are in turn hunted by predators that also come in a range of sizes. In most of the mammal world these roles are taken by placental mammals. But on this large temperate island south of mainland Australia, some simple substitutions have given rise to a weird and wacky fauna.

Meganesia, the Gondwana fragment of which New Guinea, Australia and Tasmania are all a part, does have some placental mammals—in fact, it is the only place in the world where all three kinds of mammal are found. Feeding their young milk is one of the defining characteristics of a mammal, but the three mammalian groups—marsupials and monotremes as well as placental mammals—go about it quite differently.

Like humans, placental mammals bear their young at an advanced stage of development, relying on a sophisticated structure, the placenta, to nurture the fetus in the uterus. After it is born, a youngster suckles milk from its mother's nipples as it needs it. Some placental babies are so well developed they can run almost as soon as they are born. Australia's representatives of the placental mammals are native rats and bats. Marsupials give birth at a very early stage of development, when the young are still very tiny. After they are born the babies move to a special pouch on the mother's abdomen, and attach themselves to a nipple.

The monotremes—of which two, the platypus and the echidna, are found in

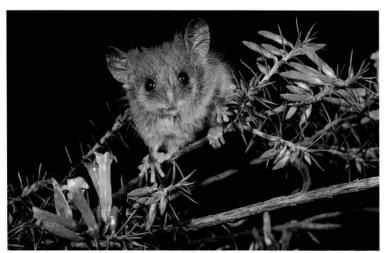

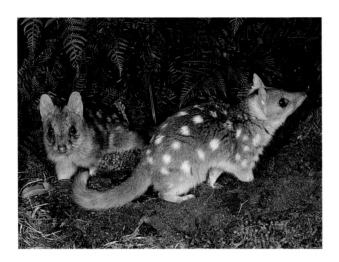

Tasmania—are the strangest of the mammals. They lay eggs, from which the young underdeveloped mammal hatches, just like a baby bird. The females do not have nipples, so their babies are fed milk from enlarged pores on the mothers' bellies.

The island of Tasmania is quite different from its mother continent Australia and contains only a subset of the species that the continental land mass holds. This relative simplicity makes it easier to understand the substitutions that have gone on in the marsupial world.

Kangaroos and wallabies are the best known grazing marsupials, and these vegetarians take the role that deer or antelope would fill in the northern hemisphere. They have massively developed back legs and enormous muscular tails which acts as a third leg. Their unusual hopping gait is an extremely efficient means of travel, with the muscles and ligaments of the legs acting as springs that conserve and recycle energy from one hop to the next. A kangaroo can easily maintain speeds of up to 25 miles (40 kilometers) per hour.

Marsupials are a very diverse group, as a quick comparison of the largest species and the smallest species in Tasmania makes abundantly clear. The gray kangaroo, the second largest species of marsupial in Australia, is Tasmania's largest. A male gray kangaroo can weigh nearly 150 pounds (66 kilograms), and a female may reach half that weight. Although the females give birth to only one baby at a time, they can end up with a single tiny baby in the pouch and a much older, larger joey at foot. To deal with the age gap, they produce two different kinds of milk. At the other end of the scale, the quarter-ounce (7 gram) little pygmy possum is Tasmania's smallest kind of possum. These tiny beasts have four nipples and can carry up to four minuscule babies at one time, all of the same age. To avoid predators such as owls, these arboreal animals live low, nesting in dead wood cavities or even on the ground.

*The elegant little eastern quoll (*Dasyurus viverrinus)*, ABOVE, is about the size of a large kitten. Its pert nose and upright ears are characteristic of a group of baby-faced assassins that hunt for small birds, reptiles and insects in Tasmania's undergrowth. Their close relative, the better known Tasmanian devil (*Sarcophilus harrisi)*, OPPOSITE, is a hunter and scavenger whose name means "flesh-eating," although their joeys, such as these five-month-olds seen here at the entrance to their nest, RIGHT, are rather "cute little devils."*

The kangaroo's breeding system allows the larger animal to take a flexible approach to living in an often uncertain environment. If conditions deteriorate and food becomes difficult to find, the mother will expel the baby in her pouch, and concentrate on the joey at foot and, if necessary, she will jettison that as well. Many kangaroos and wallabies also carry a third embryo, a fertilized blastocyst, in their uterus. It stays in a state of embryonic diapause (suspended development) until the female determines that conditions are suitable, and only then does it develop.

Differences between marsupials aren't confined just to size or number of babies. The kangaroo, for instance, once had a lot of unlikely relatives that were definitely not fellow vegetarians. These were the killer kangaroos, which evolved to fill the carnivorous niches of wolves, lions and hyenas. All are now extinct. The last of

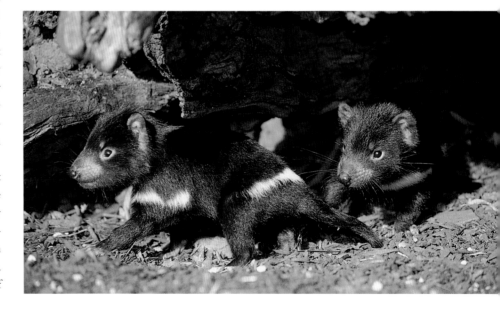

Tasmania A Topsy-turvy World

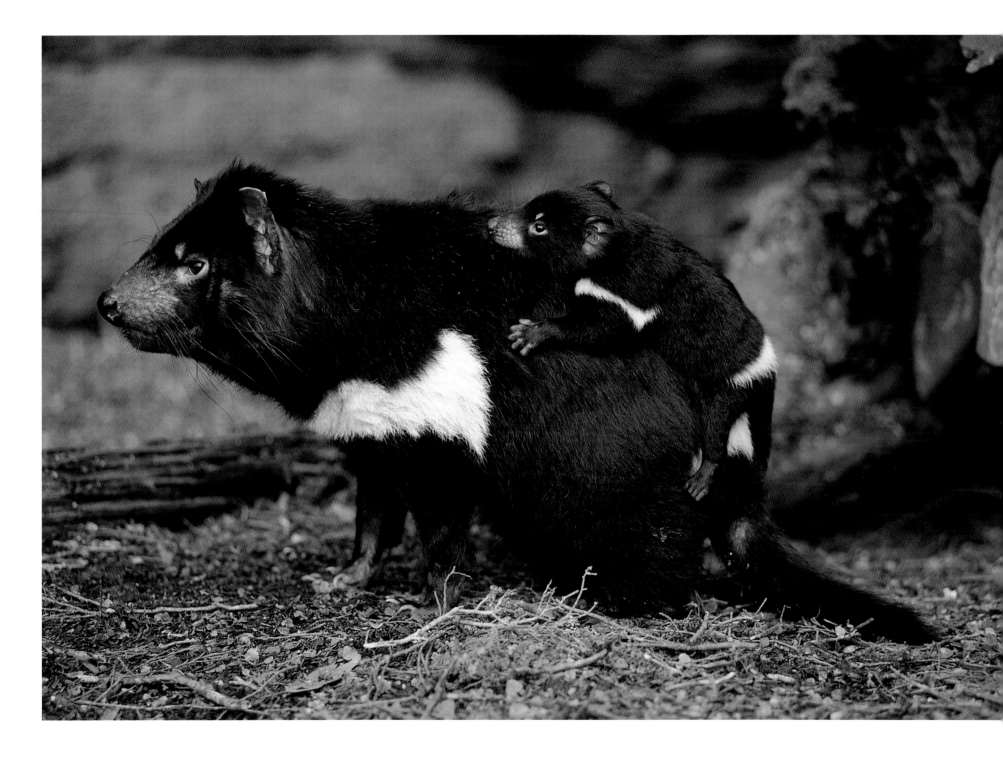

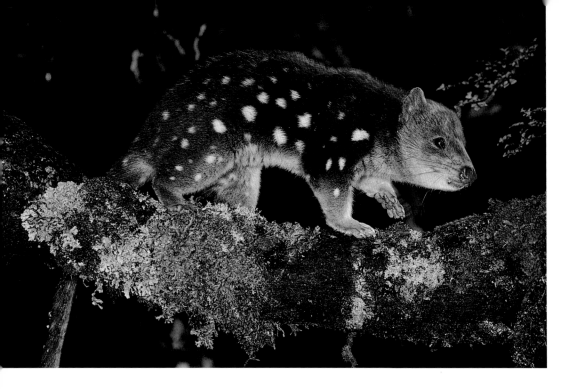

The spotted-tailed quoll or tiger cat (Dasyurus maculatus), ABOVE, is an efficient hunter that stalks the trees of Tasmania's temperate rainforests at night. Tasmania is the last stronghold of a whole suite of small to medium-sized carnivorous marsupials.

Although Tasmania lies off the south coast of Australia, many of its plants, animals and landscapes appear utterly unique, even to Australians. In the temperate highlands of Cradle Mountain, RIGHT, a young Tasmanian devil wanders across a marsupial lawn among pandani plants with their distinct pineapple-like leaves.

Tasmania's short-beaked echidna (Tachyglossus aculeatus setosus), OPPOSITE, is sometimes referred to as a spiny anteater. The Tasmanian subspecies of this Australian-wide species has a thick coat of fur that almost conceals the dense layer of prickles. It's a close relative of New Guinea's long-beaked echidna, but has very different feeding habits—it specializes in breaking open termite and ant nests, whereas its northern counterpart feeds on worms.

the marsupial lions disappeared about 50,000 years ago. Marsupial wolves—confusingly called Tasmanian tigers because of their striped rumps—were exterminated in the early 1900s. Having disappeared from New Guinea and Australia much earlier, Tasmania had been this species' final stronghold.

Today Tasmania retains the world's most complete set of larger predatory marsupials, all belonging to a group called the Dasyurids. At first glance, most of these creatures appear cute and appealing—the quolls, for instance, look like soft toys. But appearances are deceptive, for these are baby-faced assassins, capable of killing prey as large as themselves.

The largest surviving Dasyurid is the Tasmanian devil, as large as a small stocky dog, for which the term "baby-faced" definitely does not apply. Like the Tasmanian tiger, the devil was once found across Australia, although not in New Guinea. Like the kangaroo, the devil is the result of a bizarre experiment in body shape, but whereas the kangaroo ended up with massive back legs and tail, topped by a puny underdeveloped chest and forelegs, the Tasmanian devil is the reverse: it has a massive head and shoulders, with the rest of its body tapering away to small hind legs and a scrawny tail. While the kangaroo can bound effortlessly, maintaining good speeds over long distances, the Tasmanian devil can muster only an ungainly rocking-horse gait. But as a scavenger, the Australian version of a hyena, the Tasmanian devil is formidable. There is nothing it will not eat—skin, bones and even teeth—and table manners are not its forte: five or six Tasmanian devils squabbling over a road-killed wombat is a blood-curdling sight and sound.

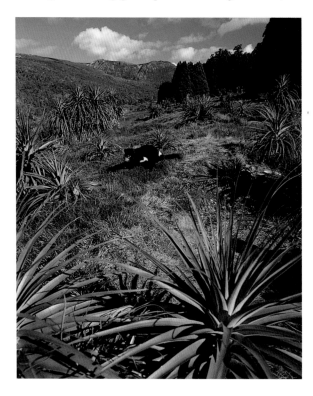

Next in size is the spotted-tailed quoll. Long bodied and long tailed, the male is as big as a young fox, while the smaller female matches a medium-sized domestic cat. Despite its size, however, the spotted-tailed quoll is a killing machine, the marsupial equivalent of a gigantic weasel. Like the weasel, the quoll is fearless about tackling prey larger than itself—a male will take on the pademelon, a small kangaroo. More often, the spotted-tailed quoll hunts birds and possums in the trees: using its long tail for balance, it is superbly at home in the treetops.

The killers get smaller and smaller—the kitten-sized eastern quoll, the rat-sized dusky antechinus, and the white-footed dunnart, which looks like an elegant long-legged mouse—each targeting progressively smaller prey. Often called marsupial mice, the antechinus and the dunnart behave

Tasmania A Topsy-turvy World

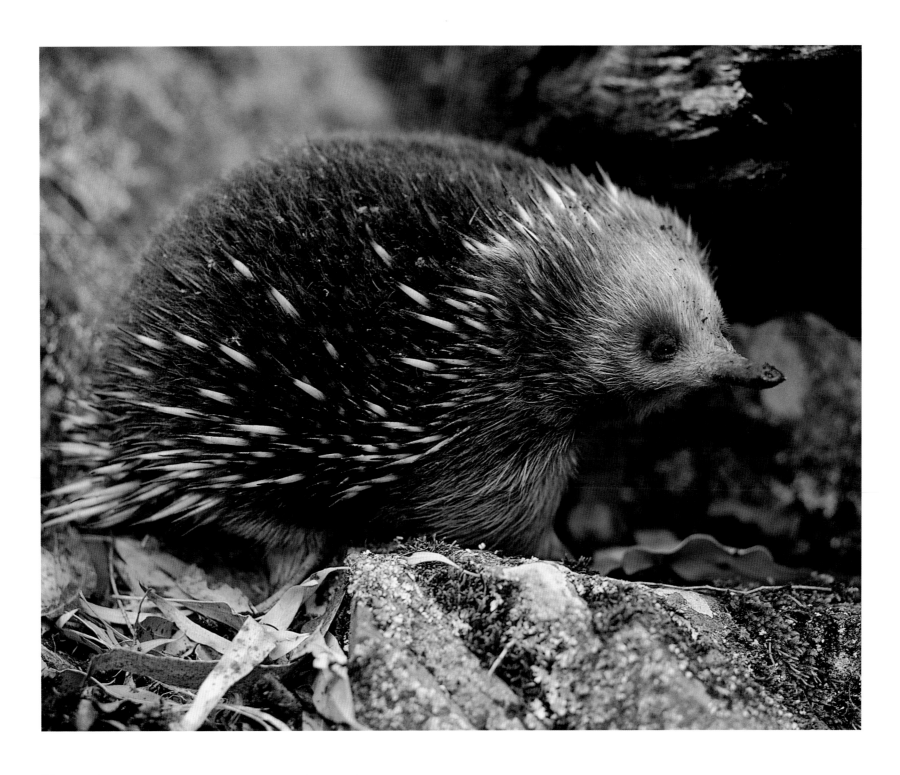

*The long-nosed potoroo (*Potorous tridactylus apicalis*), RIGHT, looks rather like a cross between a rat and a kangaroo. It prefers the higher rainfall areas of Tasmania, where it hides in dense cover and feeds at dusk on insects, roots and fungi.*

*Now rare in mainland Australia the eastern barred bandicoot (*Perameles gunnii*), BELOW, is still widespread in rural grassland areas of Tasmania. Unfortunately, the recent discovery of foxes in Tasmania means that these three youngsters may no longer have an assured future on this island refuge.*

*The common wombat (*Vombatus ursinus*), BELOW RIGHT, is another well-loved and widespread Australian marsupial. This large burrower was called a badger by early settlers, but it is actually more closely related to Australia's tree-climbing koalas than to any other animal.*

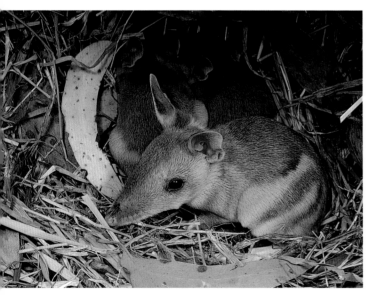

more like cats. The closest ecological parallels for these hunters of insects, spiders and lizards are hedgehogs and shrews.

With differences in size between species, between males and females of the same species, and between adults and young of the same species, the dasyurids have very effectively carved up all the potential carnivorous niches. These secretive, nocturnal killers make Tasmania's cool temperate beech forests— which are almost too cold for them—a very dangerous place for the small and unwary. These are species at the very southern limits of their temperature tolerance and, as a result, they behave at times more like reptiles. External temperatures have a strong effect on quolls and devils—they often need to sunbathe to warm up, or to shelter from the elements by curling up tightly inside a hole. When they are cold, their metabolism and even their brain function is sluggish. But because they don't have to compete with warmer, faster placental mammals, behaving like reptiles is not a handicap to their success.

It's not just the marsupials that struggle with the low temperatures, however. Coping with the cold has been a challenge for Tasmania's flora as well. The cooler parts of the island are cloaked in a primal forest with a rich Gondwana heritage that includes the southern *Nothofagus* beeches found also in Chile and New Zealand. These dark, ancient wet forests are so different from those on the mainland that you could be forgiven for not realizing you were in Australia at all. And the confusion about location is compounded because, although Tasmania does have eucalypt forests, it lacks some very obviously "Australian" inhabitants such as the koala (which is a specialist so closely tied to a handful of eucalypt species, that it couldn't cross the eucalypt gap that existed even when Tasmania was joined to the mainland by a land-bridge during the last glaciation).

Australia's only deciduous tree is a species of beech, *Nothofagus gunnii*, that makes its home on the high slopes of Tasmania's mountains, and in autumn it paints entire mountainsides gold. Snow-covered in winter, these mountains can be intensely cold, so the more usually evergreen beech tree's way of surviving winter is to drop its leaves, a classic plant solution to the problem of seasonal cold. The honey *Richea* bush, however, has become part of a strikingly original way of circumventing nasty summer weather when icy gales frequently pummel elevated areas such as Mount Wellington. If the honey bush opened its flowers in those conditions there is little chance that its insect pollinators would be active. So it has co-evolved an ingenious *ménage à trois* to ensure its flowers open only on warmer days. Each flower's pollen and reproductive parts are locked in a fused cap of petals, out of reach of its pollinating insects. The honey bush relies on the snow skink, which is active only on suitably warm days, to rip off the cap and chew on it for a nectar reward, in the process opening the flower to its pollinators. It's a beautifully crafted solution to a very particular problem.

Tasmania A Topsy-turvy World

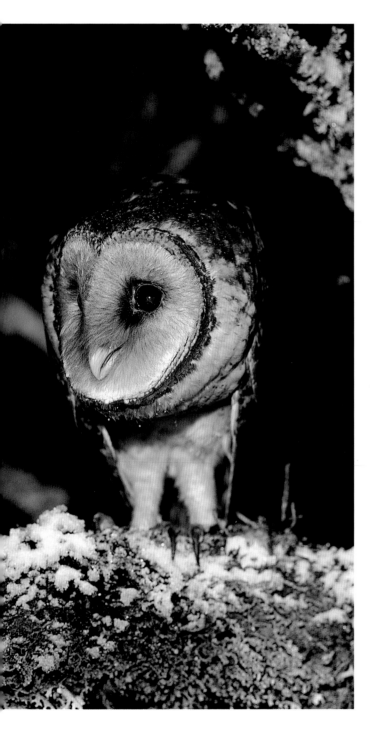

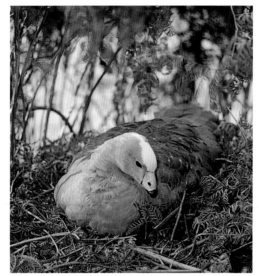

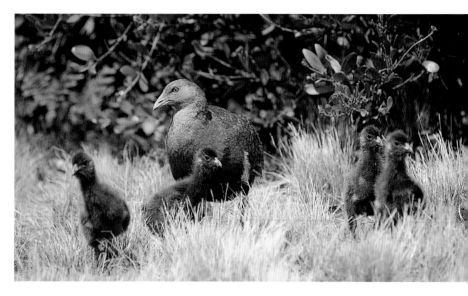

Below the high-altitude deciduous beech, an evergreen beech—*Nothofagus cunninghamii*, known locally as myrtle—forms dark and moody forests. The beech trees are festooned in lichens, with dense canopies that cut out the light and only mosses and liverworts carpet the forest floor. It truly feels like stepping into an ancient Gondwana forest.

Southern conifers, on the other hand, such as pencil pines (*Athrotaxis cupressoides*) and King Billy pines (*A. selaginoides*) create groves reminiscent of dark northern hemisphere conifer forests. These two slow growing conifers are the only members of this family in the southern hemisphere.

To step out of these dark forests into a clearing is to step into a totally different world. This is a world of grass clipped as neat as a golf course—Australia's unique marsupial lawn. Wombats and wallabies venture from the sheltering forest at night to graze, and the result is a grassy sward the envy of any green manager. The marsupial lawn is as surprising and unexpected as the animals that created it. Tasmania's forests at the southern tip of Meganesia provide an evocative glimpse of Gondwana's lost forests. But it is on another island at the northern tip of Zealandia, another remnant of the former supercontinent, where Gondwana's greatest botanical treasures are still to be found—New Caledonia, home to a vast wealth of podocarps, primitive flowering plants and even some of the world's earliest pollination stories.

*Despite its rather gentle appearance Tasmania's large masked owl (*Tyto novaehollandiae*), LEFT, is an extremely effective predator, capable of killing surprisingly large prey with its strong talons. Even a Tasmanian devil joey is not safe from this silent hunter.*

*Once considered a rare bird, the Cape Barren goose (*Cereopsis novaehollandiae*), ABOVE LEFT, now occurs in large numbers, concentrated along the coastal areas of Bass Strait in both Tasmania and on the mainland. It is usually seen in small flocks, although at times these merge into larger flocks in low-lying pastoral areas away from the coast.*

*Rather surprisingly for a flightless island bird, the Tasmanian native hen (*Gallinula mortierii*), ABOVE RIGHT, is widespread and thriving. A strong runner, often seen feeding in family groups in open pastures, it is always ready to run off into rough cover in which it can hide.*

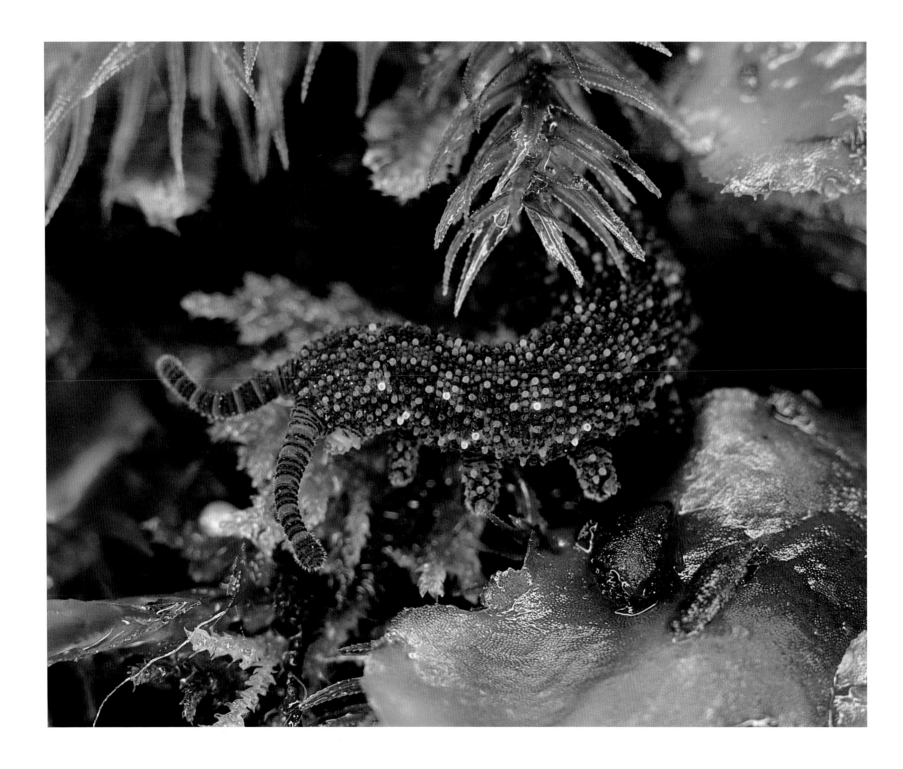

Tasmania A Topsy-turvy World

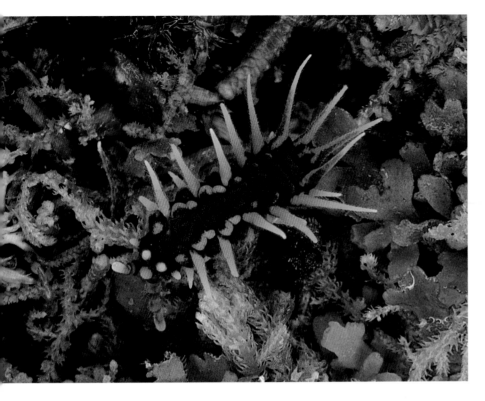

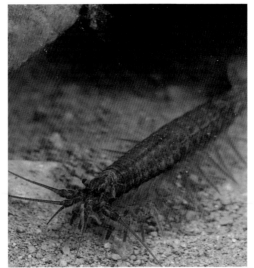

*Many of the invertebrates found in southern Tasmania's beech forests are living relicts, with an ancestry that goes back to Gondwana. They have close relatives living on other ancient Gondwana fragments such as South America and New Zealand. Peripatus or velvet worms (*Ooperipatellus insignis*),* OPPOSITE, *date back more than 300 million years.*

*Concealed deep within the leaf litter and moss, Tasmania's springtails or collembola (*Womersleymeria bicornis*),* FAR LEFT, *are some of the largest and most colorful in the world.*

*The semi-slug (*Helicarion cuvierii*),* BELOW FAR LEFT, *is a Tasmanian snail with an ancient Asian, rather than Gondwanan, connection. Its shell is greatly reduced to protect little more than its vital organs.*

*Perhaps the best known of all Tasmania's "living invertebrate fossils" is the Tasmanian mountain shrimp (*Anaspides tasmaniae*),* ABOVE RIGHT, *a shrimp that is remarkably similar to fossil shrimps living more than 250 million years ago. It retains primitive features such as a straight body and no protective hard shell, and is still commonly encountered in mountain streams.*

*A common resident of forest and woodland, this small grayish owlet nightjar (*Aegotheles cristatus*),* LEFT, *hawks for insects and moths on the wing after dark. By day it remains concealed amongst rocks or in tree hollows.*

Areas of almost pure buttongrass (Gymnoschoenus sphaerocephalus) *cover many of the plains in Cradle Mountain,* RIGHT. *Despite its name, buttongrass is a sedge, growing on acidic peaty soils of low fertility where it provides shelter and food for a great range of small Tasmanian animals such as this butterfly, the Tasmanian brown (*Argynina hobartia montana*),* ABOVE.

*King Billy pines (*Athrotaxis selaginoides*),* ABOVE RIGHT, *are a distinctive feature of Tasmania's temperate rainforests, especially at higher altitudes, where individual trees may be up to 130 feet (40 meters) tall and 1300 years old. This group of slow-growing conifers has no living relatives in the southern hemisphere. Unlike much of Australia's and Tasmania's forests, King Billy pines are not fire adapted, and as a result they survive only in higher, wetter places.*

In autumn, Australia's only deciduous tree colors Tasmania's mountainsides gold, OPPOSITE. Nothofagus gunnii *is a hardy alpine shrub that grows at high altitude, right to the snowline. Like the King Billy pine it is intolerant of fire. Other southern beech species occur in temperate New Zealand and South America.*

Tasmania A Topsy-turvy World

1000m bathymetric contour

2000m bathymetric contour

Loyalty Islands

New Caledonia

Grand Terre

Plain des Lacs

Nouméa

Isles des Pines

New Caledonia

Living Plant Museum

A prominent feature of the raised atolls around the appropriately named Iles des Pines are ancient Araucaria pines. One of the most striking of New Caledonia's thirteen species is Cook's pine (Araucaria columnaris), OPPOSITE, named after the great explorer and navigator Captain James Cook.

TUCKED OUT OF the way at the top of our local museum is a little space called Nature's Attic. It's a quaint old-fashioned treasure trove of curiosities and old specimens, and in that respect it is much like the islands of New Caledonia. Straddling the Tropic of Capricorn, New Caledonia is the Nature's Attic of the Pacific. A living plant museum, it is full of the rare, the unusual and the outright curious.

Along with New Zealand, Lord Howe Island, the Kermadec Islands and the Chatham Islands, New Caledonia was once part of the Gondwana relict of Zealandia. After drifting away from neighboring Meganesia, New Caledonia reached its current position about fifty million years ago. Since then large parts of it have been submerged and covered by thick layers of ultramafic rocks. These rocks are dark and heavy, and rich in metals such as iron and magnesium, as well as heavy metals, including copper and nickel that are generally toxic to plants. This is a relatively rare rock type. Ultrabasic soil that is formed from ultramafic rocks is usually thin and poor in nutrients, and can be a startling red color.

New Caledonia's ultramafic rocks have been heavily eroded since they re-emerged above water, but they still cover nearly one-third of Grande Terre. Grande Terre is by far the largest of New Caledonia's thirty-six islands, even though it is just 220 miles (350 kilometers long and between 30 and 40 miles (50 and 70 kilometers) wide. Its mountainous spine intercepts moist winds that blow off the sea, creating a well-watered highland. Despite the good growing conditions offered by the climate, true forest is found only in patches. Instead, large areas of ultramafic rocks are home to heath and shrublands that the locals call the maquis. The stark lunarscape of the maquis often comes as a surprise to first-time visitors, who have been expecting something a little more lush and tropical. But despite the harshness, the maquis and the moist evergreen forests that also survive on the ultrabasic soils contain most of New Caledonia's botanical treasures.

The majority of these treasures are found nowhere else—an astonishing 76 percent of the more than 3000 plant species found in New Caledonia are endemic, a proportion bettered only by other biodiversity hotspots such as Hawaii and Madagascar. There is also a huge diversity for such a small land mass. This richness is all related to the geological history of

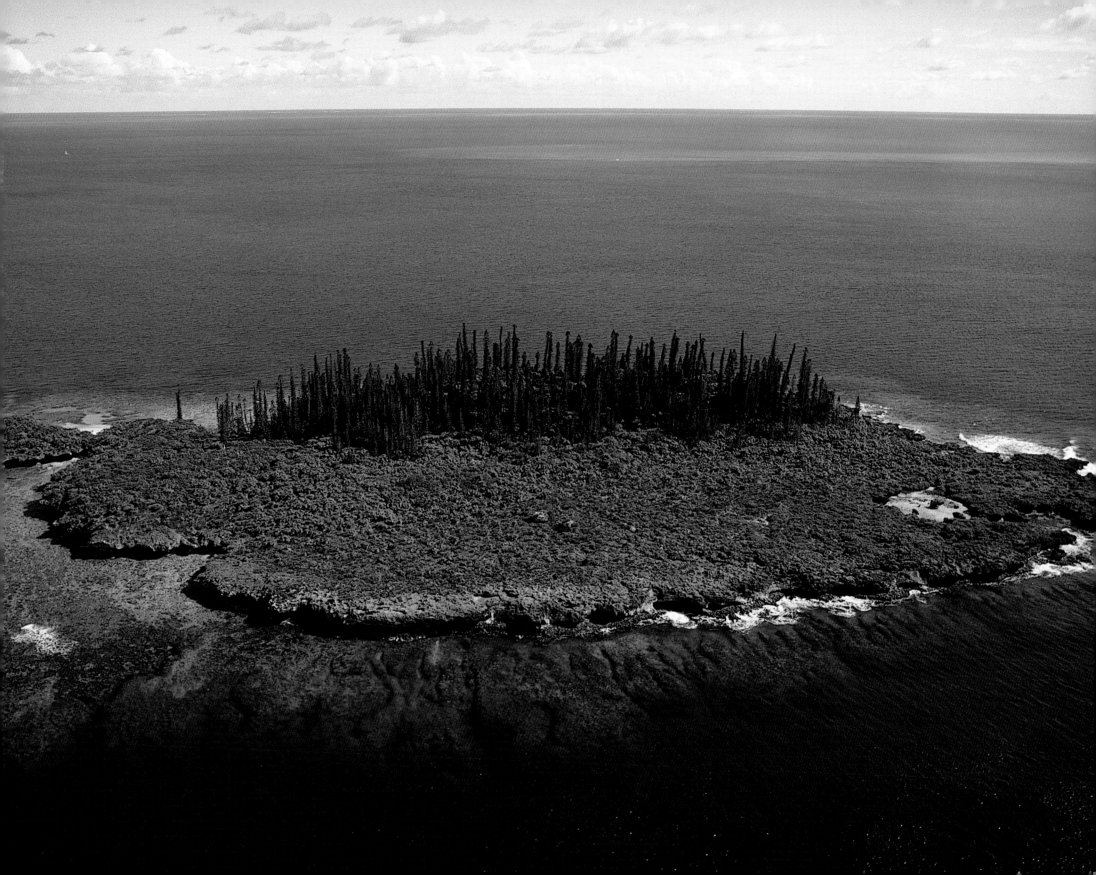

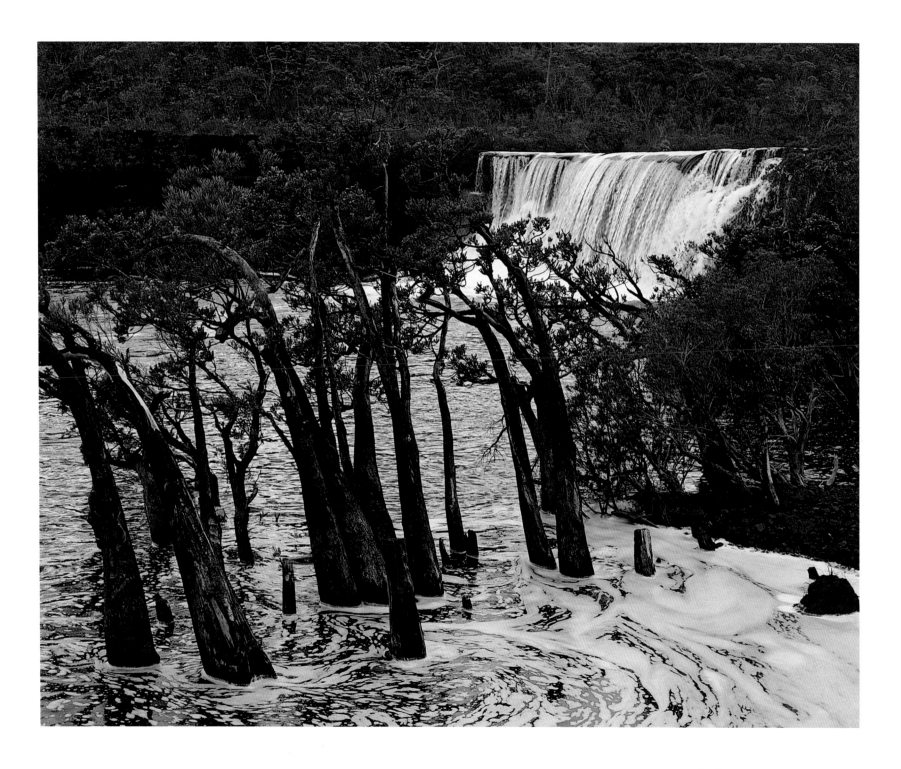

New Caledonia Living Plant Museum

the islands—many early Gondwana relics survived here after they had become extinct in Australia because of increasingly dry conditions there. In the extreme environment of the ultramafics, plants had to adapt and specialize. Plants became finely tuned to the nuances of the local soil—some adapted to soils with high nickel levels, some became accustomed to high copper levels, and others "learnt" to thrive in soils with moderate levels of both.

Among New Caledonia's 3000 plus species are some of the world's most primitive plants and their descendants. A few—including *Psilotum nudum*, a direct descendant of the first plant with stems, and *Tmesipteris tannensis*, which is related to the earliest plant with leaf-like structures—are also found in other places through the Pacific.

Elsewhere in the world, flowering plants, or angiosperms, which made a sudden appearance on the botanical stage, usually eclipsed all the earlier plants and now far outnumber them. But on New Caledonia it's the earlier plants, the gymnosperms, that still reign supreme. To visit here is to truly step back onto Gondwana.

Araucaria are ancient pines, and thirteen of the world's nineteen species are found in New Caledonia. (The other six species, including the familiar monkey puzzle trees and the newly discovered "living fossil," the Wollemi pine, are spread between Australia and South America.) These relics have not just survived here in New Caledonia—they've thrived, and now range in form from broad, spreading candelabras to tall, pencil-thin columns. When Captain James Cook found New Caledonia on his second voyage to the Pacific in 1774, he and his men were puzzled by the sight of tall objects they thought might be towers. The ship's father and son scientists, the Forsters, continued to maintain they were stone pillars even after the rest of the party were satisfied that they were indeed looking at trees. They had found *Araucaria columnaris*, now called Cook's pine, and Cook and his carpenter thought they would make ideal ship's masts.

Another forty species of ancient southern pines are also found here, including trees in the genus *Agathis*. New Zealand's kauri trees and Fiji's dakua trees are other members of this genus. They're not the only shared link to other parts of Gondwana: New Caledonia shares a suite of southern podocarps with New Zealand, Tasmania and Australia. Not all the New Caledonian species are instantly recognisable as podocarps, however—the island's own special brand of magic has cast some species into unlikely roles. The genus *Decussocarpus* has become semi-aquatic, thriving on lake margins, while the peculiar and aptly named *Parasitaxus* is over 3 feet (about a meter)

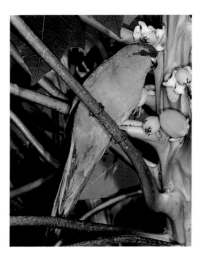

*Several members of the Podocarp family of ancient southern pines survive on fragments of Gondwana, but none are quite as extraordinary as these two species from New Caledonia. The semi-aquatic podocarp (*Decussocarpus minor*), OPPOSITE, often grows with its trunk in the water. Parasitaxus ustus, FAR LEFT, is the world's only parasitic podocarp, parasitizing one other podocarp species, Falcatifolium taxoides.*

*The New Caledonian species of red-crowned parakeet (*Cyanoramphus saisseti*), ABOVE, is practically indistinguishable from other species that occur across the Pacific as far afield as New Zealand's subantarctic islands. Believed to be the ancestor of all Cyanoramphus parakeets, it is a striking example of the powers of long-distance dispersal.*

*New Caledonia once contained one of the greatest diversity of reptiles to be found anywhere. Even today its gecko species display a tremendous variety of size and forms. There is a sideways-compressed creature that closely resembles a chameleon, and one that has a well-developed crest of spines running back from spiky eyebrows. Leach's giant gecko (*Rhacodactylus leachianus*), LEFT, seen here basking on an Araucaria trunk, is the world's largest surviving gecko.*

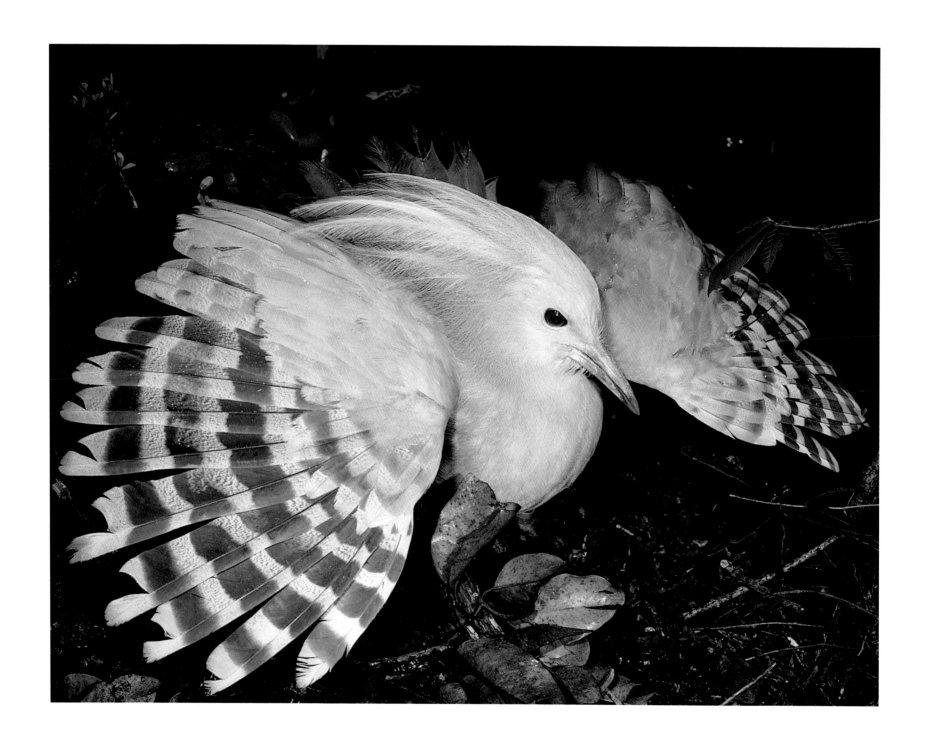

New Caledonia Living Plant Museum

high and looks like a purplish-red coral that's been transplanted ashore. It gets its energy by parasitizing the roots of another podocarp, and is the only known parasitic gymnosperm in the world.

There are even more astonishing treasures to be found in this botanist's paradise. The single most extraordinary feature of New Caledonia's flora is the huge concentration of primitive flowering plants. The appearance of flowering plants has always been an enigma— they burst upon the world scene during the Cretaceous, and by the end of the period were the dominant plant forms on earth. Charles Darwin described their sudden appearance in the fossil record as "an abominable mystery." Flowers are ephemeral and delicate and don't fossilize well, leaving very little material for palaeobotanists to work with as they search for answers to questions about how they evolved and why. But the next best things to fossils are living primitive flowering plants, and the best place in the world to study them is the walk-in museum of New Caledonia.

Only very recently has genetic work revealed that the oldest known flowering plants in the world are water lilies and a nondescript shrub from New Caledonia. *Amborella trichopoda* is a small shrub with tiny greenish-yellow flowers and red fruit. Its primitive features include a lack of vessels in its wood for conducting water out of the ground and into its leaves. Although it is not the very first flowering plant it is the sole surviving member of the most ancient lineage of flowering plants, a group that now numbers more than a quarter of a million species.

The first flowers probably evolved in mountainous highland areas of the South Pacific, and clusters of primitive species found in places such as New Caledonia and the wet tropics of Australia lend support to this theory. The ancient family of Winteraceae, which is related to the magnolias and has a fossil record dating back at least 120 million years, is well repre-

sented in New Caledonia with eighteen species. New Caledonia shares the genus *Bubbia* with New Guinea and Queensland, and five of the six species in the genus *Zygogynum* are found only in New Caledonia (the remaining species occurs on Lord Howe Island).

The flowers of these primitive groups clearly show how structures such as stamens and petals evolved from leaves. Leaf-like structures wrap around an ovary, which is surrounded by flattened stamens with pollen embedded in their surface. To avoid self-pollination, the female part of the flower opens a day earlier than the male parts. The extraordinary flowers of *Zygogynum* are matched

*The kagu (*Acionyx jubatus*), OPPOSITE, is New Caledonia's most distinctive native bird. A male erects his crest and spreads his wings in a threat display to distract attention from his beautifully camouflaged chick on the forest floor nearby, LEFT. More typically, however, this chicken-sized bird drifts wraith-like through New Caledonia's forests past massive trees such as kauri (*Agathis montana*), ABOVE LEFT.*

*A fork fern (*Tmesipteris tannensis*), ABOVE, hangs from a tree fern trunk in the forest. Fork ferns are very primitive plants, regarded as being relatives of the very first plants to produce leaf-like structures. They have found sanctuary on a number of Pacific islands.*

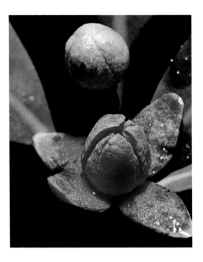

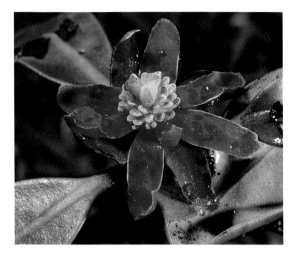

The opening bud, ABOVE, of the one of the world's earliest flowering plants, Zygogynum baillonii. The opened flower of this brightly colored species, ABOVE RIGHT, shows how structures such as stamens and petals evolved from modified leaves.

The distinctive Strasburgeria robusta, RIGHT, is a primitive flowering plant with large apple-sized fruit and is the sole member of its endemic family. Its nearest modern relative is probably the camellia, another member of the tea group of plants.

A large red velvet mite (Trombidium sp.), OPPOSITE, stalks through leaf litter in search of soil-dwelling prey. Mites are the most widespread and abundant of the world's arachnids, a group that comprises spiders and their relatives.

in their primitiveness by their pollinators, moths in the ancient genus *Sabatinca*, which have chewing mouth parts and feed on pollen, as well as moving it between flowers—they may be one of the first examples of how moths and butterflies became closely associated with plants. What is lovely is that these little moths allow entomologists glimpses into the past, in the same way that New Caledonia's primitive plants offer botanists a view of times past.

Although *Zygogynum* has a little insect helper for pollinating, it never evolved a similar relationship with any animal that could disperse its fruit. The large, green, apple-like, woody-fleshed fruit just fall to the ground underneath the parent plant. Was it perhaps once associated with a now extinct reptile that distributed its fruit?

As well as many endemic species and genera, New Caledonia also has five endemic plant families, including Amborellaceae, whose sole member *Amborella* is the oldest known flowering plant discussed earlier, and the family Strasburgiaceae, which is related to the tea group of plants. Like *Zygonynum*, *Strasburgeria robusta* has a large, green, apple-like fruit and it too lacks an obvious connection with any modern disperser.

Not all the New Caledonian plant species are ancient relicts. Many other groups arrived here well after the islands had separated from Australia and many are closely related to Australian species. The forty-two species of proteas, grevilleas and banksias give it a strong Australian flavor, which Cook commented upon during his 1774 visit, although eucalypts are a noticeable absence. There are more than 200 species of Myrtaceae, including tea trees, and more than twenty species of *Metrosideros*, many of which are des-cended from the New Zealand species.

New Caledonia's incredibly rich flora is not matched by its fauna, however. In fact, it has a strangely unbalanced biota, with an almost depauperate fauna. To make matters worse, many of its animals are extinct.

Once upon a time the islands probably had one of the greatest reptile diversities to be found anywhere, including a giant horned vegetarian tortoise with a heavily armored tail that looked like a medieval spike and mace, and a dwarf land croco-dile, up to 6½ feet (2 meters) in length. New Caledonia shared these species, or at least similar species, with Fiji. The crocodiles were distantly related to hoofed carnivorous crocodiles, which became extinct everywhere else about sixty million years ago

New Caledonia shares its giant land snails, such as Placostylus mariae, ABOVE, *which trace their ancestry back to Gondwana, with other Pacific islands such as Fiji and New Zealand. Unfortunately, sack-loads of these ancient snails are taken from the forest each year and transported to Noumea, where they are consumed in French restaurants as escargot.*

*Screwpine (*Pandanus tectorius*), ABOVE RIGHT, is a typical coastal plant on many Pacific islands. However, this is New Caledonia, a living plant museum, and even this ubiquitous plant has evolved into more than twenty unique endemic forms here.*

*Three golden bat flies (*Brachytarsina amboinensis*), BELOW RIGHT, cling to the fur of a New Caledonian bat. They have greatly reduced eyes and biting mouthparts, but their strong grasping legs ensure they are not dislodged, even when their host is flying or walking.*

*New Caledonia has many spectacular examples of some of the early flowering plant groups. *Grevillea exul*, OPPOSITE, belongs to the Proteaceae family, which is well represented in Australia.*

but on this isolated haven survived until just 1800 years ago, after humans first arrived. The dwarf crocodiles had sharp teeth at the front of their mouths and heavy crushing teeth at the back: they may have used this array of teeth to feed on giant molluscs such as *Placostylus* landsnails, which are found in both New Caledonia and Fiji. There was also a medium-sized monitor lizard that was an opportunistic predator, and there are still many species of skinks and geckos, the majority of which are Gondwanan relicts, and include in their midst the world's largest surviving gecko—Leach's giant gecko.

New Caledonia's avian fauna is particularly poor, comprising only forty-four species, most of which probably arrived after the islands became isolated. The most outstanding species is the kagu. This unusual bird is mostly flightless, although it manages to fly up onto low branches, which it probably once needed to do at night to escape the attention of the monitor and the crocodile. It has large eyes and a crest on its head that it erects when excited or courting. The kagu also exhibits an odd wing-waving display that may have once helped it lure the ancient reptiles away from its nest, although probably not very effectively.

Gray and vaguely heron-like, the kagu has long been classified in a diverse group of birds that includes rails and cranes, but it didn't appear to have any close relatives. However, some recent anatomical and molecular research has shed some interesting light on this group, and in particular on the kagu and its place in the bird world. It turns out that the kagu's closest living relative is the sun bittern, an almost flightless bird that lives in the rainforests of Central and South America. The common ancestor of these two birds lived on Gondwana, at a time when Zealandia and South America were both joined to Antarctica. Even if the ancestral bird were as flightless as its descendants, it could easily have dispersed across Gondwana by walking. Interestingly, scientists increasingly believe kagus and sun bitterns share their Gondwana beginnings with many other groups of birds, even modern groups such as songbirds, which it was traditionally believed evolved in the northern hemisphere.

Larger birds did once inhabit New Caledonia. The biggest was a giant megapode the size of a turkey. The only other megapode that came close to it in size was Fiji's big megapode. Next in the size stakes was *Porphyrio kukwiedei*, a member of

the widespread group of swamp hens, while third place went to a larger species of kagu. The surviving kagu clocked in at fourth place, followed by an extinct rail that was related to rails still found in New Zealand.

Today the kagu, the largest avian survivor, still drifts ghost-like through ancient araucarian forests, a Gondwanan vision that fills the forest with strange cries and puppy-like yelps, the only survivor of a small suite of strange birds. Yet on another, larger bit of old Zealandia, on New Zealand far to the south, a whole world of unusual flightless birds once also existed.

New Caledonia Living Plant Museum

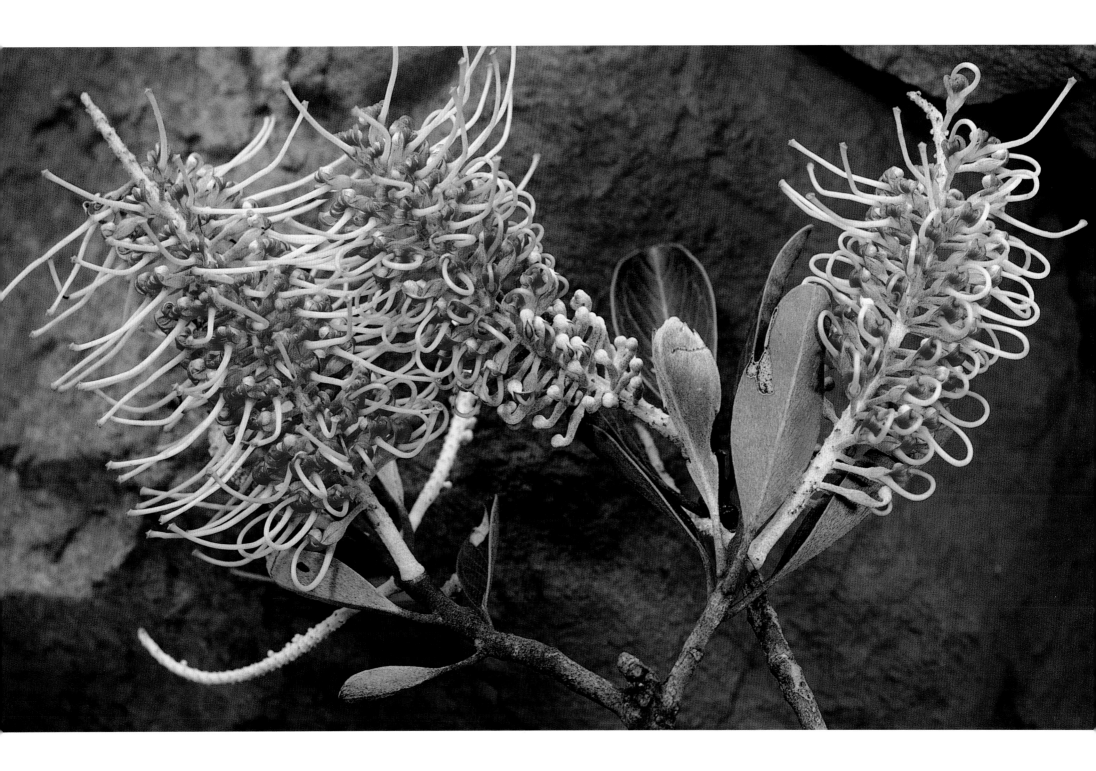

New Caledonia

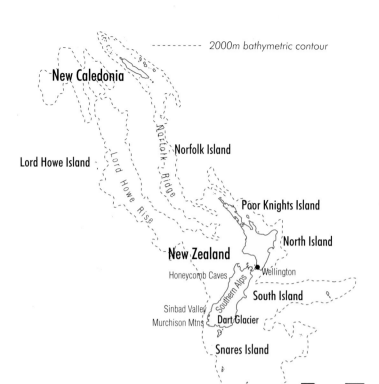

2000m bathymetric contour

New Caledonia

Norfolk Ridge

Norfolk Island

Lord Howe Island

Lord Howe Rise

Poor Knights Island

North Island

New Zealand

Honeycomb Caves

Wellington

Southern Alps

Sinbad Valley

South Island

Murchison Mtns

Dart Glacier

Snares Island

New Zealand
Land of Birds

The kiwi, BELOW RIGHT, is the most aberrant of birds, even amongst its own group the ratites, the ancient flightless walking birds, and is a lesson in not taking New Zealand birds at face value. It is small, whereas most of its relatives are very large, but it still lays an egg that is as enormous as those of its bigger relatives.

Perhaps the most spectacular example of adaptive radiation in New Zealand birds occurred in the flightless giant moas, the largest of which were so tall that a person standing beside one would have been unable to look across its back. Much of what we know about these extinct birds has had to be painstakingly pieced together from clues from subfossil bones and remains. For a long time scientists assumed the moa held its neck upright like a giraffe, but more recent reconstructions, such as this Dinornis giganteus, OPPOSITE, show the bird with its neck and head angled forward from the body.

NEW ZEALAND'S WONDERFUL flightless birds form a magical cast of characters that are exceptionally distinctive and unusual. But, sadly, what we see today is just a pale shadow of what once was. It's like arriving late for a play that has been hailed as a masterpiece—you've missed the first act but enjoy the second part, despite not having any context for it. Because it is some of the earlier missing characters in New Zealand's forests that make sense of everything. Giant browsing ratite birds, for instance, shaped the plants and the giant Haast's eagle *Harpagornis* was a mighty predator with talons the size of tiger claws, whose presence influenced the behavior of the other large birds.

In the inverted world of Tasmania, marsupials substituted for the placental mammals that never lived there. In New Zealand the substitutions are even more bizarre and unexpected. This is a land where birds became substitutes for deer, goats, shrews and even moles. They could be browsers, grazers, hunters and insectivores—all roles that on continents are taken by

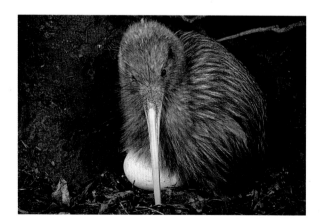

mammals. This was possible because New Zealand had no terrestrial mammals, apart from a few species of bats. This truly was a land of birds.

All the transforming ingredients of island magic were present: long isolation in time and space; a wide variety of habitats; a small eclectic cargo of founding species; and a thin but steady stream of enterprising immigrants. Some species were lost along the way as New Zealand morphed considerably in shape and size—at one point about 25 million years ago most of New Zealand was under water. Geologists tend to argue that all of New Zealand's islands were under water at that time, but biologists counter by

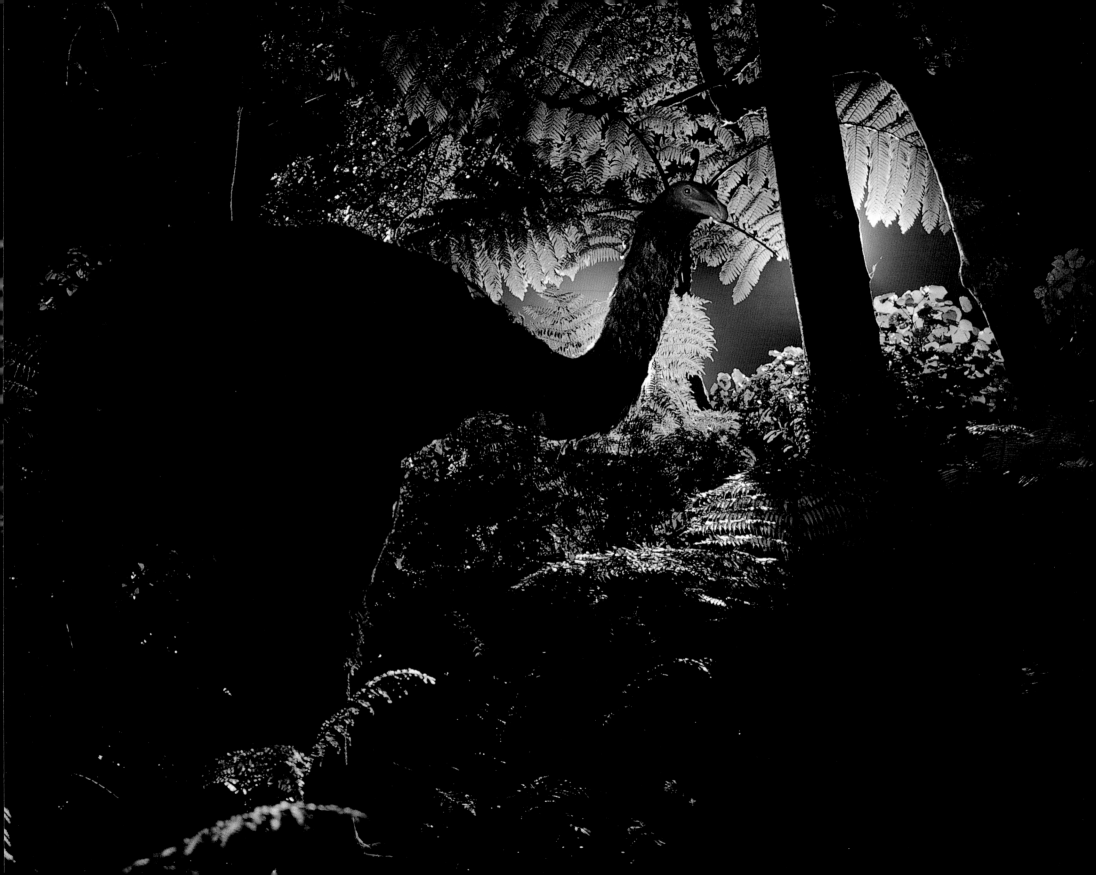

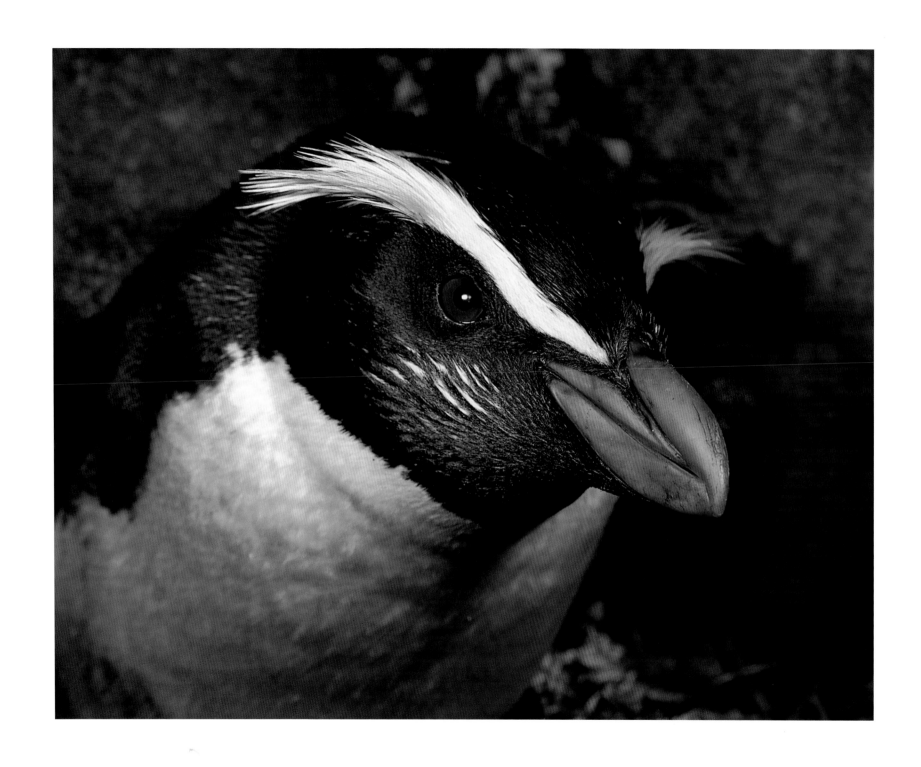

New Zealand Land of Birds

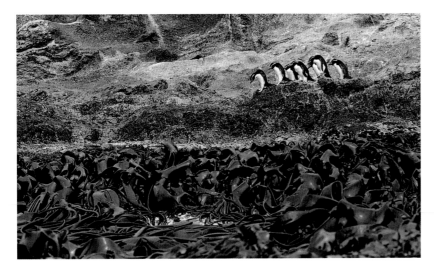

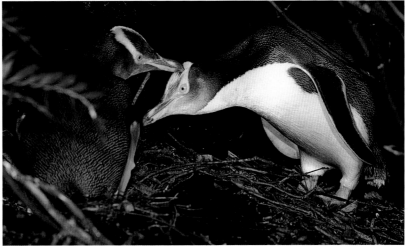

saying that all the Gondwanan relicts that occur here would have needed at least some land to survive on.

One result was the evolution of birds that are long-lived and slow-breeding. Many of them are giants of their kind, such as the nocturnal kakapo, the world's heaviest parrot. The sweet-smelling kakapo, or owl parrot, is the very essence of a New Zealand bird, a naïve innocent time traveler that struggles to belong in the modern world. Where else do you find a bird whose response to possible danger is to drop its head and stay immobile for long periods, sometimes ten or fifteen minutes at a time. Perhaps the reason it does so lies in the sub-fossil bones that are all we have left of so many other New Zealand species: if the hunter were a bird operating by sight and sound rather than by smell, then keeping perfectly still was probably a sensible option.

The kakapo's feathers certainly provide perfect camouflage: they are a complex and subtle pattern of green, yellow and brown that blends so well into a sunlight-dappled forest floor that the birds can be invisible to even a close observer. We usually think of parrots as bright, tropical birds, but other New Zealand parrots such as the mountain kea and its forest cousin the kaka are also quite drab, though their subdued olive-brown coloring is relieved by hidden color: extravagant flashes of red or orange under their wings.

An outstanding feature of New Zealand's avifauna is the number of flightless birds. Over half of the endemic land birds were either totally or almost flightless. In the rest of the world, less than 1 percent of birds are flightless. Flight allows birds to escape speedy predators and to travel far in search of food, but these characteristics weren't that important in New Zealand. Because there were no mammalian predators on the ground and food was abundant, many birds gave up flying rather than expend unnecessary energy on a mode of locomotion that didn't offer any particular advantages. The presence of flying hunters in the daytime sky was even more reason to give up flight and to change to the night shift, as the kakapo did, along with another surviving species—the kiwi.

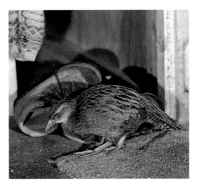

*Flightlessness is a feature of New Zealand's seabirds as well as its land birds, with penguins being the best example. More than three-quarters of the world's penguins occur in the New Zealand region, and all five of the crested penguins, including the Fiordland crested penguin (*Eudyptes pachyrhynchus*), OPPOSITE, and the Snares crested penguin (*Eudyptes robustus*), ABOVE LEFT, breed here. The crested penguins all share a distinctive yellow crest, but New Zealand's unique yellow-eyed penguin (*Megadyptes antipodes*), ABOVE RIGHT, has taken this feature one step further—even its eyes are an unusual yellow. A large number of extinct fossil species are found here, including one that was nearly as tall as a human.*

*The weka (*Gallirallus australis*), LEFT, is a New Zealand example of a flightless giant rail, a group that is a feature of remote oceanic islands. It's renowned in New Zealand for being a curious opportunist that is capable of turning its usual wily hunting skills into thievery and scavenging around human habitation.*

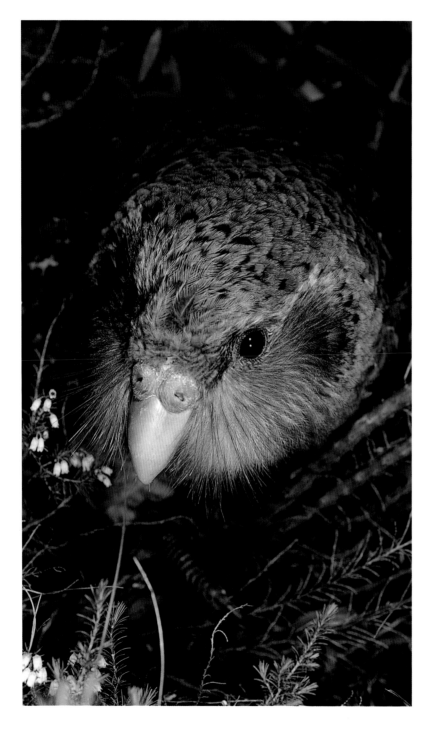

The kiwi is the most extreme example of flightlessness—it has walked so far along this path that it has lost its wings almost entirely. A kiwi wing is just a vestigial stump with a tiny claw on the end. And its feathers no longer look like feathers, but like hair.

Several other characteristics of the kiwi are remarkable, too. The female lays a record-breaking egg that can weigh up to 20 percent of her body weight—perhaps once the kiwi was much larger but as its adult body shrank its egg stayed the same size. And the kiwi is the only bird in the world with nostrils at the tip of its long beak, so it can probe the soil with the beak and sniff out its prey of earthworms. Then it uses its long bill like a pair of chopsticks to clamp onto a worm and gently pull it out of the ground bit by bit, thereby ensuring it gets the whole worm. Finding food by smell makes sense for a bird that is active in the dark. And being nocturnal was a good way to avoid the small but select group of predatory birds.

Eyles' harrier hawk and *Harpagornis*, or Haast's eagle, were the largest of their kind in the world. Sadly, along with half of New Zealand's endemic landbirds, they are now extinct. Among the "disappeared" are the largest birds the eagle preyed on: the moas. There were at least eleven species of this remarkable bird. They included one that lived in the mountains and was as agile as a goat, one that was a massive, squat, elephant-like beast, and a 6½ feet-tall (2-meter) forest browser that may have been like an okapi, or possibly an avian rhino. Imagine a scene set in dense shrubland, with huge birds walking around the landscape instead of continental herds of browsing mammals, and that would have been what prehistoric New Zealand looked like. The predators squabbling over a fresh kill would have been birds. So too would have been the scavengers, patiently waiting for the hunters to eat their fill.

The moas were New Zealand's most spectacular example of adaptive radiation. Along with the kiwis, moas were New Zealand's representatives of the ratites, a group that includes cassowaries and emus in Australia, ostriches in Africa and rheas in South America, as well as Madagascar's extinct elephant bird. The assumption has always been that moas and kiwis evolved in New Zealand from a common ancestor that was onboard Zealandia when it drifted away from the rest of Gondwana. But recent molecular work has thrown that idea on its head. It turns out that kiwis are more closely related to emus and cassowaries than they are to moas. The corollary of this is that kiwis must have come to New Zealand much later than the moas, although exactly how they reached an already isolated island is unclear. The lack of any kiwi fossils older than a million years old only adds to the mystery.

Mammalian herbivores on continents have shaped the vegetation they eat with cutting teeth and soft mobile mouths, but moas may have shaped a significant portion of New Zealand's plants with a very different browsing pressure. One school of thought

New Zealand Land of Birds

The endemic flightless nocturnal giant parrot, the kakapo (Strigops habroptilus), OPPOSITE, is so rare that every individual has a name. This is Sinbad, a young male with the rare distinction of being the offspring of the last remaining Fiordland male kakapo. Sadly, kakapo have become extinct on mainland New Zealand within our lifetime, surviving now only as relocated populations on offshore islands.

The takahe (Porphyrio hochstetteri), BELOW, is the world's largest surviving flightless rail. It was once widespread over New Zealand's North and South islands, but since the arrival of humans it has been forced to retreat to cold alpine areas and now naturally occurs only in Fiordland's Murchison Mountains in the South Island, LEFT.

holds that the high number of woody plants with a divaricating growth habit—nearly 10 per cent of New Zealand's woody flora—evolved that habit as a defence against being eaten. Divaricating plants typically have a chicken-mesh tangle of extremely strong, thin stems with a few small leaves scattered inside. Modern moa equivalents such as ostriches, that can only pluck, strip and tug with their beaks, struggle to harvest useable quantities of these plants, which are so strong that some botanists think they should be called wire plants.

Moa beaks, however, were much deeper than ostrich beaks, and moas also had very powerful muscles to close their bills, which meant their beaks were like an effective pair of shears that could cut twigs as thick as ⅓ inch (6 millimeters). But even if they attacked a divaricating plant with the efficiency of a pair of hedge clippers they still would have been rewarded with a meal of only twigs and tiny leaves. Another confounding point is that a heavily trimmed divaricating plant cannot regenerate new growth and dies. The jury might still be out on the role of moas in shaping the vegetation, but in the meantime the "moa browse theory" is a rich source of debate among scientists.

Other plants have strange juvenile forms—a young matai, a podocarp species also known as black pine, looks dead, and a juvenile kahikatea, or white pine, is grayish-brown and very amorphous and difficult to see. Some species have a divaricating juvenile stage, then revert to more usual adult foliage once they are above moa-head height. It's all effective camouflage to escape a bird that used color and shape to recognize objects.

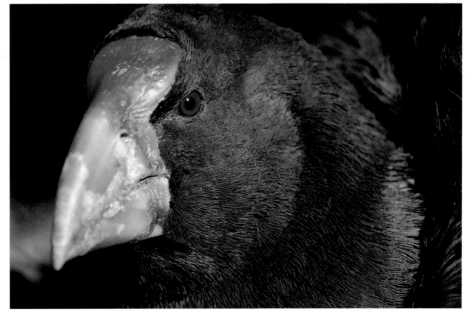

New Zealand Land of Birds

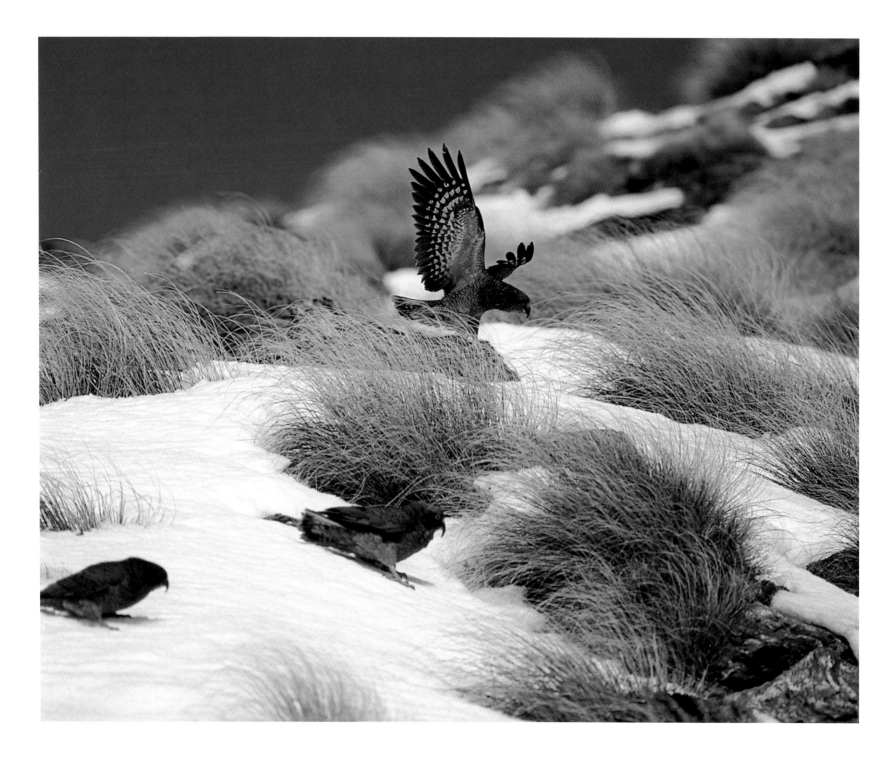

New Zealand Land of Birds

New Zealand boasts some other unusual plant-animal associations. The most remarkable is the quite recent discovery that the short-tailed bat pollinates a bizarre root parasite, *Dactylanthus*. Like the kiwi and kakapo with which it shares the night forest, this little bat spends much of its time on the ground. It furls its wings like umbrellas to protect them, and runs around on all fours, rustling through the leaf litter in search of invertebrates, such as insects, snails, spiders, and worms. We have filmed a group of bats actively burrowing and digging in the litter together like a flock of hyperactive sheep. The digging made sense of their short velvety fur—dirt just brushes off it.

The mysterious *Dactylanthus*—which some people call the wood rose from the gnarled twisting shapes the host's roots produce in response to the plant's parasitism—spends most of the year hidden underground, sucking goodness from the roots of its hosts. But every autumn it pushes a clump of flowers above ground which contain nectar laced with squaline, a pheromone designed to attract mammals—in this land of birds it was luring the only kind of mammal in the forest. And as they greedily drink the nectar, the short-tailed bats are dusted with pollen, which they generously, if inadvertently, move between plants.

Other wonderful associations take place high above the ground. New Zealand has more than sixty species of geckos and skinks, the greatest diversity of reptiles on any temperate land mass. This is an actively growing number—many of the species are cryptic, and are only being revealed by genetic work. A few species have been lost, however, including possibly the enigmatic kawekaweau, an enormous gecko that may once have been the largest in the world. Only a single specimen of this giant lizard exists and, although it is purported to have come from New Zealand, not a single fossil bone has ever been found among the many thousand of other lizard bones that have been unearthed.

However, some fossil bone discoveries in 2002 threw dramatic new light on New Zealand's reptile story. Amongst many fossils collected from a 15–20 million-year-old lake were some very unexpected and exciting remnants—the first records of a snake and a crocodile in New Zealand. Identified from just two jaw fragments, including teeth, the snake is a very primitive type of snake. The crocodile, known from just two scales and three teeth, was probably a small terrestrial species, up to 6½ feet (2 meters) in length and similar to the extinct land crocodiles of Fiji and New Caledonia. These early reptiles date from a time when New Zealand's climate was much more tropical than it is today; the ancient lake and its environs would have resembled the Florida Everglades. So far there is no evidence of any mammals amongst the new fossils, other than bats, but if animals as unlikely as snakes and crocodiles can turn up, who knows what may be uncovered in the future.

No one has any idea what ecological roles these reptiles might have played in New Zealand, but modern lizards are very important ecologically. The number of lizard species in New Zealand rivals that of the small bush birds and, like the birds, lizards play a pivotal role in pollinating flowers and dispersing seeds.

*The kea or mountain parrot (*Nestor notabilis*), OPPOSITE, is another eccentric representative of the parrot group in New Zealand. New Zealand parrots are fairly drab in coloration compared with tropical parrots, but in all other respects they are outstanding. The kea's bright underwings, an omnivorous diet and being active both day and night are characteristics it shares with the forest parrot, the kaka.*

*In a land of birds, bats such as this short-tailed bat (*Mystacina tuberculata*), LEFT, were the only terrestrial mammals. Short-tailed bats have been present in New Zealand for at least 35 million years. Like so many New Zealand birds the short-tailed bat spends a significant proportion of its time feeding on the ground. Its ground foraging and burrowing behavior have led some people to suggest these bats should be known as "flying moles."*

*Hamilton's frog (*Leiopelma hamiltoni*), ABOVE, is New Zealand's largest surviving native frog. Its modest appearance belies its significance as a very ancient relict—New Zealand's endemic frogs are the most primitive in the world, with features such as a lack of eardrums, an inability to croak and no webbing between its toes.*

New Zealand Land of Birds

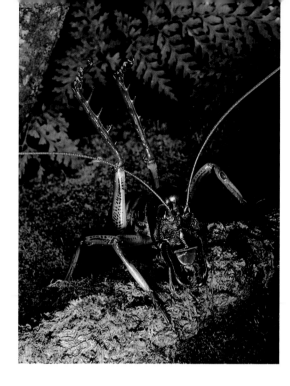

On the Poor Knights Islands, off north-east New Zealand, birds are busy during the day feeding on the prolific red brush-like flowers of the *Metrosideros* tree, the pohutukawa. The nights belong to the reptiles—they are so numerous there may be up to five individuals feeding at a single flower. Tiny feather-like scales under their chins trap pollen for up to twenty-four hours. Flax bushes and ngaio trees as well as the pohutukawa benefit from the scaly visitors.

The lizards also feast on fruits, and help spread seeds through the forest. Duvaucel's geckos will even manage to swallow the olive-sized orange fruit of the karaka tree—which is no mean feat—but will usually target smaller fruit such as blue or white *Coprosma* shrub berries. Larger, red fruit is designed to be more attractive to birds that also unwittingly work as carriers and dispersers.

The flowers of native mistletoe species rely on avian honeyeaters such as bellbirds and tuis for pollinating. Usually remaining tightly shut until a strong-beaked bird gives their tip a sharp twist and tweak, the flower then opens explosively, offering the bird a nectar reward and a daub of pollen to carry to the next flower.

Although most of New Zealand has a relatively temperate climate, even subtropical at its northern tip, it lies a long way south. Fierce westerly winds sweeping around the globe at these latitudes hit a chain of mountains running north-south, often dumping heavy loads of snow. There are permanent glaciers and ice fields, and the country has been subjected to long glacial periods. As a result, some of the New Zealand biota shows remarkable cold tolerance adaptations.

The kea, or mountain parrot, is a bird of the snow as well as the forest, and it breeds in mid-winter, often high above the snow line. While the bird is a good flier, its feet and claws serve well as crampons if it chooses to walk and these attributes enable this exceptionally intelligent and opportunistic bird to survive in the harsh extremes of the Southern Alps.

*Color, shape, pattern and structural characteristics set Helm's butterfly (*Dodonidia helmsii*), OPPOSITE, apart from New Zealand's five other endemic Satyrine butterflies. Whereas the other species favor grassland habitats, Helm's butterfly is a creature of forest glades. The hairy eyes are a particularly distinctive feature.*

*The tuatara (*Sphenodon punctatus*), LEFT, is one of New Zealand's most distinctive vertebrates. It is the last living descendant of a world-wide group of reptiles that evolved early on in the era of the dinosaurs and died out everywhere else about 60 million years ago. Tuataras often use, and even share, the burrows of fairy prions, small seabirds (shown here) with which they share their island home. They are nocturnal predators and feed on large insects such as wetas.*

*This large-headed male Wellington tree weta (*Hemideina crassidens*), ABOVE, has his legs raised in an aggressive defense posture. These ancient flightless grasshopper relatives are nocturnal, and unusually they have coped with modern life so well they are now commonly encountered in many suburban backyards.*

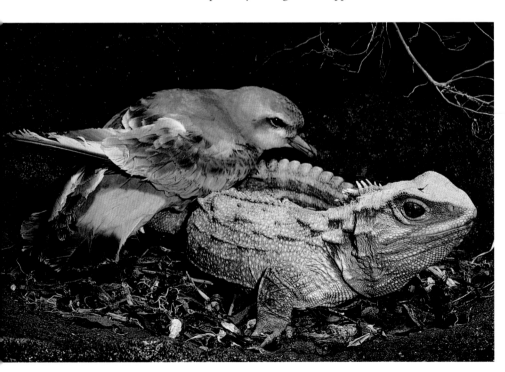

Other species have physiological as well as behavioral adaptations to the cold. The mountain weta, a giant flightless cricket, is capable of freezing as solid as an ice-block for hours on end, although if at all possible it avoids being caught outside in bad weather, and huddles instead in groups under stones where the temperature is usually higher than that of the outside air.

As with the reptiles, the number of known species of weta is increasing rapidly as scientific interest has been focused on them. These giants were the insect mice of New Zealand. A very recent discovery is a skill that is almost more remarkable than freezing. One of the tusked wetas—the barbirusa of the insect world—can survive many minutes totally submerged in water.

New Zealand is a glorious mixed-up Dr Seuss-like world, a remnant of an ancient

New Zealand's mistletoes are regarded as parasites because they physically tap into their host plants, although they have green leaves and manufacture some of their own food through photosynthesis. Flowering mistletoe provides a vivid splash of color in New Zealand's uniformly green southern beech forest. Remarkably in this species, red mistletoe (Peraxilla tetrapetala), ABOVE RIGHT, the bright red to orange flower buds can't open without physical help from pollinating birds. The birds forcefully twist the bud causing the flower to open explosively.

A caver enters Honeycomb Cave, RIGHT, in the Paparoa Ranges on the South Island's West Coast. Limestone caves and tomos (water-formed chute-like holes) in this area have revealed a wealth of subfossil evidence about New Zealand's extraordinary biota. Amongst the treasures are massive moa leg bones, talons of the giant eagle as well as countless small bones of families of primitive perching birds.

New Zealand's temperate rainforests are characterized by a high number of podocarp species, such as the kahikatea (Dacrycarpus dacrydioides), OPPOSITE, New Zealand's tallest forest tree that can grow to more than 165 feet (50 meters) in height. It usually grows in pure stands in lowland water-logged soils. Such lowland forests were typically among the first areas to be cleared during human settlement. The Dacrycarpus genus also occurs in New Caledonia and New Guinea.

continent with a lopsided biota shaped by island magic. Whereas islands such as Hawaii and the Galapagos have had spectacular radiations of single groups, New Zealand has specialised in one-offs or in small, select collections. The imperturbable tuatara is the sole surviving relict of a very ancient group of reptiles. The kokako, or blue-wattled crow, has a call so musical and resonant it stops you in your tracks. It is one of a small radiation of three remarkable wattlebirds, which have profoundly different bill shapes. New Zealand's wrens, of which only the tiny rifleman and the alpine rockwren survive, have a huge significance that belies their small size. Recent molecular work places these two old inhabitants at the very base of

the songbird's family tree—they provide yet more evidence that many bird groups arose in Gondwana. These are all animals that dazzle and amaze first-time visitors.

Their tragedy is that they were sublimely unsuited to cope with an invasion of modern mammals that began less than a thousand years ago with the arrival of the most destructive mammal of all—humans. Even though New Zealand is enormous in comparison to all the other islands in Polynesia—indeed, it is larger than all the other islands combined—it is still an island group. Its fauna had survival strategies and defences designed for a bygone era, that have proved to be of no use against ruthless modern mammals.

The arrival of humans in New Zealand had the same cataclysmic effect on its plants and animals that the meteorite that landed at the end of the Cretaceous had on the dinosaurs. Ironically, the reason that birds such as New Zealand's wrens have such an importance in the bird world is that Gondwana, safely tucked away in the southern hemisphere, was spared much of the disruption that the meteor caused in the north. But sadly, New Zealand's story is not unique wherever humans have gone in the Pacific, plants, animals and even entire ecosystems have disappeared.

New Zealand Land of Birds

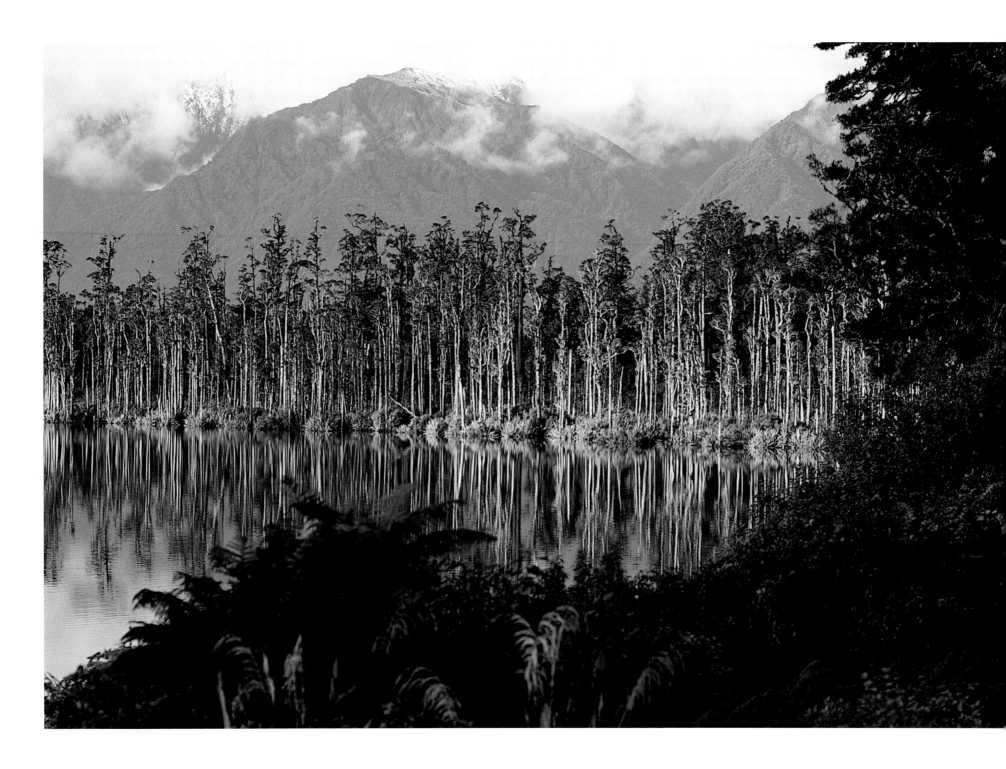

New Zealand Land of Birds

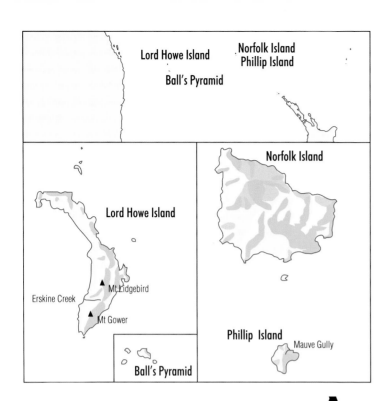

Lord Howe & Phillip Islands

Islands of Contrast

The ravaged landscape of Phillip Island, RIGHT, is in stark contrast to the stunning view of Lord Howe Island, OPPOSITE, taken from Mount Gower and showing Mount Lidgbird. Until the late 1700s and early 1800s these two islands were remarkably similar, sharing an almost identical suite of birds, and other animals and plants. The arrival of European settlers, however, set these two islands off on very divergent paths. Lord Howe Island is a gem which retains more than 80 percent of its original forest cover and is the world's southern-most coral reef, now recognized as a World Heritage Site. Phillip Island, on the other hand, has lost almost everything, including its precious soil, and is now protected with efforts being made to salvage something from the devastation. These two islands clearly illustrate the consequences of human activity on fragile island ecosystems.

Although their modern political allegiances may be Australian, Lord Howe Island and the Norfolk Island group are biologically more closely allied to New Zealand. If the sea level were lowered by around 3000 feet (a thousand meters) to expose the sunken continent of Zealandia, it would reveal an enormous land mass with two big fingers—the Lord Howe Rise and Norfolk Ridge—stretching north from New Zealand. Lord Howe Island is the only part of the Lord Howe Rise that appears above the water. Only 7 by 1½ miles (11 by 2.5 kilometers), this 6.9 million-year-old eroded shield volcano is now just one-fortieth of its original size. Like Hawaii, it formed over a hotspot in the ocean floor, and it is the youngest peak in a chain of older volcanoes that stretch 620 miles (1000 kilometers) to the north as a line of

submerged seamounts. Ball's Pyramid, a slender pinnacle thrusting 1808 feet (551 meters) out of the ocean 14 miles (23 kilometers) to the south-east of the main island, sits on the same seamount.

The 1240 mile-long (2000 kilometer) Norfolk Ridge culminates in New Caledonia, and halfway along is a high bump that is the three-million-year-old Norfolk Island group. Norfolk Island and New Caledonia are joined by old submerged islands that in the past might well have served as stepping stones enabling plants and animals to move between the islands. The Norfolk

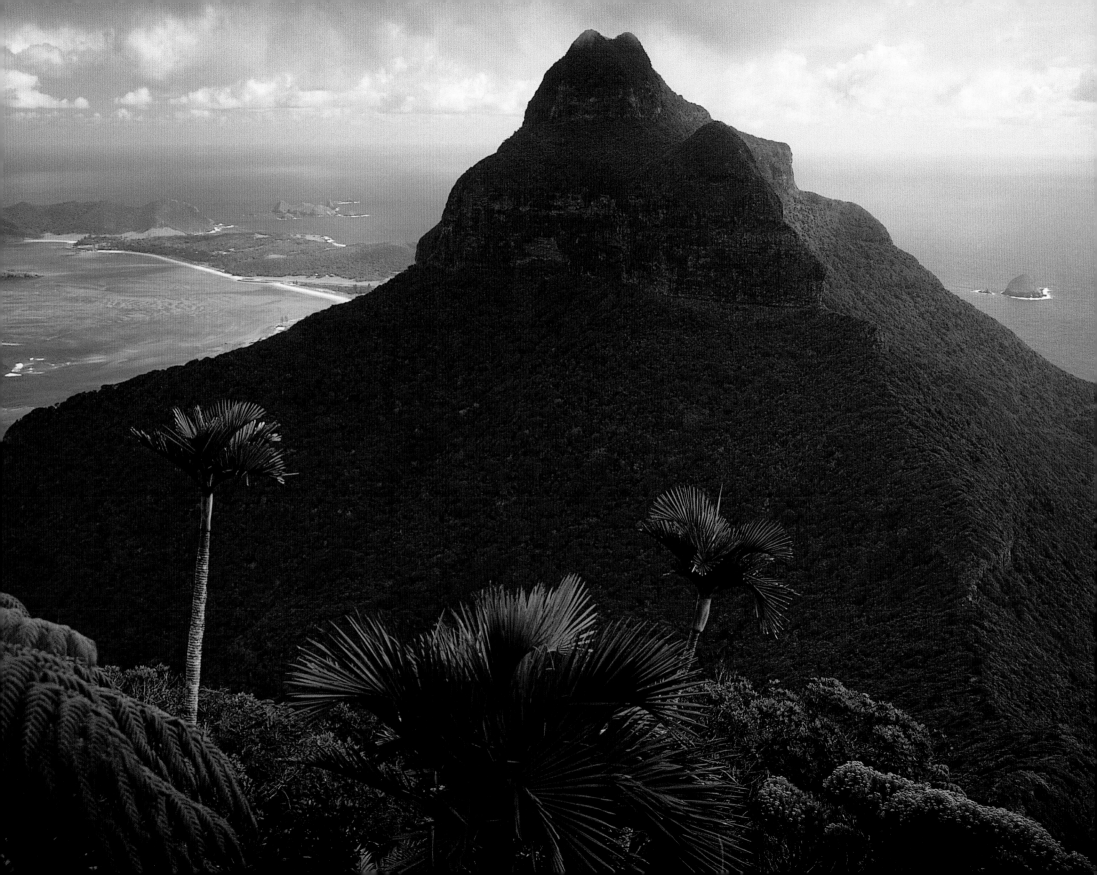

*The Lord Howe broom (*Carmichaelia exsul*),* ABOVE, *a small tree with aromatic flowers, is another forest plant with a strong affinity to New Zealand. It is the only member of the genus* Carmichaelia *to occur outside New Zealand, which is a stronghold with more than forty species.*

*Lord Howe Island's beautiful mountain rose (*Metrosideros nervulosa*),* RIGHT, *is typical of* Metrosideros *species found across the Pacific, many of which grow on cool, moist mountain ridges. It is one of two species of* Metrosideros *found on Lord Howe Island, and is just one of a high number of genera and species that it shares with New Caledonia, Australia and New Zealand.*

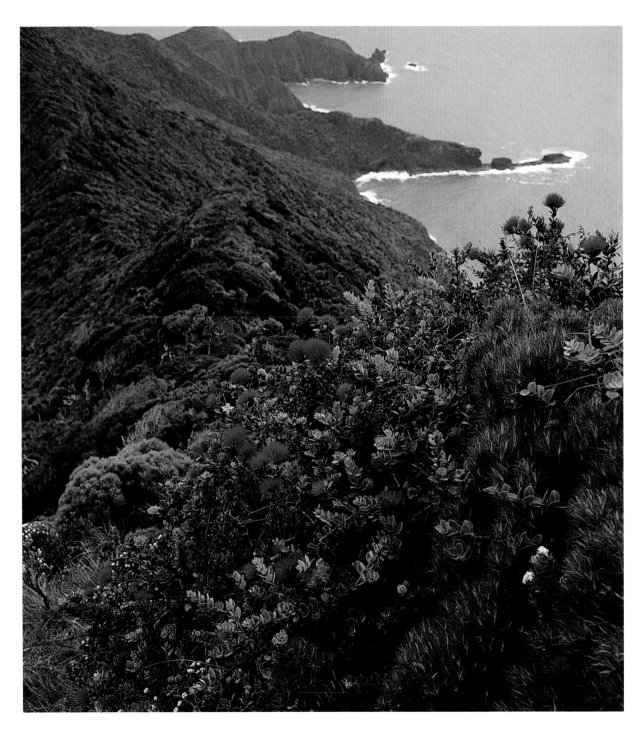

Lord Howe & Phillip Islands Islands of Contrast

Island group is made up of three islands, one of which is called Phillip Island.

Norfolk and Lord Howe Islands are both warm, moist tropical islands that lie in quite close proximity to New Zealand, Australia and New Caledonia, so it's not surprising that these places all share quite a few species. Lord Howe Island, for example, shares 120 plant genera with Eastern Australia, 102 plant genera with New Caledonia, seventy-five with New Zealand and sixty-six with Norfolk Island.

There are also pronounced similarities with the birds. Both Norfolk and Lord Howe had their own endemic forms of birds found in New Zealand: a *Rhipidura* fantail, a *Cyanoramphus* parakeet, a *Ninox* morepork, a *Petroica* robin and a *Gerygone* warbler. Norfolk Island, which lies closer to New Zealand, also had a *Hemiphaga* pigeon and *Nestor* parrot much like New Zealand's forest parrot, the kaka.

In stark contrast to New Zealand, however, where most of these species are still thriving, both islands

have lost almost all of their endemic land-birds. The fantail and the robin are the only species still common on the Norfolk Island group. The birds aren't the only losses. There is now a marked difference between the two island groups in the amount of vegetation. Nearly 80 percent of Lord Howe is still covered in forest, whereas Phillip Island has less than 1 percent. What

went wrong? Why did the birds die out, and why did the forest survive on one island and not the other?

The answer in both cases is humans. All these losses have occurred since European discovery, and the differing fortunes of the two islands' flora and fauna is inextricably linked with their varied human histories.

Beautiful Lord Howe, one of the smallest World Heritage sites, was given this status in 1982 in recognition of its outstanding natural features. Foremost among these are the scenic values of this rugged and spectacular island with its dramatic peaks, high number of endemic plants, and the high percentage of forest cover that it retains. The island's scientific importance comes from its volcanic formations and its lagoon, which is the southern-most fringing coral barrier reef in the world.

Lord Howe truly is paradise on earth, and well deserves its place on the cover of this book. It has carved out a niche as a mecca for people seeking natural holidays.

*Four species of endemic palm are found on Lord Howe Island. The little mountain palm (*Lepidorrhachis mooriana), ABOVE, *is a dwarf palm barely 6½ feet (2 meters) tall, and like the other mountain palm it is confined to mountain tops. The two other species—the curly palm and the thatch palm—are lowland palms with tall thin trunks that are cultivated widely.*

*Hotbark (*Zygogynum howeana), LEFT, *is common in the sheltered forests of Lord Howe Island from sea level to mountaintop. Its modest white flowers are among the earliest flowers to have evolved. The name derives from the hot peppery taste of the plant's leaves and bark.*

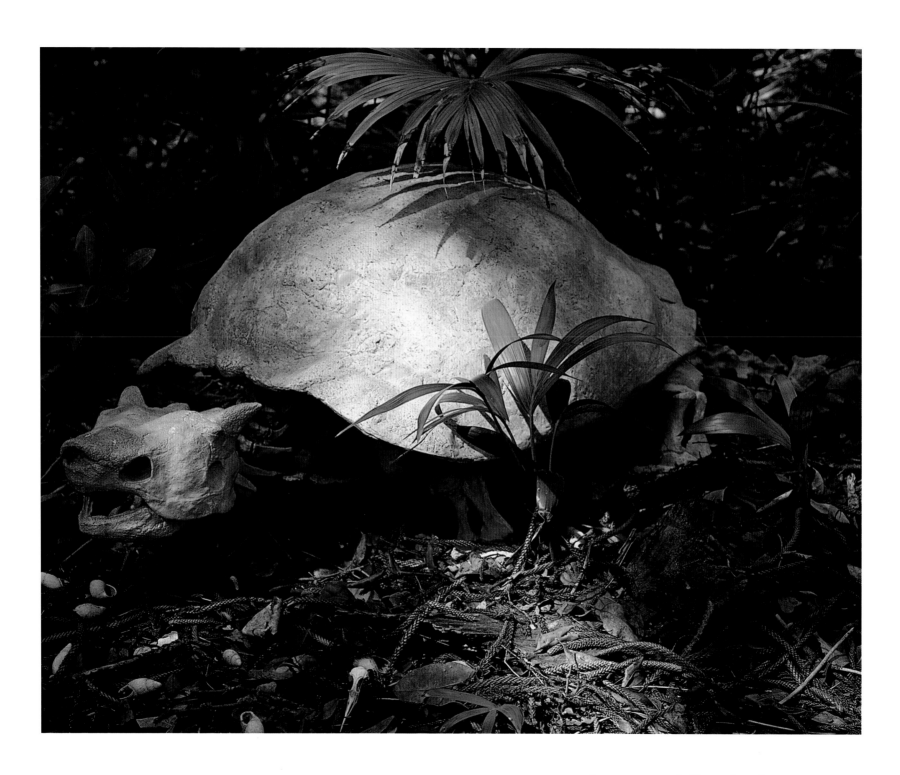

Lord Howe & Phillip Islands Islands of Contrast

That Lord Howe has remained such a paradise is the result of a series of fortunate accidents. The island was first inhabited in 1834, and residents existed by providing fresh vegetables and meat to whaling ships that called into the island. This industry collapsed in the late 1860s, but from the 1870s the locals began collecting the seeds from two species of endemic *Howea* palms. The seeds were shipped to Australia and a thriving trade in so-called Kentia palms developed. Kentia palms were highly favored in European drawing rooms—they were hardy and tolerant of cool, dark, dry indoor conditions, and they looked warm and exotic. This trade was a strong commercial incentive to retain the forest, so only small areas were cleared for farming or replanting in palms. Another point in the forest's favor was that early on the Government of New South Wales, recognizing the island's unique values, retained ownership of the land and leased it to the inhabitants.

However, in 1918 the ship the *Makambo* ran aground at Lord Howe, with the unfortunate result that ship rats made it onto the island, and within just a few years five forest bird species had disappeared. The rats also greatly reduced numbers of geckos and skinks, two species, incidentally, which are shared with Norfolk Island. Another species that seemed to have disappeared was a giant flightless stick insect, called the "land lobster" by the locals. This Gondwana relict had close relatives in New Guinea, Vanuatu and Fiji. Male land lobsters had sizeable spikes that resembled a bottle opener on the inner side of the tops of their legs. Locals knew not to pick up a land lobster; if disturbed the stick insect would close its legs and impale a person's hand with the spikes, much as a lobster uses its pincers to nip. Recently, land lobsters have been rediscovered on rat-free Ball's Pyramid, much to the excitement of the biologists who found them.

Because the rats quickly became a threat to the palm seed industry, the inhabitants responded by trying to control them through trapping and hunting with dogs. Poisons were introduced in the 1930s and the war against rats has been raging ever since. The palm industry has been saved, but the forest birds were already doomed.

Continental pigs, goats and cats were among other introduced species that have caused damage on the island, although huge efforts have been made to rectify the problems. Pigs were removed by 1979, and a recent project to eliminate goats seems to have been successful. Feral cats were destroyed during the 1970s, and in 1982 legislation was passed to prevent residents bringing in new cats. They were, however, allowed to keep old neutered cats, and in 2002 the last one of these was living out its days on the island.

*This reconstruction of the extinct Lord Howe giant horned turtle (*Meiolania platyceps*), OPPOSITE, is displayed in the forest surrounded by* Placostylus *shells. Numerous fossil bones, including five skulls, have been found, making the Lord Howe species the best known example of a group of turtles known also from New Caledonia, Australia and Argentina. It probably became extinct at the beginning of the last Ice Age.*

*A number of endemic invertebrates inhabit the palm forests on the high slopes of Mount Gower, on Lord Howe Island. The young translucent semi-slug (*Parmellops etheridgei*), ABOVE LEFT, is just one of a number of molluscs, including several Gondwana relicts, found in the high humid forests. In summer the forest reverberates with the noisy calls of Lord Howe cicadas (*Psaltoda insularis*), ABOVE. The native freshwater Lord Howe shrimp (*Paratya howensis*), BELOW LEFT, shares Erskine Creek with a tiny freshwater crab that is also native to New Zealand and Australia.*

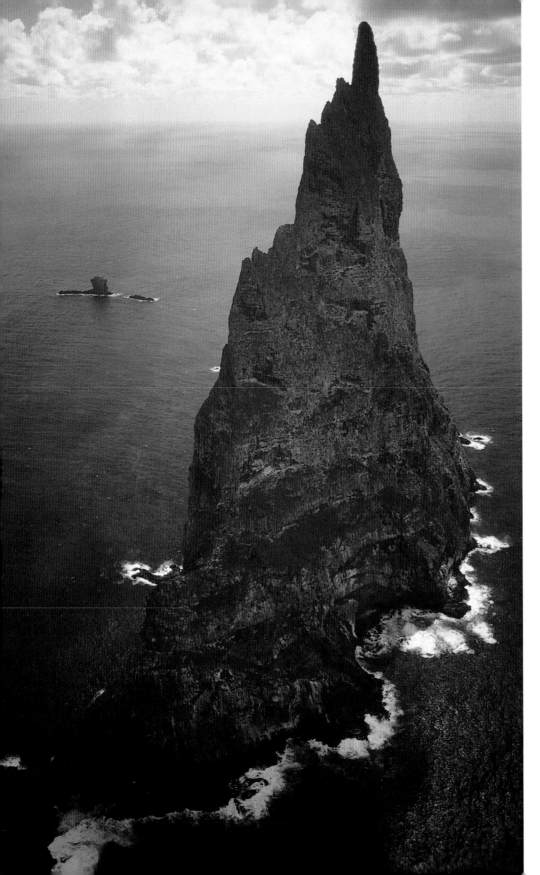

One of the greatest conservation success stories has been bringing the Lord Howe Island woodhen back from the brink of extinction. The woodhen is a flightless rail, related to New Zealand's weka, and its numbers had dropped to about five pairs. An intensive management and captive breeding program in the early 1980s has seen their numbers climb to around 300, and woodhens are once again living at sea level as well as on the island's remote high peaks.

The big earner these days is tourism. About 350 people live permanently on the island, and only 400 visitors are allowed at any one time. Residents are permitted to own only one car per family, and only islanders can lease land. The regulations are all designed to maintain the island's heritage and provide a unique experience for visitors. This is an island where you are met at the airport by woodhens, and you can see wedge-tailed shearwaters and petrels courting on roadside verges as you walk around at night. Perhaps this level of compromise is what is needed to save our global environment. Could Lord Howe be a template for the future of all islands?

In direct contrast, Phillip Island is so wrecked it could serve as a template for how to annihilate an ecosystem. Once again the fortunes of its natural history were directly linked to human history, but with very different results. Norfolk Island's main island is similar to Lord Howe in many respects. As well as its namesake, the Norfolk pine, which grows on ridges and higher slopes of the island, there are more than 150 species of endemic plants and animals. Among them is an endemic palm related to the nikau palm of New Zealand. But there is an almost shocking difference between the main island and Phillip Island, just 4 miles (6 kilometers) offshore.

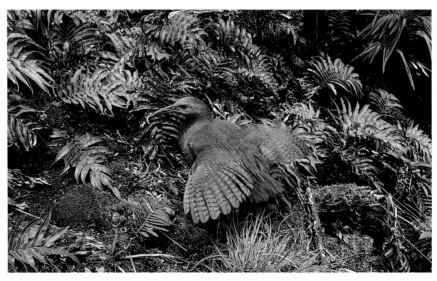

Lord Howe & Phillip Islands Islands of Contrast

In 1774, during his survey of the Pacific Ocean, Captain Cook sighted the straight-growing Norfolk pines and thought they'd make effective ship spars. However, the wood proved to be too knotty and weak, so unlike the Lord Howe Islanders and their palms, Norfolk Islanders didn't have the opportunity of developing an industry from their forest. A potential industry based on flax also failed because its fiber was inferior to Ireland's linen flax.

Although ships visiting the island during its early years of settlement couldn't tie up conveniently and had to use lighters to ferry people ashore, rats still managed to get onto the islands. As early as the 1790s there were reports of rats attacking crops and of land birds disappearing, and in 1796 pigs were deliberately released onto Phillip Island. The pigs grubbed among the white oaks and the flax, and soon grew fat in the seabird colonies.

Norfolk Island was a harsh place, serving as both a settlement and a penal colony for several years. But it was so isolated and expensive to supply that for eleven years from 1814 it was totally abandoned. Then the Government of Australia decided the island would make a perfect penal colony, and in 1825, fifty-seven of the worst convicts and their soldier guards were sent to Norfolk. The island had a very harsh penal code, and it was described as a place of the most extreme punishment possible short of death.

At some point during this era, rabbits, as well as the occasional escaped prisoner, made it to Phillip Island. The

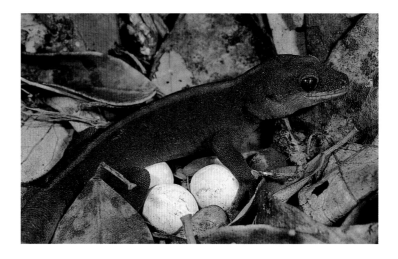

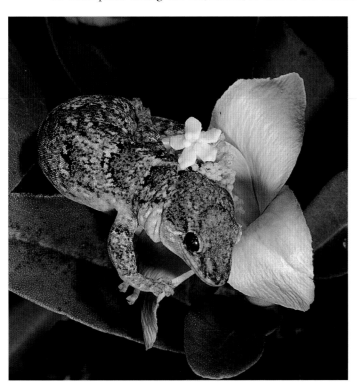

convicts were duly collected and sent back to Australia, but the rabbits were left to their own devices. It was the beginning of an onslaught that would lead to Phillip Island becoming one of the most degraded environments on Earth. The damage inflicted on this island has been as horrific as the punishment meted out to the convicts—raw wounds of red and purple soils now cover the island and bleed into the sea every time it rains.

Although it was a complicated task removing them from the steep cliffs, the rabbits have now been eradicated from Phillip Island. The innovative solution to the problem of rabbits surviving on inaccessible ledges was to use bows and arrows to fire vials of myxomatosis-infected rabbit fleas. The vials shattered on impact, releasing the fleas, and the rabbits all died. Seabirds are slowly returning to breed on the island, half a dozen Phillip Island hibiscus plants cling to life in a nature reserve, and a few *Araucaria* trees survive as testament to the forest that had all but

Ball's Pyramid is a spectacular rock outcrop, 1808 feet (551 meters) high, 13 miles (23 kilometers) south-east of main Lord Howe Island, OPPOSITE LEFT. *It is home to many nesting seabirds and the Melaleuca scrub growing on its ledges is the last remaining refuge for a heavily armored giant flightless stick insect known to the locals as the "land lobster."*

The Lord Howe woodhen (Tricholimnas sylvestris) is Lord Howe Island's best known bird, partly because it was extremely rare during the 1970s, with just a few pairs confined to the high slopes of Mount Gower, where this bird was photographed sunning itself, OPPOSITE. *Its numbers have recovered to more than 300 birds, following an intensive conservation program, and woodhens are now commonly seen all over the island.*

Guenther's gecko (Phyllodactylus guentheri) is widespread on Lord Howe, although more commonly encountered on offshore rock stacks. Perhaps surprisingly, the same species also occurs on ravaged Phillip Island, where this gecko was photographed guarding its eggs in the leaf litter, ABOVE. *Another individual forages for nectar amongst the flowers of the white oak,* LEFT.

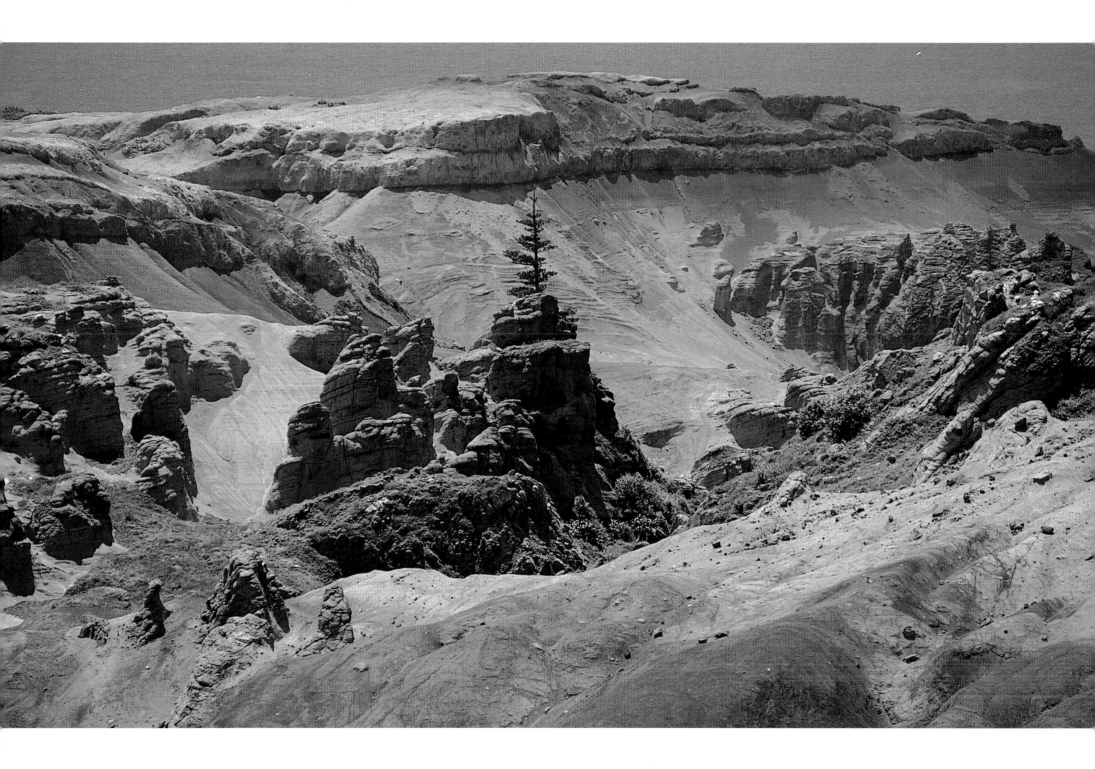

Lord Howe & Phillip Islands Islands of Contrast

Perhaps the most exotic-looking of all Phillip Island's surviving endemic flowering plants, and certainly the rarest, is the Phillip Island hibiscus (Hibiscus insularis), FAR LEFT. It is seen occasionally in gardens on nearby Norfolk Island, where this plant was photographed but is now close to extinction, with only a handful of wild plants surviving on Phillip Island itself. Other spectacular endemic species like the glory pea (Streblorrhiza speciosa) were destroyed by introduced rabbits and have disappeared forever.

The bright pink flowers of the white oak (Lagunaria patersonia), ABOVE LEFT, provide a splash of color on the stark bare slopes of Phillip Island. A few white oak trees, magnificent forest giants, tenaciously remain in a sheltered gully near the island's summit.

The Phillip Island centipede (Cormocephalus coyneii), BELOW, can reach almost 8 inches (20 centimeters) in length, and is a powerful predator capable of killing geckos and nestling birds. This individual has killed and eaten a Guenther's gecko. Such scenes are commonplace on islands as diverse as New Zealand and the Marquesas, where different giant centipede species hunt other lizard species. On islands across the Pacific the usual roles of invertebrates and reptiles are often reversed.

disappeared. But the pigeon and the kaka have gone forever—they are irreplaceable lost treasures.

There is evidence of Polynesian people having lived on Norfolk Island in the past, but these people left. However, although Norfolk Island has lost most of its natural treasures as well as those first people, it has gained a new and distinctive life form: the Norfolk Islander. These people are direct descendants of mutineers from the British ship *Bounty*, and their forebears moved here *en masse* from Pitcairn Island in 1856. In 1800, after years of in-fighting and deaths, the sole surviving original mutineer, John Adams, had decided to raise all the children and their Tahitian mothers as god-fearing Christians. It was the human equivalent of a small founding population passing through a major bottleneck, and being transformed as a result. But whereas evolution alters the physical appearance of plants and animals, the first signs of change in human populations are cultural, and such changes can come about very rapidly indeed.

Norfolk Islanders today speak a language that is a strange mix of old English and Tahitian. They have their own unique camaraderie that acknowledges rivalry and tensions, but in a good-natured and tolerant way that defuses matters. They are a unique product of their unique environment and history—over time it seems that island magic can transform people, as well as plants and animals. Perhaps the ultimate example of this happened on another Polynesian island on the far side of the Pacific—Easter Island.

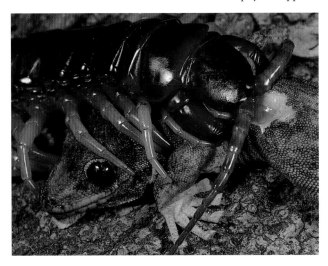

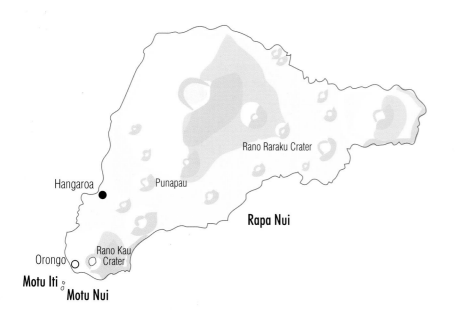

Rano Raraku Crater

Hangaroa

Punapau

Rapa Nui

Orongo
Rano Kau Crater

Motu Iti

Motu Nui

Easter Island
The Lost World

A handful of seeds were once all that remained of toromiro (Sophora toromiro), RIGHT, an Easter Island endemic that was once probably a common forest tree. Today, however, a precious few plants grow in botanic gardens around the world. Several seedlings have been returned to the island but unfortunately they struggle to grow. Toromiro bears a close resemblance to New Zealand's kowhai (Sophora microphylla), a species which is also native to South America.

The monumental rock platform known as Vai Uri OPPOSITE, is situated near the main village of Hanga Roa. Seen here with its statues silhouetted against the night sky it is probably one of the most accessible archaeological sites on Easter Island. Strangely reminiscent of the stone columns belonging to great fallen European civilizations, these constructions are reminders of the impermanence of even the greatest of human endeavors. Yet they also symbolize the power of islands in shaping not just plants and animals, but human cultures as well.

O N THE BASIS of its peoples and cultures, the Pacific Ocean is divided into three great regions: Melanesia, Micronesia and Polynesia. Polynesia, which is by far the largest region, is a vast triangle, with New Zealand at its southern tip and Hawaii at its northern point. Its far-flung eastern tip is the incredibly isolated Rapa Nui, better known as Easter Island. Despite the huge distances involved Polynesians settled all these islands in a wave of colonization that began in about 1500 BC. They were very successful—until AD 1500 the Polynesians were the most widely spread people on Earth. However, their settlements weren't always lasting. When the *Bounty* mutineers settled on Pitcairn Island in 1790 it was uninhabited, although they found signs that Polynesians had lived there before them. There were breadfruit trees and coconut palms growing, and other evidence of human settlement such as stone adzes, fish hooks and pig bones. Recent work has shown that the fertile soils of the island once supported a sizeable population, which dated back to AD 1100, but nobody knows what happened to these people.

More mysteriously, the *Bounty* mutineers also found on Pitcairn small, carved stone statues on stone platforms, facing inland with their backs to the sea. Only one fragment of these statues survives—the mutineers threw the rest into the sea. Stone carving is not commonly practiced by Polynesians, and it provides a tantalizing and unique link between Pitcairn and Easter Island,

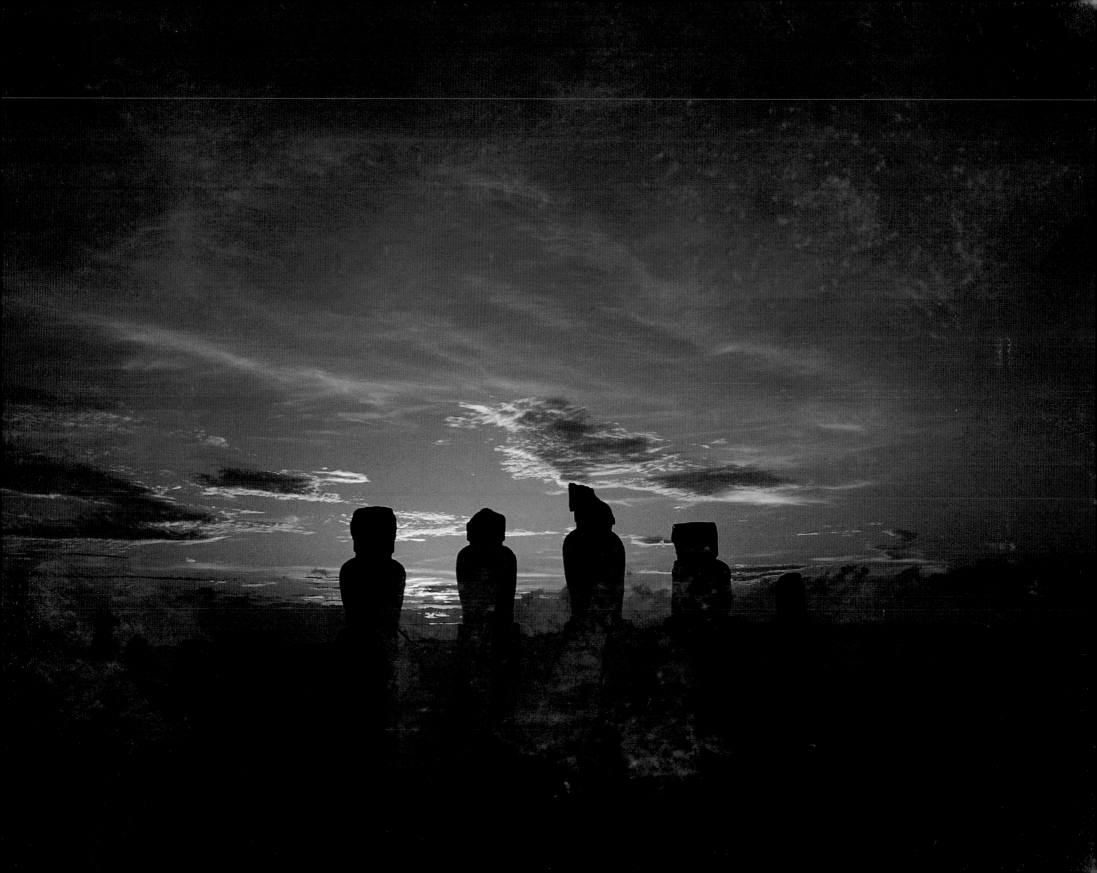

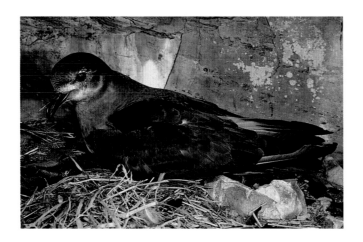

further to the east. The giant stone statues of Easter Island are world famous. They escaped the watery fate of the Pitcairn statues, and have survived as enigmatic clues to the mystery of what happened to a once-great civilization.

When Captain Cook visited Easter Island briefly in 1774 during his second voyage, he observed a civilization that was in a sharp decline. Many of the statues, or moai, had been toppled from their bases, even though only ten years earlier visitors remarked that the statues were all standing with their red topknots still in place. Cook also noted that there were no freshwater streams on the barren island, and that freshwater came mostly from small lakes in three extinct volcanic craters.

From the time of the first visit by Europeans in 1722, all visitors commented on the island's bare treeless appearance, and the presence of small, independent warring tribes. There was no sign of the highly stratified civilization that would have been needed for the creation of nearly a thousand monolithic statues. Because no records of Easter Island culture appeared until after 1877, much knowledge and information has been lost. As a result, Easter Island has always been a place of great mystery. Where the people came from, why they developed such a sophisticated stone-carving culture, and what led to the fall of this great civilization are all hotly debated questions.

*Easter Island's seabird fauna was once the richest in the world, not surprising given the island's location between the subtropics and the subantarctic. It was a breeding ground for numerous species, such as the Kermadec petrel (*Pterodroma neglecta*), ABOVE, a surface-nesting bird that still returns each year to breed on the slopes of the small outlying islands of Motu Nui and Motu Iti, situated off the southern coast of the main island. The red-tailed tropic bird (*Phaethon rubricauda*), RIGHT, is seen here making spectacular aerial dives off Motu Nui and Motu Iti's cliffs and ledges where it breeds.*

*On the seacliffs at Orongo, OPPOSITE RIGHT, on the south coast of the island, rock carvings depict figures of the birdman cult, the heads of the birdmen being a stylized representation of the magnificent frigate bird (*Fregata magnificens*), OPPOSITE, which once bred on the islands. While the frigate birds no longer nest here these ocean wanderers still regularly fly past, reminders of a more bountiful time.*

Where the carvers came from has always been a particularly contentious question. Easter Island is very isolated, and whoever settled the island would have had to make an epic voyage to get there. Norwegian ethnologist Thor Heyerdahl and others have argued that the people came from South America, to the east. But the consensus now is that they were Polynesians sailing from the west. Great seafarers and navigators, the Polynesians were capable of constructing massive canoes that could carry large groups of people and supplies. Their skills were such that they were able to disperse right through the Pacific, settling the far-flung islands of New Zealand, the Marquesas and Hawaii, and taking with them the mainstays of Polynesian life—coconut, taro, yam, banana, breadfruit and food animals such as pigs, dogs, rats and chickens. Not all of these tropical species would have proved suitable in Easter Island's cooler climate, but early Europeans recorded crops of yams, taro, bananas, sugar cane, gourds, paper mulberry trees, and sweet potatoes—all of which had a westerly origin, except the sweet potato, which originates in South America. It is an interesting complication that has been a source of both confusion and clarity in the debate about where Easter Islanders and Polynesians in general came from.

Despite its South American origin, the sweet potato

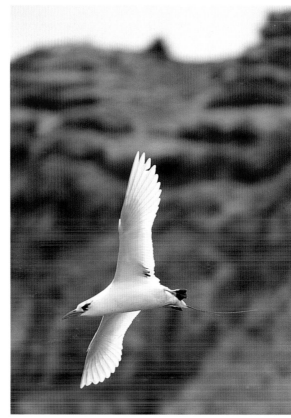

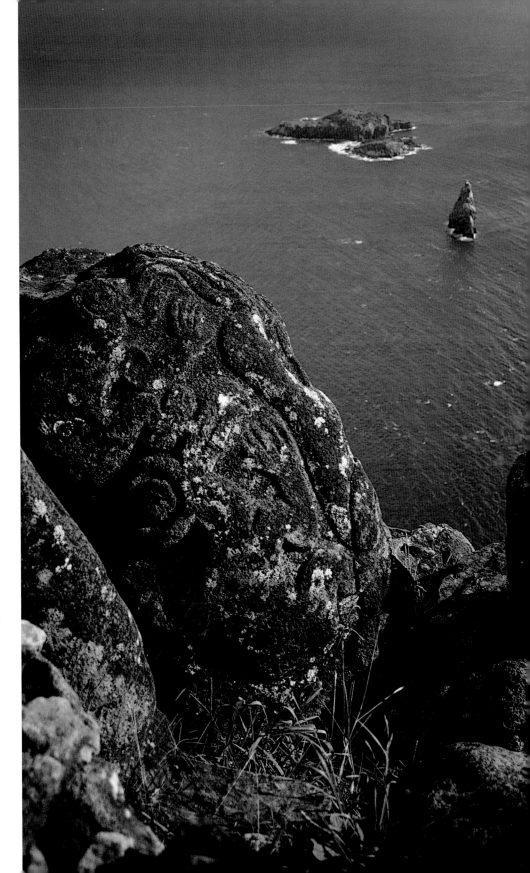

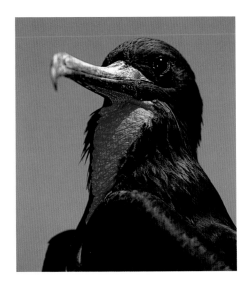

is a staple Polynesian food and is widely cultivated throughout the Pacific, especially on more temperate islands such as New Zealand and Easter Island. A Polynesian mind might well have seen in the sweet potato a valuable source of starch. It has all the prerequisites for sustenance on long ocean voyages: it is easy to store, is sweet, starchy, grows readily from small tips, and is easy to cook and prepare. Later on it would prove its worth as pig food. It is quite conceivable that, at some stage, voyaging Polynesians reached the shores of South America, then left with the newly acquired sweet potato, which they spread throughout the Pacific.

The sweet potato may very well have been both the making—and breaking—of Easter Island. Initially it may have provided an opportunity to overcome the limitations imposed by naturally available food, allowing the population to grow above the island's natural carrying capacity. Then later it would have supported life after all the original resources—fish, shellfish and timber—had been stripped, allowing a large population to indulge in making the statues. But that may have been their downfall—an artificially large population that unwittingly destroyed their environment and ultimately ran out of food. Archaeologists estimate that the island's population may once have reached nearly 10,000; some put the estimate as high as 20,000. Early Europeans estimated the population in the 1700s to be just one to two thousand. By the mid 1880s the population had dwindled to just 111 people.

What plants and animals were present on the island before people destroyed everything is as much a mystery as anything else to do with Easter Island. Scientists analysing pollen from lake sediments in the Rano Raraku crater found large quantities of palm pollen below about 4 feet (1.2 meters). That, and the discovery of a few distinctive nuts, eventually led to the palm being identified as either the same species or a very close relative of the Chilean wine palm, which is the largest palm in the world and a useful source of nuts and palm honey, as well as timber and thatch.

In the mid 1950s, before the pollen work was done, a Swedish botanist found fewer than fifty surviving species of native plants on Easter Island. This was an astonishingly low number, even for such an isolated island, and included only one woody tree—*Sophora toromiro*, which belongs to a genus of plants that includes New Zealand's yellow-

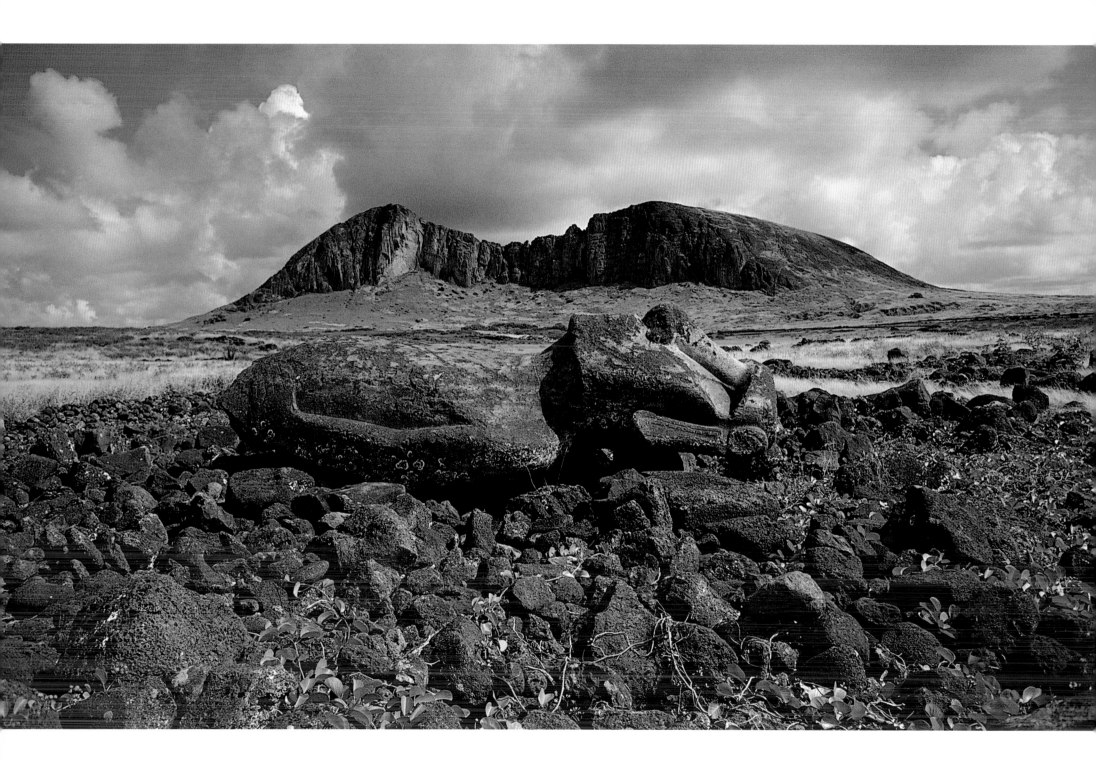

Easter Island The Lost world

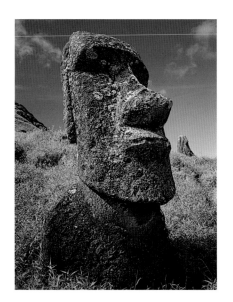

flowered kowhai. The genus is widespread across the Pacific because it has durable seeds that can survive long periods immersed in sea water. Thor Heyerdahl collected a few seeds from the last remaining tree in the crater, and these were successfully germinated back in Europe. Although the tree now flourishes in a few botanic gardens, repatriated plants have struggled back in their homeland.

Recent work on several charcoal deposits that occur on the island has identified more than thirty species of rainforest plants, evidence that at least part of the island was once covered in forest. This nicely complements the record of a small land snail, one that would have required dense, moist rainforest to survive.

It seems, in fact, that Easter Island was once a very diverse and thriving ecosystem. The most stunning revelation has been recent work on bones found in caves. These show that Easter Island once had the richest assemblage of seabirds in the world. Because of its location it was home to both subtropical and subantarctic seabird species.

It has been harder, however, to find evidence for other probable missing species—land birds, for instance. Did lorikeets from New Guinea, Cardueline finches or *Metrosideros* seeds ever blow here, as they blew to other islands in the Pacific? There is some evidence of an iguana—but what kind?

It's staggering to think that Easter Island was once covered in rainforest and palm forest. Early islanders would have used the trees to make canoes, and there are frequent depictions of canoes in rock art on the island. As the forest slowly disappeared so did the canoes and the wooden houses. By the time Europeans began visiting the island many people appeared to live in caves, and the only canoes were either untidy bundles of reeds collected from the margins of the crater lake and bound together, or so small and patched as to be almost unseaworthy. With the loss of the canoes went the ability to fish offshore—and also, crucially, the islanders' ability to quit their ruined homeland.

The disappearance of the forest was hastened by two factors: firstly, the settlement activities of a large human population, which harvested trees for building, to make rollers for statues and for burning to make charcoal; and secondly, the proliferation of an animal that these intrepid human travelers took with them wherever they went. The small Polynesian rat was valuable to the migrants as a ready source of food. However, in the long run it led

A fallen moai, OPPOSITE, deliberately toppled from its stone platform, lies not far from the quarry at Rano Raraku where it was shaped. Other statues were moved far greater distances, to opposite ends of the island. Just how such massive statues were shifted is still heavily debated.

The deserted quarry, BELOW, full of scattered unfinished moai, or statues, lies on the slopes of Rano Raraku. Some partially finished statues are visible where they were being carved out of the rock, while on the slopes below upright statues have been partially buried by debris and silt from above. Grass has grown around them, giving the impression that the statues are just heads, LEFT, but in reality they are full height statues that were in position waiting to be moved from the quarry.

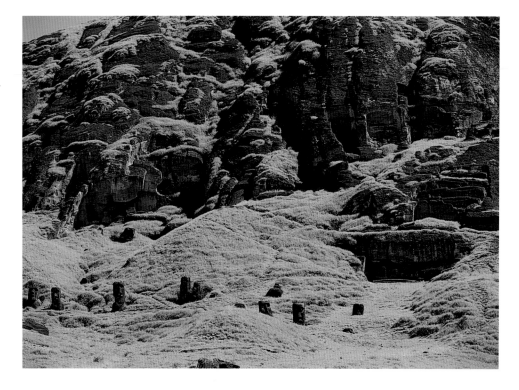

Easter Island The Lost world

to the destruction of many other food sources. The rats ate palm seeds, thus preventing regeneration of the forest, and they ate the eggs of sea and land birds, hastening their demise.

Once the forest went, so did the fertility of the soil and the reliability of water sources. The island was on an irreversible downward spiral, and it took the people with it.

There are plenty of other mysteries associated with the people of Rapa Nui. First is that of the moai themselves: what was the purpose of these monster statues? It seems they weren't gods, as early Europeans assumed, but representations of high-ranking ancestors. The monolithic stone statues are truly impressive—the standing statues range from $6^1/2$ to almost 33 feet (2–10 meters) tall. A monstrous $65^1/2$-foot (20-meter) statue lies unfinished in the quarry, a 265-ton (270-tonne) folly that may have proved to be unmoveable.

The moai were carved with stone picks and flakes from a soft yellow basaltic rock known as tuff, found in the volcanic crater of Rano Raraku on the eastern side of the island. Some sported red scoria topknots on their heads, and their now empty

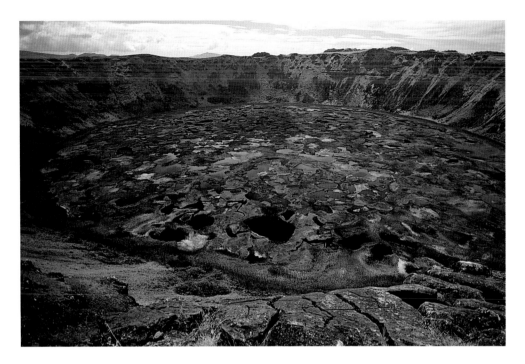

Fossil pollens trapped in sediments of small lakes such as these in the crater of Rano Kau, ABOVE, *together with charcoal deposits found elsewhere, indicate that the now bare slopes of Easter Island were once heavily vegetated.*

The carved relief on the back of a statue's red topknot is clearly visible on this toppled specimen, RIGHT, *but is usually difficult to see on standing statues. The red scoria topknots, or* pukao, *were carved and transported from their own quarry at Puna Pau.*

Nobody knows what Easter Island's forests looked like, nor what treasures they once held. Did they look like this lush rainforest, OPPOSITE, *full of tree ferns and endemic palms? Did the* Metrosideros *tree whose seeds blew as far as the Marquesas also grow here? Did finches or iguanas ever visit and colonize here? We'll never know the answers, let alone learn what other extraordinary and bizarre beasts and plants the Easter Island species factory may have created.*

eye sockets were once filled with carved coral eyes. The statues, mounted on stone ahus, or stages, were positioned in an almost unbroken line around the coast and all faced into the middle of the island.

After they were carved at the crater quarry, somehow the statues were moved to various sites around the island. The jury is still out on whether the statues were rolled on sleds and palm trunk rollers, or rocked back and forth on their bases. Possibly different methods were used for different sized moai but, however it was done, carving then moving such huge statues into position was an incredible undertaking. The islanders' ability and motivation to make the statues eventually outstripped their ability to move them around the island—only one-quarter of the moai were ever erected. The quarry is full of statues in various stages of completion.

One of the reasons this is all so difficult to substantiate is that, like all Polynesian cultures, the Easter Islanders have an oral tradition for recording history. There is no written language, except for the mysterious *rongorongo* tablets—twenty-nine pieces of wood, densely inscribed with over 14,000 characters or hieroglyphs. Many of the characters are symbols, such as birds and hooks, and they are arranged in parallel lines. The meaning of the script eluded people until very recently, although the islanders have always claimed they are a history of how the island came to be inhabited. It took New Zealand linguist Steven Fischer eight years of research to decipher the enigmatic script. The clue was

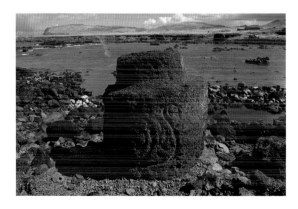

Easter Island The Lost world

Easter Island The Lost world

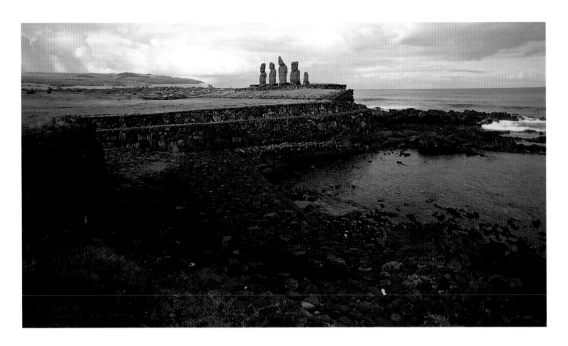

a verbal chant, recorded in 1886, which proved to have the same structure as the text on the tablet known as the "Santiago Staff," which would become the Rosetta Stone of the *rongorongo* script. It turns out that the *rongorongo* are creation chants, with a basic repeating structure: something copulated with something else, and the offspring was whatever, for example, "land copulated with fish and the offspring was the sun." In this way all the major items in the Rapa Nui world were described. Although it flourished for only three generations, from the 1770s or 1780s until the mid-1860s, the *rongorongo* script is the only written language that evolved in all of Polynesia.

As well as the distinction of the *rongorongo* script, Easter Islanders have another unique position in the world. Other Polynesian cultures may have begun carving stone figures, but none took it to the extremes of Easter Island. Other cultures, such as the lost people of

In recent times moai and platforms such as those of Vai Uri, ABOVE, have been carefully restored. All standing moai have had to be re-erected on platforms, some of which have also had to be reconstructed. Here at Ahu Tahai rock walls and a canoe ramp have also been restored between two rebuilt platforms.

Pitcairn Island, moved on in their canoes, possibly when they had exhausted their environment. The Easter Islanders devastated their island so badly that they destroyed the only possibility of escape.

The history of Easter Island reads as a parable for life on islands at a number of levels. Despite its isolation and great distances from other lands, humans managed to reach and settle it. Once they had arrived, the island began to weave its own brand of magic over the settlers. The result was not a glorious radiation of finches and flowers as on Hawaii or the flourishing of Tasmania's strange suite of baby-faced killers, but it was a creation unique to this island. The moai were the result of a creative people, with time on their hands, making the most of an abundant natural resource. The *rongorongo* script was an expression of a complex and unique island culture.

Unfortunately, the simple original ecosystem that the island had once played host to could not withstand the human onslaught. Large complex continental ecosystems are resilient and better able to cope with change. Island ecosystems are fragile and vulnerable. What happened on Easter Island is merely the most extreme example of a phenomenon that has occurred throughout the Pacific—whenever humans arrive on an island, island life suffers.

It is up to all of us to decide whether Easter Island will serve as the template for islands in the future, or whether we aspire to the more utopian vision that Lord Howe Island provides. It's clear in our minds that islands truly are magical places and that their unique and sometimes improbably bizarre plants and animals deserve to survive and be given the opportunity to continue to evolve. We have already lost species that are certainly more fantastic and unbelievable than anything we can imagine. Let's cling tenaciously to the survivors—because the world would be a much poorer place without the magic of islands.

Easter Island The Lost world

THE WAY OF THE DODO

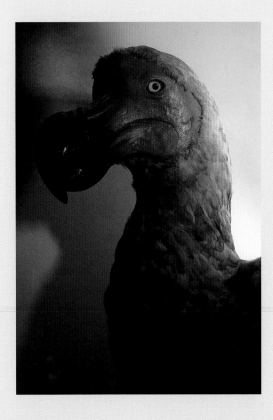

The dodo (*Raphus cuculatus*), a giant flightless pigeon, is the classic example of island life. It was well known to sixteenth-century Portuguese sailors who regularly called in at Mauritius to pick up dodos for fresh meat. In a remarkably short time, however, this once very common bird disappeared so completely that not a single intact specimen exists. Even this bird is an illusion, an artist's creation. It was made by the Rowland Ward Company of Piccadilly in London, a firm of taxidermists that flourished from the 1890s until the 1970s. They specialized in supplying dodos to museums, creating them from the feathers of other birds.

Island magic conjures up real creatures that are unexpected, unusual and fascinating. Their downfall is that they are exquisitely vulnerable—it takes very little to send most island species the way of the dodo. Easter Island's original ecosystems and the dodo have already disappeared—the challenge for all of us is whether we can hang on to the remaining wonderful multitude of species and islands that we have showcased in this book.

Glossary

Adaptive radiation A burst of evolution in which a single ancestral form develops into different species adapted to varying environmental conditions or ways of life.

Araucaria A family of evergreen coniferous trees found in Australasia and South America, the best-known example being the monkey puzzle tree.

Bathymetric contour A line joining all points of equal depth below sea level. In this book, the reference is to an earlier sea level.

Biota The plants and animals which occupy a particular habitat.

Copra Dried coconut kernels.

Divaricating Plant growth in which plants fork and branch freely, sometimes resulting in an interlacing mass of stems or branches.

Endemic A term for plants and/or animals that are confined or restricted to a particular region; also for a characteristic that is prevalent among a people or organisms in a defined area.

Herbivorous Animals that live and feed on plants, grass and/or herbs.

Megapode An Australasian bird that builds a mound in which its eggs are laid and hatched.

Mesic An environment that is neither extremely wet nor extremely dry.

Mosasaur A large, extinct marine reptile.

Plastron The abdominal section of the shell of a tortoise or turtle.

Podocarp A predominantly Southern Hemisphere family of evergreen conifers. Most are forest trees.

Prosimian Primitive primates with small brains, of the sub-order Prosimii. They include lemurs and tarsiers.

Ratite Living, flightless birds, having a keel-less breastbone.

Tsingy The Malagasy name for Madagascar's bizarrely eroded limestone formations.

Bibliography

Auffenberg, Walter. 1981. *The Behavioural Ecology of the Komodo Monitor*. Gainesville: University Presses of Florida.

Bahn, Paul and John Flenley . 1992. *Easter Island, Earth Island: A Message from our Past for the Future of our Planet*. London: Thames and Hudson.

Beehler, Bruce M., Thane K. Pratt and Dale A. Zimmerman. 1986. *Birds of New Guinea*. Princeton, N.J.: Princeton University Press.

Carlquist, Sherwin. 1965. *Island Life: A Natural History of the Islands of the World*. Garden City, N.Y.: Natural History Press.

_____. 1974. *Island Biology*. New York, N.Y.: Columbia University Press.

Clunie, Fergus. 1984. *Birds of the Fijian Bush*. Suva: Fiji Museum.

Darwin, Charles. 1839. *The Voyage of the* Beagle. (Reprint edition: J.M. Dent and Sons, London, 1980.)

Dawson, John. 1988. *Forest Vines to Snow Tussocks: The Story of New Zealand Plants*. Wellington: Victoria University Press.

De Roy, Tui. 1998. *Galapagos: Islands Born of Fire*. Auckland: David Bateman Ltd.

Flannery, Tim. 1994. *The Future Eaters: An Ecological History of the Australasian Lands and People*. Victoria: Reed.

Fuller, Errol. 2002. *Dodo: From Extinction to Icon*. London: HarperCollins.

Gibbons, J.R.H. and I.F. Watkins. 1982. "Behaviour, Ecology and Conservation of South Pacific Banded Iguanas, *Brachylophus*, including a Newly Discovered Species". *Iguanas of the World*. Burghardt, G.M. and A. Stanley Rand (eds.). New Jersey: Noyes Publications.

Grant, Peter R. 1986. *Ecology and Evolution of Darwin's Finches*. Princeton, N.J.: Princeton University Press.

Hermes, Neil (ed). 1985. *Annotated Checklist of Vascular Plants and Vertebrate Animals of Norfolk Island*. Flora and Fauna Society of Norfolk Island.

Hutton, Ian. 1986. *Discovering Australia's World Heritage: Lord Howe Island*. Canberra: Conservation Press.

Jolly, Alison. 1980. *A World Like Our Own: Man and Nature in Madagascar*. New Haven, Conn: Yale University Press.

Kingdon, Jonathon, 1989. *Island Africa: The Evolution of Africa's Rare Animals and Plants*. Princeton, N.J.: Princeton University Press.

Kinnaird, Margaret F. 1995. *North Sulawesi: A Natural History Guide*. Jakarta: Wallacea Development Institute.

Lanting, Frans. 1990. *A World Out of Time: Madagascar*. New York: Aperture.

Lindsey, Terence and Rod Morris. 2000. *Collins Field Guide to New Zealand Wildlife*. Auckland: HarperCollins.

MacArthur, Robert H. and Edward O. Wilson. 1967. *The Theory of Island Biogeography*. Princeton, N.J.: Princeton University Press.

Morris, Rod and Peter Hayden. 1995. *Wild South's Living Treasures of New Zealand*. Auckland: HarperCollins.

Olson, Storrs L. and Helen F. James. 1982. "Fossil Birds from the Hawaiian Islands: Evidence for Wholesale Extinction by Man Before Western Contact". *Science*, Vol. 217, 13 August 1982.

Pratt, H. Douglas, Phillip L. Bruner and Delwyn G. Berrett. 1987. *A Field Guide to the Birds of Hawaii and the Tropical Pacific*. Princeton, N.J.: Princeton University Press.

Preston-Mafham, Ken. 1991. *Madagascar: A Natural History*. Oxford: Facts on File.

Quammen, David. 1996. *The Song of the Dodo: Island Biogeography in an Age of Extinctions*. London: Hutchinson.

Ryan, Paddy. 2000. *Fiji's Natural Heritage*. Auckland: Exisle.

Strahan, Ronald. 1983. *The Australian Museum Complete Book of Australian Mammals*. London: Angus & Robertson.

Van Oosterzee, Penny. 1997. *Where Worlds Collide: The Wallace Line*. Victoria: Reed.

Wallace, Alfred Russel. 1869. *The Malay Archipelago, the Land of the Orang-Utan and the Bird of Paradise: A Narrative of Travel with Studies of Man and Nature*. (Reprint Edition: Dover, New York, 1962.)

_____ 1880. *Island Life, or the Phenomena and Causes of Insular Faunas and Floras, including a Revision and Attempted Solution of the Problem of Geological Climates*. (Reprint Edition: AMS Press, New York, 1975.)

Weiner, Jonathon. 1994. *The Beak of the Finch: A Story of Evolution in Our Time*. New York, N.Y.: Alfred A. Knopf.

Worthy, Trevor H. and Richard N. Holdaway. 2002. *Prehistoric Life of New Zealand: The Lost World of the Moa*. Bloomington. IN: Indiana University Press.

Index

159